# Bodies of Inscription

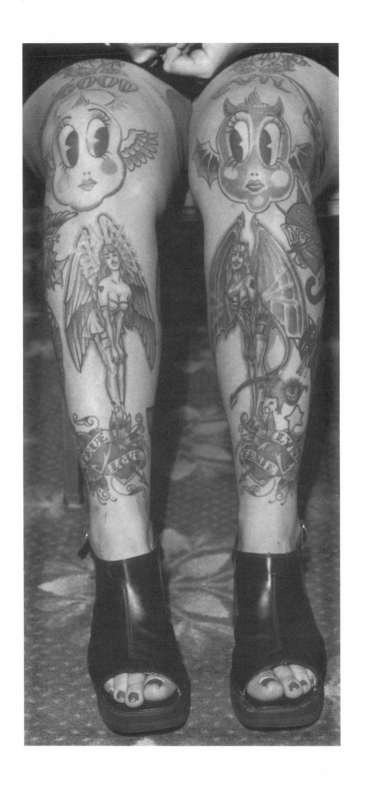

# BODIES OF

# INSCRIPTION

*A cultural history of the*

*modern tattoo community*

## Margo DeMello

Duke University Press   Durham & London   2000

© 2000 Duke University Press

All rights reserved

Printed in the United States of America

on acid-free paper ∞

Designed by C. H. Westmoreland

Typeset in Scala by Tseng Information Systems, Inc.

Library of Congress Cataloging-in-Publication Data

appear on the last printed page of this book.

*Frontispiece:* Lynn Cosnell tattooed by different artists.

Photo by Vida Pavesich.

Third printing, 2001

# *Contents*

# *Preface*

This book would not be what it is, and indeed could not have been written at all, without the personal involvement in tattooing I have had since this project began in the late 1980s. As one who defines myself as both insider and outsider to the tattoo community, it is not an "objective" account of tattooing, and the impact of my own life history on my work will be apparent to anyone who knows me. For those who do not know me, I offer this account of my personal history as a way of explaining to readers my own biases and perspectives, and, perhaps, as a caution to other researchers who decide, as I did, to study a subject that is close to home, as this approach is not as easy as it may seem. But more importantly, I hope it sheds light on the complex ways that life experience necessarily affects the anthropological encounter—especially when that encounter is with people very much like oneself.

I have been getting tattooed since 1987 and have defined myself as a member of the tattoo community since 1988 when I began attending tattoo conventions and reading tattoo magazines, as well as collecting more extensive tattoos. When I began studying within the community, I was a tattooed woman married to a brand-new tattooist. During the first years of research, my husband Shannon and I both struggled to find a way to "join" what is known as the tattoo community, a process that was in many ways extremely alienating and that also made me aware of the powerful borders both within and around this community. As a tattooed person, I experienced a community that was neither as friendly nor open as I had imagined it to be. As an anthropologist, I realized that my experi-

ence was from the perspective of the lower rungs of a highly strati-fied community. In this community, young tattooists without the sponsorship of an elite tattooist scramble to make a name for them-selves in a highly competitive atmosphere and use elite tattooists and tattoo styles as their aesthetic model. To become successful, new tattooists must usually first apprentice with an older, more experienced and preferably well-known tattooist, or at least must achieve the "sponsorship" of a well-known artist. Because who one knows is so important in this community, and because tattooists are not eager to share secrets (or fame) with new tattooists, finding someone to help get one's foot in the community is a difficult pro-cess. "Enthusiasts" or "fans" also make their initial contacts in the community through names—the name of the artist who did one's work. Both new tattooists and the newly tattooed, then, struggle to achieve contacts, friends, and a name in a community that appears, on the surface, to be solely defined by wearing tattoos.

Michael Moffatt writes about the difficulties of studying in one's own community: "Identifying with 'them' does not necessarily mean you are like them, or that they are all like one another, or that they all trust or identify with you, or that they want to be studied by you" (1992, 207). They certainly do not. Part of the reason for this, though, has to do less with the reality that communities are not homogeneous and more with the specific features of this par-ticular group, such as a concern with status, a fairly rigid hierarchi-cal system (reflected in tattoo contests, tattoo magazine publishing practices, and differential hourly wages of tattooists), and a strong (and understandable) suspicion of outsiders.

My position in the community, then, has vacillated between in-sider and outsider, member and researcher. For the first couple of years of fieldwork, I tried to achieve as much of an insider position as possible and thus struggled with issues of status, inclusion, and exclusion. I certainly felt like more of a native than a nontattooed person would, in that I fit all the "requirements" of membership (having multiple tattoos, reading tattoo magazines, attending tat-too conventions), yet I still experienced competition and snobbery. Later, however, I decided that I no longer needed to fit in and, espe-cially as I became more critical of the community's elitist nature, I moved in a different direction. I began to act and feel more like a researcher, less like a native: I began to "other" myself. While I still

had the same tattoos and to an outsider still looked like a native, I no longer felt like one.

Because of the tremendous amount of press and scholarly coverage surrounding tattooing today, many tattooists and tattooed people are hesitant to talk to journalists or researchers; many are simply tired of being analyzed. This made my work difficult, as I did not want to be intrusive. On the other hand, my position as a tattooed person has without doubt helped me meet people, make contacts, and carry out interviews. Many tattooed people spoke to me as a fellow member and even approached me first. I also asked different questions than most interviewers (who continue to ask whether it hurts, how much it costs, why they do it, and so forth), which was welcomed. Additionally, many tattooed people truly *enjoy* talking about themselves and their tattoos, and I am grateful for this openness. Collecting tattoo narratives proved more effective than asking point-blank questions about class issues or other controversial topics, so this became a favorite method of mine toward the end of my research. People recognized the folkloric value of their stories and responded to the idea of story collecting.

Perhaps the greatest difficulty I had with working in this community came from the fact that many of its members are both well educated and sensitive to outside condescension. Even those without a college education have a lay understanding of both anthropology (through their exposure to *National Geographic,* PBS programs, and the like) and tattooing (scholarly accounts are easily accessed through the Internet, at mainstream bookstores, or through tattoo supply houses like Spaulding and Rogers or National Tattoo Supply). Their knowledge led some people I interviewed to feel that they knew more about the subject than I did. On more than one occasion I had to defend both myself and my research against tattooed people who either believed I was doing something wrong or that my research was stupid. Consider, for example, a conversation I had with Bob, a tattooist from Los Angeles, at a tattoo convention in San Francisco:

"Since you're looking at the anthropological aspect," Bob said, "tattooing is one of the rare things out there that's characteristically human in a direct anthropological way by definition, because it existed in all cultures without cultural exchange. There's only a few things that are truly characteristically human. Pair bonding is char-

acteristically human. All cultures and societies without cultural exchange have developed pair bonding."

We then debated about whether pair bonding was characteristically human. Later, as I concluded the interview, he returned to the topic of anthropology and said with irritation, "You never asked me any anthropological questions." I wasn't sure how to respond to this because I didn't know what he considered an "anthropological question" to be.

"You know when I said [tattooing is] characteristically human, it just went like," and here he gestured with his arm, implying that it went right over my head. He continued to chide me: "That took a real lot of thought to evolve to the point where you understand that this is something that humans are going to do."

When working in non-Western societies, or when working with marginalized groups within the United States, anthropologists have traditionally held a higher status than their research subjects and have often abused this position in order to gain information. When working with middle- or upper-class people, as I did, this situation is often reversed, and anthropologists find themselves in the awkward position of trying to interview people who not only have little respect for the researcher's educational level but, as my conversation with Bob illustrates, may also question the nature of the research itself. Ultimately, though, I am glad my research was in a community that is both well read and well spoken. I would not want to return to the time when anthropologists write and their subjects don't speak (or write) back. My subjects did, and I am grateful for those who took the time to talk with me and to share the (often) intimate details of their lives, bodies, and professions with me, especially when there was little I could offer in return for their valuable time.[1]

# *Acknowledgments*

As an anthropology graduate student at the University of California-Davis in the early 1990s, I had no idea what (or, more accurately, *whom*) to study for my field research. Unlike most of my graduate student peers, I was not eager to travel across the world to live with people whose culture is radically different from mine, who eat different foods (I'm a vegetarian), and who probably would resent my presence. Besides, due to my work with an animal rescue group, I had a house full of animals to care for and was not in any position to do any long-term travel. It ultimately took one of my professors at the time, Smadar Lavie, to suggest that I study a topic that was literally under my nose—tattooing. At the time, even though I was tattooed myself, married to a tattooist, and spent quite a bit of time with tattooed people, I had never thought about tattooing as a research topic, so I am very grateful to Smadar for setting this project in motion.

I offer my deepest thanks as well to Aram Yengoyan, Suad Joseph, Carol Smith, Jay Mechling, and Ruth Frankenberg. They were with me from my exams through the writing of my dissertation, and provided invaluable support. Aram Yengoyan offered emotional, psychological, and academic assistance from start to finish, and his work on culture and ideology has influenced this manuscript a great deal. Suad Joseph and Carol Smith both spent a tremendous amount of time helping me refine my research questions. In particular, Carol challenged me to sharpen my focus on class, and Suad provided valuable criticism on early drafts of the dissertation. Jay Mechling exposed me to work being done outside of anthropology

and greatly influenced my thinking on the nature of social movements. And Ruth Frankenberg graciously joined my exam and dissertation committee at the last minute and took the time to give me thoughtful comments despite her own arduous schedule. Ruth also put me in touch with Ken Wissoker at Duke University Press, who became my editor, and for that I am extremely grateful. Also at the University of California-Davis, Dick Curley gave me teaching assistantships throughout the research and writing phases of this project, helping keep me alive in the process. I would also like to acknowledge Norman Stolzoff, who provided intellectual stimulation, moral support, and (most important) friendship throughout my graduate student years.

I extend my thanks as well to Philippe Bourgois and James Quesada from San Francisco State University, who hired me as a lecturer for two years while I completed this manuscript and who invited me to present my work on a panel that they organized at the 1996 American Anthropological Association Conference. I also want to thank Janet Rose and Kenneth Coulson, who gave me the opportunity to participate on two earlier panels—at the American Studies Association Conference in 1996 and the American Anthropological Association Conference in 1993. My work was enriched by comments on all of these occasions. Special thanks as well go to Isabela Basombrio, who organized a one-day conference on tattooing at the Detroit Institute of Arts in 1997. I am truly grateful for the opportunity to have participated in this conference and to have heard the work of Dan Wojcik and Dora Apel, both of whom inspired me.

I am grateful to many others as well. I would like to thank Tom Young and Vicki DeMello for their assistance in this project. Vicki helped by collecting some of the personal narratives that I have used herein, and Tom's photographs were used in many of my slide shows. Jules Tuyes was a student assistant for a semester, hunting down background materials, conducting interviews, and even getting tattooed (!), all without pay, and I am forever indebted to him.

I am also grateful to an anonymous reader from Cambridge University Press and two thoughtful readers from Duke University Press who gave close readings of this manuscript and provided detailed comments. Ken Wissoker and Richard Morrison from Duke

Press have been enthusiastic about this project from the beginning, and I am extremely thankful that they never gave up on it. My manuscript also benefited from Sara Diamond, who helped by editing several chapters and who motivated me to finish the book after a long recess.

Special thanks to Vida Pavesich, whose beautiful photographs appear throughout this book and to the men and women who allowed us to photograph them.

I am of course most indebted to all those in the tattoo community who shared with me their personal narratives. Their thoughtful answers to my sometimes invasive questions made this project possible. I am afraid that some of the people who helped me the most to create this book will strenuously object to some of the statements and ideas that are included. It is my hope that those tattooists and tattooed people who read this ethnography will consider it not a personal criticism but will instead see it as a critique of certain aspects of North American society, which are reproduced and writ large within the tattoo community.

To protect the privacy of those who spoke with me, I have fictionalized all names used in this book except for historical names. I also used real names when I was sure that the statements made to me were on the record. I would like to thank the following men for graciously allowing me to use their names in this manner: Don Ed Hardy, Leo Zulueta, Shotsie Gorman, and Lyle Tuttle. As Shotsie jokingly told me, "Tattooists only enjoy reading about themselves. If you put their name in, they'll all buy it." Well, Shotsie, this one's for you! I want especially to extend my thanks to two tattooists and tattoo historians, Ed Hardy and Chuck Eldridge. Both Ed and Chuck provided me with invaluable resources and contacts in the community, and their guidance and support cannot be measured. I am also grateful to Chuck and the Tattoo Archive for lending me much of the artwork used in this book. I thank as well Charlie Cartright and Shannon Shirley for allowing me to work in their tattoo studios, interview their customers, and generally get in the way.

I am deeply indebted to my parents, Bill DeMello and Robin Montgomery, for their unceasing support over the years. They saw me through a painful divorce and relocation halfway through my research, and without their love and care, this book would

never have happened. Finally, this book is for Tom Young, whose love, patience, and financial and emotional support sustained me throughout, and who thanklessly accompanied me to tattoo events at which he, an untattooed man, felt extremely out of place.

# *Introduction*

## Bodies and Social Orders

A tattoo is more than a painting on skin; its meaning and
reverberations cannot be comprehended without a knowledge
of the history and mythology of its bearer. Thus it is a true poetic
creation, and is always more than meets the eye. As a tattoo is
grounded on living skin, so its essence emotes a poignancy
unique to the mortal human condition.

—V. Vale and Andrea Juno, *Modern Primitives*

I started getting tattooed when I was 16. A friend and I went up to
L.A. We went to Bob Roberts and had our first tattoos. Something
little and feminine. We told him we were 18, and my one friend
has really large breasts [laughs] so that got us in.

—Deborah L.

It is April 1988, in Arlington, Texas, and we are seated in the ball-
room of the Hyatt Regency Hotel. It is the Nineteenth Annual Meet-
ing of the National Tattoo Association, and the room is filled with
200 attendees, almost all white and all tattooed. We are eating a

choice of chicken or vegetarian pasta. Many among us are tattooists by profession. Others are fans. We are variously truck drivers, secretaries, house cleaners, college professors, artists, and construction workers. On the stage is the Fat Chance Belly Dance troupe, a group of white, mostly professional women, all tattooed, whose dance style mimics various Middle Eastern dance forms, including Turkish, Egyptian, and Persian. The dancers' tattoos, like those of the crowd watching them, reflect many different styles: Celtic, tribal, traditional Americana, biker, and Japanese. One dancer, Theresa, wears a branch of ivy around her waist, and a colorful Celtic snake dances up her arm. After the dancing, we will watch as the organization bestows its annual prizes for best tattooing in major categories. Categories include best male and female full body, best black and white, and most unique tattoo. My favorite is the winner of the best female back piece, a beautiful underwater scene composed of a sea turtle and assorted ocean flora and fauna, colored in rich greens, oranges, and blues.

These images are striking not only as works of art but also because they illustrate the multiple dimensions of culture and history at play in the North American tattoo community.[1] White Americans, middle class and working class, from the cities, suburbs, and small towns—all wearing tattoos borrowed many times over from many different cultures—gather once a year to show off their tattoos and to honor the best. A one-dimensional understanding of tattoos simply cannot survive in the face of this diversity.

The tattoo was first brought to the West from Polynesia by eighteenth-century British explorers. Since then, tattooing has been mapped and re-mapped through its history in the United States, first by nineteenth-century American servicemen and carnival exhibits; later by members of the American working class; then in midcentury by bikers, convicts, and other marginalized groups; and finally in the late twentieth century by members of the middle class. Here, at the tattoo convention, these diverse histories and cultures converge. Merchant marines, bikers, and doctors come together to compare tattoo aesthetics ranging from Japan, Polynesia, the inner cities of southern California—even computer technology now finds its way into the tattoo imagery of the late twentieth century.

This book is about the emergence of tattooing, since the 1980s,[2] as a new cultural, artistic, and social form, and it is also about the di-

verse community of people who have come to embrace it. Since its arrival in the United States, the tattoo has shifted back and forth between the upper and lower classes, and it has also shifted in meaning. In each stage of its artistic and social evolution, the tattoo itself has been redefined, moving from the mark of the primitive to a symbol of the explorer, a sign of patriotism and a mark of rebellion, to where it stands for many today, as a sign of status. In this ethnography I explore the current middle-class repackaging of the tattoo, a process that highlights the tattoo's "primitive," exotic roots and at the same time seeks to erase its white, working-class beginnings in this country.

In this book I also look carefully at the creation of a community formed around the celebration of tattoos. Although the term "tattoo community" may refer to any and all tattooed people, my reference is more specific and includes those who actively embrace the notion of community and who pursue community-oriented activities (like attending tattoo shows). The community is open to all tattooed people, yet it is also hierarchical: stratified by class and status, it is now largely defined by elite tattooists and tattoo magazine publishers who are primarily from the middle class.[3]

On another level the tattoo community may also refer to a new, predominantly middle-class movement (born out of the "Tattoo Renaissance," per Rubin 1988b, Sanders 1989) that celebrates tattoos as spiritual, poetic, and self-empowering. Community members see in tattooing a means to revitalize modern North American society—to change the world by changing one's body.

I have chosen to use the term "tattoo community" throughout this ethnography even though I will also argue that it is a contested term that, by itself, does not capture the variation and conflict within the tattoo culture. Within the "community," there are broadly defined class groups, and within each larger group there are also numerous subcommunities. But to use separate terms like "the biker tattoo community," "the middle-class elite tattoo community," or the "young punk tattoo community" would be to impose artificial boundaries, because these subcommunities overlap. The tattoo community *is* a real community in the sense that it is experienced by tattooed people across the country; and yet it is differentiated, by class and status among other features, such that it often seems to exist in pieces more than as a whole. Thus my task,

to paraphrase Benedict Anderson (1983), is to discover how the tattoo community, as a *unified* community, came into being, how its meaning has changed over time, and why the idea of the community has commanded the legitimacy that it has. I want to call attention to the term "community" by moving back and forth between its multiple meanings. For example, I will examine the ways in which elite members of the community have defined the movement so as to subtly exclude working-class members, even though they represent the roots of tattooing. I will also look at the ways in which the popular media have helped redefine tattooing today.

I will argue that the new movement around tattooing is coalescing through three related processes. First, the tattoo has been appropriated from the working classes whose members now find themselves marginalized within the movement, thus creating, in effect, two separate subcommunities. Second, I will argue that the tattoo has been, in a sense, sanitized or stripped of its working-class roots, in order to ensure that the tattoo is now fit for middle-class consumption. Third, the tattoo has been assigned a new set of meanings, derived primarily from non-Western cultures, giving the tattoo an exotic, primitive flavor. One of the key ways that this transformation has occurred, and the primary way in which the elite members of the community now define tattooing, has been through discourse—through individuals talking about and writing about tattooing—on the pages of magazines, on Internet chat groups, at tattoo studios, or at conventions.

The shift in the customer base for U.S. tattooing, from almost exclusively working-class beginnings to include many more middle-class customers, has been treated by a number of scholars in recent years (Sanders 1987; Rubin 1988b; Smith 1989; Campbell 1992; Gambold 1992; Miercke 1992). These researchers note the changes in demographics and the evolution of the tattoo itself, from a standardized, formulaic design executed by craftsmen to a custom-designed, fine art image executed by professionally trained artists. These same observers, however, have not looked beyond the changes in group membership and tattoo imagery to understand the discursive processes and practices by which tattooed people now imagine themselves, and are imagined, as a community. Nor has there been an attempt to understand the political and cultural ramifications of a transformation this radical. Here I am referring

to the transformation in meaning that has accompanied the more easily visible social and artistic changes. This book addresses these issues directly and shows that the conversion is not complete. There are still, in fact, many working-class people involved in tattooing, and much of contemporary tattooing is still stylistically traditional. Nor have changes in tattooing practice occurred without challenges. The community's new middle-class members are not a homogeneous group (nor are the working-class members). Rifts within and between various echelons of the community illustrate the strongly hierarchical, status-conscious aspects of this new social movement and the overlapping nature of its subgroups.

## *Class and Status within the Tattoo Community*

As Barbara Ehrenreich points out in *Fear of Falling: The Inner Life of the Middle Class* (1989), there is a tendency among journalists, scholars, and the media in this country to make sweeping claims about values, characteristics, and culture that in actuality only reflect the class of those speaking: the North American middle class. The middle class is seen by writers and television pundits everywhere as a universal entity and, in Ehrenreich's words, "a social norm . . . from which every other group or class is ultimately a kind of deviation" (1989:3). This attitude is shared by many nonmedia folk as well, as most U.S. citizens (unless they occupy the most extreme positions of the class hierarchy) define themselves as middle class. The ubiquity of middle-class identification extends into the tattoo community, too, with tattooists and fans alike, regardless of background, claiming middle-class affiliation. One of my tasks in this book, then, is to denaturalize the middle class and to show that, contrary to popular claims, there is an oppressive class system at work within the tattoo community.

One way that class is obliquely expressed within the tattoo community is through the naming practices that are used to describe tattoo styles and their wearers. Terms such as "biker," "sailor," or "scratcher" are used in tattoo magazines and articles on tattooing to refer to certain working-class tattoo practices that are said to be outmoded and are differentiated from newer practices defined as "pro-

fessional" or "fine art." These are all status terms that mask class differences within the supposedly egalitarian tattoo community. John Hartigan, in an essay on white trash, writes, "The social differences embodied by white trash do not exist in a vacuum; they are elements that the white middle class relies upon to distinguish themselves from the lower orders: 'We are not that'" (Hartigan 1997:51). "Biker" or "scratcher" operate in much the same way as the term "white trash" does, as "a cultural figure and a rhetorical identity . . . a means of inscribing social distance and insisting upon a contempt-laden social divide, particularly . . . between whites" (50). Writers and spokespeople, both within and outside the tattoo community, use terms like "biker" to *mask* class difference, yet at the same time to *distinguish* a class of people and their practices as different from, and inferior to, the preferred practices of the middle class. This "biker/not biker" distinction serves to structure the relational basis of class identity within a community that denies the existence of class, because by defining "biker" as that which is bad, "not biker" is very clearly defined as that which is good. If class operates on a continuum, then "biker" is positioned at one end in order to give meaning to the other end ("not biker" or middle class), as well as to all points in the middle. By using this language, working *and* middle-class community members can present themselves as respectably middle class while distancing themselves from bikers, sailors, ex-convicts, and other tattooed people labeled as "trash."

"Biker" (or "scratcher" or "sailor") is a powerful image that is both a description of real people and their lifestyles and is also a stereotype, which often has little to do with reality. For example, bikers *do* wear tattoos, and some (but certainly not all) biker tattoos are poorly executed and contain antisocial imagery and expressions. But the biker stereotype is also used to refer to everything bad, old fashioned, and not middle class about tattooing today. Here, not only are real distinctions between particular practices erased (between, for example, sailor tattooing, biker tattooing, or other working-class forms of tattooing) in favor of a caricature but all are used in such a way as to define an alternative, better tattoo. Barbara Ehrenreich points out that unlike racial stereotypes, class stereotypes are freely used by many in the middle class today, with the habits and tastes of the white working class described as tacky, unhealthy, hopelessly bigoted, and parochial (1989:7). The middle

class imagines the behaviors and values of the working class to be based on these stereotypes. That imagination, in turn, informs the middle class's perception of itself (as, for example, liberal, tolerant, and healthy). Again, if class difference is relationally constituted, we can see how stereotypes of one class are used to define and represent what the other class is not. Furthermore, this form of imagining operates on both sides of the class continuum. Just as many middle-class tattooed people imagine their working-class counterparts to be bigoted slobs, working-class tattooed people may see the middle-class as made up of equal measures of yuppies, elitists, queers, and feminists.

While I am interested in the role that class plays in the construction of tattooing today, I do not draw direct links between the class positions of tattooed people and their particular practices or motivations. I am instead interested in tracing a broad set of ideas held by one class group about another, and in particular, how middle-class ideas about the working class and about itself help to define contemporary tattooing for *all* participants. Because class is not an essentializing category, class position does not inevitably determine the type of tattoo one wears nor the value system one associates with the tattoo. Rather, class is, per Bourdieu (1984), an indicator of the processes by which cultural taste is ranked and distributed.

But what is the middle class, and how can I presume to trace "middle-class ideas"? Again, I am hampered by the apparent universality of the middle class. When I use the term "middle class" in this book to refer to an informant, my definition includes having a college education as the basis of middle-class status, since property ownership and income levels are not very indicative of class status within the tattoo community. But even this definition is unsatisfactory because people's backgrounds and life experiences are more slippery than the equation, college = middle class, allows. But in general, I use the term "middle class" to refer to ideas and not people. Using Barbara Ehrenreich's work as a model, I have chosen to focus on the ideas expressed by mainstream journalists, opinion makers, scholars, and the media, all of whom are themselves middle class. Thus the focus in this book is on media representations, discourse, and social movements. And while many of the ideas popularized through the middle-class media did not necessarily originate within the middle class, they were at least re-

interpreted (and often commodified) by the middle class, leading to their popular acceptance. I realize that some will question this (rather interpretive) use of the term "middle class." I hope, however, that by the end of this book, most readers will agree with (or at least recognize) the patterns that I have outlined. (Regarding my own informants, I did not keep statistics about the class, sexuality, ethnicity, or gender of them—defining these characteristics is difficult, and I am uncomfortable asking. But I will say that the majority of those who shared their narratives with me were what I consider middle class, and of those, the majority were women. I do not know how many were gay or straight, because I did not ask, although I would guess that at least 20 percent were gay.)

To complicate the picture further, other (nonclassed) measures of status are important in the tattoo community as well. Status is marked by a number of features, including the type of one's tattoos (custom or flash);[4] who created one's tattoos (i.e., the status of the artist); the number of tattoos one has; how much media coverage one has received (in the tattoo magazines); and what kinds of links one has to high-status tattooists. For the tattooists themselves, status is gauged by artistic credentials (including training, skill, and degree of innovation); professional credentials (who was the artist's mentor; whether one runs a custom shop or a street shop); shop locale (urban or rural, West Coast versus East Coast); and relationships with the factions that develop around certain tattooists and tattoo organizations. But even these criteria are complicated. Having a fine arts background, for example, would normally carry high status for a tattooist. But having a reputation as a former gang member can, in some cases, carry a certain kind of status as well.

Class and status are both important aspects of this book, and I deal with them in different ways. In chapter 3, I track the emergence of the middle-class-driven Tattoo Renaissance by examining how tattooing—as an art form and social practice—has been transformed over the last two decades. In chapter 4, I examine how the mainstream media, tattoo magazines, and tattoo organizations also participate in defining modern tattooing by emphasizing differences between the new, middle-class-favored forms and the old, primarily working-class forms. In chapters 5 and 6, I discuss how ideologies and discourses drawn from social movements popular within the middle class bolster the legitimacy of tattooing, which

in turn helps to encourage middle-class participation in the tattoo community.

## Social Bodies, Cultured Bodies

A concern with the body, differences between bodies, and the relationship between the social and physical body is a central focus in this book. My work, then, draws from the literature that focuses on the body in culture, including works by Mary Douglas, Michel Foucault, and the vast numbers of feminist and other scholars who look at the body in culture.[5] These scholars examine how the body is both inscribed by culture and counterinscribed by individuals.

Another stream of research on the body in culture has focused on the class(ed) body. The most important thinker here is Pierre Bourdieu, and in particular, his book, *Distinction: A Social Critique of the Judgement of Taste* (1984). Bourdieu writes of a "universe of class bodies which . . . tend to reproduce in its specific logic the universe of the social structure" (1984:193). These "class bodies" can be distinguished, according to Bourdieu, through expressions of the different tastes, appearance, habits, and lifestyles of each. Because members of each class operate from a different "habitus"— an internalized form of class condition that informs how one inhabits one's body—it is to be expected that their tastes in clothing, food, or sports will differ. Bourdieu's claim that "the body is the most indisputable materialization of class taste" (190) provides a context for my own attempt to locate within the tattoo practices of the contemporary United States a logic defined by class.

Beyond the contributions of Bourdieu, Mikhail Bakhtin's work (1984) has also informed a number of contemporary studies that deal with the difference between lower-class and upper-class bodies (Stallybrass and White 1986; Fiske 1989; Kipnis 1992). Laura Kipnis, for example, in her work on reading pornography, focuses on how class constructs the pornographic body. She borrows heavily from Bakhtin's discussion of the homology between the lower body stratum and the lower social classes (as represented in the work of Rabelais), such that the body becomes a privileged trope of the lower social classes and through which bodily grossness operates as a critique of dominant ideology. Bakhtin's distinction between

the grotesque body of European carnival and the classical body of canonical Renaissance literature also provides a foundation for my own understanding of the politics of bodily control within the tattoo community.

A final reason why a theoretical understanding of the body must be central to any work on tattooing has to do with the classic treatment of tattooing within anthropology. Tattoos, along with scarification,[6] body piercing, and other forms of body modification, are seen as universal features of "primitive" society. These practices have been found in the earliest archaeological records from the Upper Paleolithic era and are understood to be visible indicators of age, social status, family position, tribal affiliation, and so forth. Terence Turner (1995) explains that in societies with "simple" systems of exchange (i.e., where social status is not constituted primarily through the exchange of goods), visual bodily display, *as a mode of circulation*, may communicate and create status and identity (Turner 1995). Succinctly put, modifying the body is the simplest means by which human beings are turned into social beings—they move from "raw" to "cooked" with the tattoo. While I am not debating the merits of this widely accepted view (see also Brain 1979; Rubin 1988b), the notion that body modification is somehow fundamental to human culture has become extremely popular among members of the tattoo community and is dealt with at length in chapter 6 of this book.

## Re-creating Traditions

Contemporary tattooing has evolved from a practice that was originally imported from the islands of Polynesia and later transformed into a form of working-class folk art. Within just the last twenty years, tattooing has undergone a new transformation. In this book, I demonstrate how this transformation has come about and how a completely new version of the tattoo has come to occupy a central place in the North American popular imagination.

How traditions are invented, how they are invested with history and authenticity, and how they are embraced by new communities—all these questions are addressed by Eric Hobsbawm et al., in *The Invention of Tradition* (1983). Hobsbawm defines "invented

tradition" to mean "a set of practices, normally governed by overtly or tacitly accepted rules and of a ritual or symbolic nature, which seek to inculcate certain values and norms of behavior by repetition, which automatically implies continuity with the past" (Hobsbawm 1983:1). What is interesting to Hobsbawm about invented traditions is that they typically come complete with an invented history, to which they constantly refer. Aram Yengoyan (1992), in a response to Hobsbawm, shows that newly invented traditions are not created in a vacuum but instead must be based on a prior text that "provides the intellectual and emotional grounding from which the new symbols and institutions are understood and recast to maintain continuity" (1992:10). Even though the history of the "tradition" may be factitious, there must, for Yengoyan, be some link between the new tradition and the community embracing it.

In the case of non-native American tattooing, the tradition first came from the islands of Polynesia within the context of colonialism, then was adapted by various subcultures within the working class, and was once more reinvented in the 1980s, primarily by middle-class tattoo artists and wearers. Through each step of this evolution and reinvention, the participants must rework the tradition to make it fit the sensibilities of the new community. In the 1980s, the new middle-class tattooists and their customers did not possess the working-class text, or grounding, necessary to make tattoos a meaningful part of their lives, and so they created a new text with new meanings.

In other words, in order for a borrowed or reconstructed tradition to be embraced by a new community, the tradition must be mediated by familiar aspects of the new community's culture. With respect to tattooing in a middle-class context, this occurs through the introduction of different notions of the body, aesthetics, and spirituality, all of which are more palatable to a middle-class sensibility and help ground the new tradition. This happens primarily through the popular accounts of tattooing found in mainstream and community-produced publications, as well as in the stories tattooed people tell about their tattoos. Through narratives, the tattoo community is restratified, and tattooing is redefined on the basis of middle-class standards of taste—standards that ultimately form the basis for the new, middle-class text.

In *Anti-Oedipus* (1983), Gilles Deleuze and Felix Guattari discuss

a similar process of appropriation and redefinition. In their account, "deterritorialization" refers to a situation in which a cultural practice is borrowed from its original context and is assigned, or recoded with, a new meaning. In this formulation, the cultural form is freed of its original significance and once freed, it can be reinvested with an entirely new meaning, all the while keeping the external form basically the same. In the case of tattooing, the process is more complex, because the tattoo is *already* coded with multiple layers of meanings—working class, biker, primitive, exotic, etc. Thus, in order for the tattoo to become a middle-class cultural form, some of its older meanings have had to be removed, other meanings highlighted, and still other new meanings added.

## Tattoo as a Discursive Tradition

The tattoo is a powerful symbol of affiliation and identity. For Chicanos (Govenar 1988), convicts (DeMello 1993), sailors (Hardy 1982c), and others, tattoos serve to position individuals within communities and relationships and to express personal and collective identity (Sanders 1989). As I argued elsewhere (1991), North American tattoos fulfill a need to inscribe the self as an individual and as a part of, or in relationship to, a group. In earlier writing, I saw the primary source of tattoo power in terms of the literal ability to "write oneself" and subsequently to be "read" by others. Today, I realize that tattoos are powerful in another way: as a site of discourse. People talk about tattoos. They talk about their own tattoos, about each other's tattoos, about tattoos in general, and this talk, I argue, has a practical effect: it actually shapes the tattoos. I call people's stories about their own tattoos "tattoo narratives." These narratives serve in an important way to create meaning, by providing an intellectual and emotional context for the tattoo. I argue (in chapters 5 and 6) that these narratives are especially important for middle-class tattoo wearers because they must consciously create a new meaning for their tattoos as the traditional, or working-class meanings, are unacceptable to them. By creating and reciting their own narratives, tattooed people are allowed to verbalize their motivations for becoming tattooed, how they chose a particular tattoo, and what their tattoos mean to them.

In the popular press, in tattoo publications, and within academia, there is more writing about tattoos than ever before. Prior to the 1980s, there was some interest in tattooing among scholars and journalists, but it was primarily related to the supposed connection between tattoos and deviance.[7] Since 1980, there has been a noticeable increase in the attention paid to tattooing in the popular press. There are now at least eight major tattoo magazines published regularly in the United States, and articles on tattooing appear in magazines, journals, and small-town newspapers on a regular basis.

I contend that the increase in writing and speaking about tattooing, and the nature of that discourse, actually *produces* contemporary tattooing and the modern tattoo community. This new discourse is based on ideologies borrowed from other cultural groups (like gays and lesbians) and social movements (like the New Age and men's movements, and feminist spirituality) and has resulted, I contend, in a totally new movement.

## *The Mark of Difference*

For westerners, the tattoo has always been a metaphor of difference. It has represented different things at different times, but ultimately the tattoo has always been seen as the mark of the primitive. The tattoo attracts and also repels precisely because it is different. For the middle class, the tattoo is almost savage in its obvious physicality. It is permanent, painful, masculine, and somewhat sexual. Wall Street and Hollywood have long recognized the visceral impact of the tattoo and have used it in movies and advertisements for decades. In 1956, to name just one example, the Marlboro cigarette manufacturer was seeking to expand its market from its mostly female target audience to a male consumer base. Advertisers created the Marlboro Man, a tough-guy type with a tattoo on the back of his hand. The campaign was so successful that Marlboro received hundreds of letters from tattooed men who not only smoked Marlboros but also asked to pose for future ads (Eldridge 1990)! The tattoo did not survive the decades following the Marlboro Man's original debut (it was replaced by the figure of the rugged cowboy), but it served the purpose of the advertising campaign: it represented masculinity, working men's values, and danger. Today, of

course, the Marlboro Man with his tiny tattoo is nothing compared to images like Robert De Niro's tattoo-covered torso in *Cape Fear,* or the heavily pierced and tattooed transgender-cannibal-psycho character in *Silence of the Lambs.* Clearly, tattoos continue to serve the purpose of symbolically associating the wearer with danger.

Today, tattoos often signify the Third World and, in particular, exotic Asia. Tattoos are living embodiments of cultures that no longer exist. At the same time that tattoos were "discovered" by Captain Cook and explorers like him in the seventeenth century, the cultures in which tattooing was prevalent were being missionized, sanitized, and in many cases, eliminated. Thus for some observers, tattoos are an uncomfortable reminder of colonialism, and for others, they provide a means through which to *know* other cultures, as in a sort of bodily tourism.

Deborah Root, in her book *Cannibal Culture* (1996), posits why certain cultures, objects, and people are coded as exotic in the West: "The process of exotification is another kind of cultural cannibalism: that which is deemed different is consumed, its aesthetic forms taken up and used to construct a dream of the outside and sometimes of escape from the Western nightmare" (1996:30). The tattoo is an especially mobile aspect of culture. It can literally be carried on the bodies of native people who migrate or on the bodies of travelers coming home from exotic places. Tattoos *seem* more exotic than other transportable fragments of a foreign culture. Getting a tattoo is a relatively inexpensive way to sample another culture that is unlike, for example, climbing Mount Everest.

But difference has both positive and negative connotations. Today, the more different, the more exotic (and authentic), the better. Tattoo wearers search the planet for cultures whose designs have not yet been discovered, whose mythologies have not yet been plumbed. At the same time, North American working-class tattoo designs (i.e., traditional Americana, biker, or sailor style) are spurned because they are either not different enough or their difference implies a working-class or white trash image. Tattoo designs from the United States are unpopular among many in the tattoo community today because they fail to provide for the wearer the fantasy of the primitive and, thus, the (symbolic) rejection of mainstream white society.

# Book Outline

This book investigates the manner in which tattooing reemerged in the 1980s and is now redefined and championed by a new audience and invested with new meanings. To understand the recent history of tattooing and the emergence of the modern tattoo community, one must look at the earlier social contexts in which tattooing took shape—from the nineteenth- and twentieth-century periods of colonialism, the years during and between the two world wars, the post–World War II era of an emerging middle class, and finally the heyday of the self-awareness and liberation movements during the 1970s and 1980s.

Chapter 1 focuses on one of the central questions of my research, What is the community? In chapter 1 I describe in detail the various arenas in which I found ideas about community: the tattoo conventions, the pages of tattoo magazines plus other media accounts of tattooing, and an arena I encountered only toward the end of my research, the Internet. In chapter 2, I look at the history of tattooing in the West from the perspective of the colonial encounter between West and non-West. Here I focus particularly on the context in which tattooing entered the Western imagination, through the exhibition of tattooed "natives" at dime museums and world's fairs and through the acquisition and display of tattoos by sailors and other members of the U.S. armed services.

In chapters 3 through 6, I present my argument about how the modern tattoo has been redefined and the tattoo community has been reconstructed over the last twenty years. Chapters 3 and 4 focus on structural transformations within the tattoo community as well as the role that discourse has played in these transformations. In chapter 3, I explore the origins of the Tattoo Renaissance and focus on the appropriation of tattooing from the white working-class population into the middle-class community. I sketch the transformation of the contemporary art form by tracing its roots to Japanese, Polynesian, and Melanesian (i.e., "tribal") tattooing, as well as in Chicano street tattooing. Chapter 4 looks at the ways in which the tattoo community became differentiated into two opposing groups, high and low, with corresponding art forms and

social practices. This chapter focuses in particular on the ways in which media representations, produced inside and outside the tattoo culture, define the community, both for members and for the general public.

Chapter 5 outlines the final stage in the process of transformation: the creation of meaning. This stage is crucial. As the middle class appropriated the tattoo from the lower classes, they left behind some of the earlier meanings associated with working-class tattooing. The middle class created (or in some cases, borrowed from other groups) new notions of the tattoo, including a different set of values, a different emphasis on the body, and a different history as well. In chapter 6 I present and analyze the tattoo narratives that I believe are central to the construction of meaning in the new tattoo community. These narratives are framed in language borrowed from social movements popular with middle-class audiences, and, as such, they point to the vastly different new cultural context of middle-class tattooing. Finally, in the conclusion, I discuss the reaction of some tattooists to the current focus of contemporary tattooing, and I forecast some possible future trends. As many older, and quite a few younger, tattooists begin to rebel against the increasing commodification and superficiality found in much of modern tattooing, we can foresee the beginning of a new social and aesthetic movement, one which will rely less on the exploitation of cultural differences and more on a truly homegrown, North American creativity.

# I

## *Finding Community*

### Shops, Conventions, Magazines,

### and Cyberspace

I don't go to a lot of conventions. They wear me out in a way.

It's just a mass of people and a sensory overload. I know a lot of

tattoo artists who work in this town. This is an opportunity for me

to watch a few artists that I've heard about, and see what they're

doing, not that I'm planning on simulating it, but it just gives

me an idea of what people are doing. And in the back of my

mind, I'm rating them. I got a checklist in my head.

I am.—Lal M., tattooist

One of the central questions of my research involves community. What is it, how is it understood, and how is it realized? Within the group and movement that has come to be known as the tattoo community, the answers to these questions vary according to the position, experience, and motivation of the person being asked, and people's views on the subject will often contradict one another's. My own understanding of community has evolved since I began this study. I first understood it to be a static, place-bound phenomenon found only within tattoo shops. This seemed logical: tattoo shops

are where tattooing occurs, thus I felt that community would also occur, or at least originate, there. Later, I realized that the notion of community was not being defined exclusively in the tattoo shop, but was a more fluid notion, one that takes shape in the realm of discourse. I found that community occurs whenever tattooed people talk about themselves, about each other, and to each other —community is a function of that discourse. Therefore, I found community primarily occurring within the pages of magazines and newspapers, in Internet newsgroups, and at tattoo-oriented events across the country. My aim in this chapter is to explore the operation of the tattoo community in the spaces where it is realized (primarily the tattoo convention) and in the texts in which it is defined (magazine and newspaper accounts). This chapter will introduce these sites and will also look at a third site, the Internet, and in particular, at the newsgroup rec.arts.bodyart, which has become for the people who subscribe to it a separate form of community. I will describe the tattoo shop first, because it is the entry point for everyone in the tattoo community. While I maintain that the tattoo convention and media accounts of tattooing are the primary arenas in which community is created, every member of this community begins his or her journey by spending time—often considerable amounts of time—in a tattoo shop.

## Spending Time in Tattoo Shops

A typical tattooist's workday begins at 11:00 or 12:00 in the morning. The tattooist usually begins the day by setting up the workspace: laying out photo albums to display the type of tattoos created in the shop, checking to make sure there are enough supplies (clean needles, bottles of ink, latex gloves), and dealing with money. The tattooist might also sterilize some of yesterday's needles if there was not enough time at the end of the previous evening. The day proceeds as potential customers enter the studio to get tattooed, think about getting tattooed, or just to look at the tattooist's wares. The wares include the posters of flash (sheets depicting tattoo designs) on the walls, design books (filled with images of flowers, animals, "tribal" and "Celtic" designs, and other images used in contemporary tattoos), tattoo magazines, and photographs of the specific tat-

toos produced in the shop. Depending on the type of shop, some customers will bring their own design, while others will choose one from the flash or design books. Some customers will try to bargain with the tattooist over prices ("I could get my buddy to do this one for a six-pack, man!"), and others will drive the tattooist crazy with questions ("Do they hurt?" "Can I get AIDS from it?" "How much will this one cost? . . . OK, well what if I get it a little bit smaller? . . . All right, what if I don't get any color, just black? How much then?"). Of course, it's easy for tattooists to take the process of tattooing for granted, but customers anticipating a new (or a first) tattoo are typically very nervous.

Much of the tattooist's day, even after customers have begun to arrive, is spent not actually giving tattoos but preparing for work (drawing and tracing designs, cleaning equipment, making needle bars, fixing machines, ordering supplies) or talking to potential customers. Actual tattoo work is variable: a tattooist will have days where he or she might only make $40 for a small name tattoo and days where the same tattooist might make $1,500. In my experience, tattooing is not the hardest part of a tattooist's job; instead, it is dealing with customers. At working-class street shops, I have seen drunks come in on a daily basis, customers vomit or faint during a tattoo, and customers challenge and pick fights with the tattooist over prices or an imagined slight. I have also witnessed men and women pulling down their pants or lifting up their shirts to show their homemade tattoo to the tattooist, hoping that perhaps it can be fixed for next to nothing.

On the other hand, at a custom-only studio frequented by those who want, and can pay for custom tattoos,[1] there are more women coming in with their friends, art students who want to learn how to tattoo, and people who have been thinking about becoming tattooed for, in some cases, months or years, and have finally decided to take the plunge. The tattooists who run these studios do not promote flash-based tattoos; instead, they expect to play a part in designing every tattoo that they create. Their walls, then, are not filled with flash, but are covered with photos and drawings of tattoos created by the artists in the shop, as well as other forms of tattoo-related art, such as comic book art or Japanese art. But not all the customers at a studio like this are middle class and professional. A lot of punks hang out at these shops, as do musicians, artists, and other

(often heavily pierced) members of the counterculture. And custom tattooists are not spared the hassles of customer service that often plague the street shop tattooist, even if they don't keep a baseball bat behind the counter for protection.

In many ways, though, all tattoo shops are alike: the colorful walls, the smell of A&D Ointment, the drill-like sound of the machines, the preponderance of young people hanging out, the nervous laughs of first-time tattoo customers, and the tattooist's emphasis on cash only, no drunks, no minors, and no facial tattoos.[2] Additionally, the process of tattooing is fairly consistent, regardless of the type of shop in which it is performed.[3]

After the first few years of fieldwork, I no longer spent much time in tattoo shops because the nature of my research changed. But the tattoo shop remains the most important place for the newcomer to learn about tattooing: who gets tattooed, what kinds of tattoos are available, how the process occurs, and what the relationship between artist and customer is.[4] (Of course, it is also the best place to get tattooed.)

## *What Is the Community?*

*Key Rituals* �»➤ One of my first, and most enduring, research questions has been: How is membership in the tattoo community constituted? I originally thought that the question of membership was personal and that individuals self-identify as members. While individual identification is extremely important, it is my assertion that there are certain key rituals that define membership. These rituals would include first, and obviously, becoming tattooed. (However, having tattoos, even multiple tattoos, does not by itself constitute membership. For example, most sailors or other military men I have spoken to do not consider themselves to be part of a tattoo community and many have never even heard the term. Individuals who have a few tattoos but otherwise show no interest in tattooing would also be excluded.) Second, it is crucial to have enough interest in tattooing to either read tattoo publications (including magazines, books, pamphlets, and calendars), attend tattoo conventions, or both. It is said that tattooing involves a commitment, as the mark made is for life. This is true. But to be a member of the

tattoo community requires more than just getting a tattoo—it involves a commitment to learning about tattoos, to meeting other people with tattoos, and to living a lifestyle in which tattoos play an important role.

Conventions and magazines are important aspects of this commitment for a number of reasons. First, tattoo conventions constitute a space where individuals with a common interest—tattoos—come together for a period of time. While tattoo shops are also places where tattooed individuals congregate, I would argue that a different kind of community is created there. The community surrounding a tattoo shop is more localized and more focused around a particular shop, tattooist, or style of tattoo (for example, a tattoo studio in San Francisco specializing in tribal tattooing will attract a small contingency of punks who identify strongly with that style and what it represents). The sense of community that individuals find in the tattoo convention or reading a tattoo magazine has less to do with the physical congregation of bodies than with a feeling of "shared specialness." Tattooed people define themselves vis-à-vis nontattooed people and the dominant society in general. What makes tattooed people feel they are part of a larger community when attending a convention or reading (and writing to and sending in photographs) a tattoo magazine is a sense that they have found people who are like them and who are not like everyone else.

The second way that conventions and magazines constitute community has to do with where and how the notion of community is defined within the movement. Without the organized structure of tattoo shows, tattoo magazines, Internet chat groups, and tattoo organizations (which often organize the shows), there would be no broader notion of community, because it is on the pages of tattoo magazines and in the literature promoting tattoo organizations and their shows that a broader idea of a community has taken shape. Before 1976 (when the first big tattoo convention was held),[5] I suggest that the term "community" was unknown among mainstream tattooed people. In addition, while tattooists communicated with each other about the best equipment and supplies, there was also a great deal of competition between tattooists; many were suspicious that other tattooists might gain access to their secrets. One tattooist says of the old days, "There was open hostility between one another, almost. If there was a guy a few hundred miles away or a few thou-

sand miles away, then that's where the communication was. But if they was fairly close, tattoo artists are like dogs—they run around pissin' on each other's territory" (Kenny P., tattooist).[6] Even with the rise of tattoo shows and magazines in the 1970s and 1980s, many older tattooists shunned these new developments, preferring to stay out of the limelight and keep to themselves. Stoney St. Clair, for example, never attended a convention and felt that the public exposure—the "glorification"—was damaging to the profession (St. Clair and Govenar 1981). Another old-timer, Broadway Bill, told me that all the new publicity surrounding tattooing made him suspicious, and he wanted no part in it. On the other hand, there did exist, prior to the development of conventions and magazines, a notion of community among other groups who practiced tattooing—bikers, convicts, sailors, or members of the leather and S/M cultures, for example—but the community was not based on the tattoo, nor did the notion of community extend outside of each specific group to embrace others with tattoos. While the tattoos worn within each group, and especially those worn by convicts and bikers, did serve as important markers of group membership, the communities of bikers, convicts, or leatherboys were based on much more than tattoos. But until the seventies, I can find no evidence—in magazine or newspaper accounts, books on tattooing, or recollections of old-timers—of a notion of community broader than that surrounding a particular shop.

*But Does It Exist?* ➺ My conversations with tattoo convention attendees and the language used on the pages of tattoo magazines indicate that there is, for most, a very clear notion of the tattoo community. This understanding asserts that, in the words of one Los Angeles–based tattooist,

> It is truly a community in that we recognize that other people who do other styles and types of tattooing, which you may not like or approve of, are all equally as valid. We're actually a family. Most of the tattooers, whatever city they go to, the first thing they'll do is look up the tattooers. Whether you like me or don't like me, you know me because I've been here for twenty-five years. . . . What does an outsider see of our community? Is the tattoo convention format our community? You know what you really need to do is be in a tattoo-

ist's living room, as he's having a beer or doing whatever he's doing, and see the tattooists who are staying in his house that he's never met before, for whom he's opened his doors and allowed them to live in his house, and eat of his refrigerator, and he has no idea who they are. People who I've never met before, who I didn't know existed before, have invited me to share their homes so immediately, they recognize that I share something that they share. Especially when you think you're an island and then this other guy that's doing the same thing, in three seconds you immediately know that that bond is there and that does happen a lot. (Barry B., tattooist)

Barry implies that the feeling of community is so strong that tattooists who do not know each other will invite each other to sleep at their homes. For Barry, and others like him, the tattoo community entails *communitas,* Victor Turner's (1969) term for a feeling of homogeneity, equality, camaraderie, and lack of hierarchy common among those who are marginalized or are undergoing a liminal transition from one state to the next. These assertions about the tattoo community as an example of communitas represent the idealized view of the tattoo community, one that is shared by not only tattoo organizations and tattoo magazine editors but by many members of the tattoo community. The following poem printed in the *Tattoo Enthusiast Quarterly* (spring 1990) illustrates this feeling.

Collectors, fans, masters of the Living Art.
Like light through a faceted stone.
Colors reflecting in all directions.
We come together in a celebration of self—
Though we are many we are one.
We share our meaning of life,
memories past and future dreams.
All come alive in the artist's hand.
(Jeri Larsen, "The Bond")

The writer's statement "Though we are many we are one" captures the idea of communitas well. By wearing the tattoo (the "Living Art"), the various colors come together "in a celebration of self." It is almost a mystical idea that tattoo collectors achieve a oneness through their tattoos. The process of becoming tattooed includes of course the pain (often ritualized in contemporary ac-

counts) as well as the process of having one's memories and dreams embodied in the tattoo. Thus, this shared process, not to mention the shared marginal status of tattooed people, forms the basis for a near-spiritual union.

On the other hand, some of the older tattooists I've spoken with dispute this notion of community and would probably find Barry's statement ludicrous that tattooists will invite strangers who are tattooists to sleep on their floors. (For one thing, there are literally thousands of tattooists in this country today, which would make for a lot of very crowded slumber parties.) While the dominant discourse is one of family, equality, and sharing, the reality for these older tattooists also includes stratification, differentiation, and competition. One prominent West Coast tattooist had nothing good to say about the notion of communitas that is so popular among many tattooists and tattoo enthusiasts:

> I think it's just stupid. It's like saying there's a brotherhood of all tattooed people. There's no commonality in those people. Of course you meet people who you have certain things in common with, but you meet others who you don't have anything in common with. . . . A lot of them are losers, they're outsiders who don't fit in. By and large, the people that go to conventions . . . [are] kind of pathetic if tattooing is the biggest thing in their lives, although I suppose it's no worse than building model airplanes or any other kind of hobby. . . . I think a lot of them are misfits, you know, and that's okay, but they shouldn't pretend that they're some kind of noble breed. It's [the notion of communitas among tattooed people] a fantasy that they're perpetrating. I think it's great that tattooists can make people feel better about themselves and that they're happy with their tattoos, and that they can get the one that they really want. That's cool. But to make this whole other thing out of it, it's just silly. (Dan P., tattooist)

Dan P., a middle-class, educated tattooist, finds the idea of the tattoo conventions representing communitas to be ridiculous for a number of reasons. First, he denies that simply wearing a tattoo gives one a deep connection with others who are tattooed. For this tattooist, tattoos do not have that kind of power. Second, the people who are best represented at tattoo conventions still seem to fit the traditional, biker image, and for Dan P., many are "losers" or "mis-

fits," and not some noble breed. The contradiction between the lofty identity of the tattoo community as a larger brotherhood and the disparities that Dan P. sees among the members strikes him as absurd.

Both of these views can be seen in the discourses surrounding the two main sites of community: the tattoo convention and the tattoo magazine. The "official" view of communitas is expressed in the literature of the tattoo community, while the critique is found between the lines—in the conflict between members and factions.

## *Tattoo Conventions*

The tattoo convention is a good example of both communitas and the hierarchy and factionalism that I and others have noted. For many individuals, and certainly for the organizers of these events, tattoo conventions embody a spirit of fellowship and goodwill, as Dan H., a businessman with a Japanese chest-piece, testifies:

> It's a lot of fun and the conventions are nice because when you become tattooed it's like you become part of the fraternal order or something. It's interesting. Everybody gets along good, it's like a big club. We're all into the same thing, we all admire each other's artwork and all the different styles and the interpretation of the art form. I can walk anywhere in this convention and say, hi, how are you doing, where did you get your work done? . . . It's like a private club. And it's neat, you've all gone through the same experience, the anticipation, what am I gonna get, is it gonna hurt and everything, and once you do it, it's an addiction. (Dan H.)

For others, however, conventions embody an entirely different spirit:

> Monkey Business. I mean, that's pretty much accurate. It's a commercial enterprise. People don't come here just to exchange ideas and meet other tattoo artists. They come here to hawk their wares so they can pay for the gas or the car or the plane ticket that brought 'em up here. I mean, these people aren't rock stars or rocket scientists or anything. They're nuts and bolts kind of people from working-class

backgrounds. They see an opportunity to make a buck and they're gonna take advantage of it. They come to . . . see their old friends and tell some jokes, or whatever. As far as it being a great meeting of the minds or something, you're not going to find a lot of it here. (Paul T., tattooist)

Paul, an old-time tattooer, strongly disavows the spiritual/fraternal notion of the community in favor of a starkly materialist interpretation, and from my own perspective, I would say that he gets it just right.

*Structure* ➤➤ During any given year in the United States, there are approximately five large national conventions and perhaps an additional fifteen or so local shows (in addition to shows all around the Western world). The large events are held at convention centers and hotels and typically run for anywhere from two days to a week, depending on the size of the sponsoring organization. There are also smaller, more exclusive shows, which are usually held for a few hours at a bar or nightclub. The tattoo show (with the exception of smaller, more focused shows such as those exhibiting photos of tattoo art or displaying some aspect of tattoo history) has a threefold structure: it is a commercial event where tattooists and vendors of tattoo-related materials rent booths and sell their products or advertise their services; it is a place where people can enter their tattoos (or tattooists can enter their designs) in contests to be voted on by the general audience or by a panel of judges (usually followed by an awards dinner); and it is a social event, where individuals show off their tattoos and meet other people with the same interests. Sometimes there are additional events, such as piercing demonstrations, dancing, or live music. The National Tattoo Association (NTA) conventions,[7] as well as the Tattoo Tours, feature seminars on topics such as the history of American tattooing, Marquesan tattooing, Chicano script lettering, portrait drawing, and prevention of transmission of communicable diseases.

Tattoo conventions, as commercial ventures, are similar to other trade shows held at hotels and convention centers across the country. Vendors rent booths to sell T-shirts, flash, and tattoo-related items, and to give tattoos. The National Tattoo Association regu-

lates activities on the floor of their conventions by limiting tattoo-ing hours and prohibiting the sale of tattoo equipment (machines, needles, or sterilizers), but other conventions are less regulated. Most shows charge from $5 to $20 for admission, with members of the sponsoring organization receiving a discount, and booths typi-cally cost around $200 to rent. Tattoo conventions can be very lucra-tive: the annual NTA event can gross as much as $200,000.

*Convention Goers* �»  There are basically two groups of people who attend tattoo conventions. The first are those whose interest in tat-tooing is strong enough that they are members of the organization that hosted the show. They have registered for the show in advance, have bought a ticket for the length of the show (up to a week), and usually have traveled some distance to get there. Next to attend is the general public, i.e., those who are interested in tattooing but did not register in advance and usually attend for only a day (the conventions are usually open to the general public only on Saturday and Sunday) and live near the convention site. Within this division, however, there is a great deal of variation. Some shows are small and only attract local participants, and some of these shows, due to the geographic location and demographics of the area, primarily attract bikers, the middle-class elite, or younger, avant-garde members. At the NTA shows, I have noticed (just by observation) that of those who register in advance and attend the entire convention, a high percentage are themselves tattooists, and many are working-class tattooists and enthusiasts. On the other hand, the general public who come to the show on the weekend are a more varied crowd and, for the most part, much younger, including punks, more members of the middle class, as well as bikers and tattooists.

Tattoo conventions also attract eccentric individuals, such as the fifty-five-year-old man who exclusively wears self-executed and handpicked tattoos and takes pictures of other people's tattoos for his "own personal collection." At a convention in San Francisco, I met a man, with no tattoos at all, who went by the name of "Pieface Mike" and made himself available to women to throw pies in his face. He showed me some of his pictures, including one of a bare-chested Annie Sprinkle (a performance artist and porn star) throw-ing a pie in his face, and said "It's not a requirement that they take

their clothes off to pie me, but it helps." When I asked him why he attends tattoo conventions, he said that while he is not tattooed, he feels like a tattooed person because tattooed people enjoy being looked at, and he enjoys being "pied."

*Contests* ➤➤ Almost every tattoo convention or show includes a contest. The typical contest includes categories for best tattooed male, best tattooed female, best male back, best female back, best black-and-white tattoo, most realistic tattoo, most unique tattoo, and best nostalgic tattoo. Contestants must fill out an entry form for each tattoo (or region of the body) that they want to enter, which includes their name, the name of the tattooist, and a description of the tattoo. The master of ceremonies reads the information as the entrants parade, singly or in groups, across a stage in front of the judges and audience. The participants' descriptions of their tattoos are revealing, and often quite funny, particularly when they are read in the monotone voice of Flo, the elderly secretary of NTA who serves as contest emcee. The following are a few entrants' descriptions of their tattoos:

> The eradication of the tyranny that is Christianity in this society in the face that is science and nature . . .

> A tribal egg with a guy being born out of it, and underneath that, a globe that goes into the armpit with a female figure holding it up with the globe melting and then out of the egg is yolk that goes all around. A rebirth thing . . .

> A fantasy scene of a castle with a dragon in the background with the smoke out of his nostrils sweeping down towards a wizard holding a crystal ball . . .

> There's a city crumbling into the ocean with an angel flying above it, a space scene behind the angel, with demon faces . . .

> A wood elf on a mushroom, with smoke coming from behind it, all leading up to a fantasy scene depicting a wizard throwing fire towards a dragon in the background . . .

The contests illustrate the hierarchical, competitive notion of community, as contestants are harshly judged on the basis of their tat-

toos, the appearance of their bodies,[8] and the status of their tattooist. It is ironic that the first tattoo convention was explicitly held in order to foster friendship, communitas, and sharing, yet the contests that have come to dominate the convention are often cutthroat. For this reason, I find watching the contests slightly depressing. Contestants who are clearly proud of their tattoos must parade on a stage and face the ridicule of the watching crowd—often their tattoos (which back home in Ohio seemed innovative, technically superior, or beautiful) are considered out of fashion, inept, or just plain ugly in this highly competitive atmosphere, where tattoos by the elite tattooists almost always win.

*Modern Day Carnival* ➤➤ The scene at a tattoo convention is carnivalesque. I recorded the following in my field notes at the National Tattoo Convention, San Francisco, March 12, 1994.

People who were going to exhibit themselves [in the contest] wore very little. For men, usually just a thong bikini, or sometimes boxers or shorts, depending on the amount of tattoos. For women, sometimes also just a thong bikini, sometimes a bikini top or bra with something sexy or revealing on the bottom, such as a pair of tights with holes cut out to show off the tattoos. . . . [During the contest] one woman was wearing a Frederick's of Hollywood teddy affair, with violet satiny material down the front and a totally open, string back. The crotch of the teddy was so narrow that you could see part of the woman's shaved genitals. Most of these women's bodies weren't model perfect, or anywhere close, so they were exposing not only their tattoos, but their thighs, bellies, and butts to the world. I was humiliated for them. Another woman came out with a bondage-type outfit, made of black vinyl, with rings and chains and piercings everywhere, on her face and her body. Clearly breaking the rules. . . . The men were good, too. Most of the men were wearing very little, and many of the men were quite fat, so to see these heavyset, forty-to-fifty-year-old men with just a G-string on was quite amazing.

One man, on the other hand, was quite attractive with long, soft brown hair. As he was on stage, a woman from the crowd called out, "what's your number," which everyone in the audience interpreted as his entry number. He held that up and she shouted, "No, your

phone number!" Everyone laughed. It made me feel like it's not just a meat market for women now, it has become that, to a lesser extent, for men as well.

Tattoo conventions reflect the values and politics of carnival, as described by Mikhail Bakhtin (1984) in his discussion of the novels of sixteenth-century writer Rabelais. For Bakhtin, European carnival represented for peasants an arena in which the styles and values of high culture could be inverted, thrown on their head, and ultimately debased. Carnival is marked by drunkenness, rowdiness, and bawdy sexuality, all of which exist outside of and threaten the dominant social order. More important, carnival is liberating, in marked contrast to the increasingly regimented morality of the Renaissance. Bakhtin also demonstrated that the liberating elements found in popular festive forms are always expressed in material bodily form. Thus such festivals are marked by images of sexuality, birth, feasts, slaughter, cursing, violence, and defecation; what he called "material bodily affluence (1984:221).⁹

This abundance of bodily function imagery accurately describes the tattoo convention. Here, anything goes and conventional social rules are frowned on. Men and women disrobe in public and show off not only their tattoos but their nipple piercings, thong bikinis, and pubic hair. They oil each other's near-naked bodies, and packs of men with cameras (both still and video) follow attractive women around the convention floor. Men hoot at the women parading on stage, and women shout encouragement to men as they undress. (At one tattoo show I attended, sponsored by *Easyriders* magazine, a group of men shouted "show us your hooters!" as all the women walked by, and many happily obliged.) People also get tattooed at conventions, so the spectacle of the body grimacing in pain is also evident. Tattoo conventions are marked by ritual inversion, exaggeration, and excessiveness of all kinds—all attributes of the carnivalesque, or grotesque, style.

This liberating view of carnival can be contrasted with the neo-Durkheimian perspective, put forth by Mary Douglas (1966) and Victor Turner (1969). In this more conservative approach, carnival (and other rituals of inversion) reinforces, rather than challenges, the hierarchical structure of society by allowing the poor to occa-

sionally act out within a narrowly prescribed arena, yet maintaining the status quo at all other times.[10]

The tattoo convention is both radical and conservative, and thus fits both readings of carnival. It challenges and subverts middle-class notions of propriety and taste through its radical display of the grotesque body, yet it also reinforces mainstream society's class-based, and gender-based, divisions. Working-class tattooists from rural areas find their artistic contributions unwelcome in the face of the increasingly sophisticated artwork created by middle-class, fine art tattooists from the big cities. And while it is thought by many that the presence of heavily tattooed women at conventions (as else-where) disrupts conventional notions of the gendered body, in fact these women must continue to play by the same patriarchal rules that exist elsewhere in society. The women who enter their tattooed bodies in the contests are being judged as much for their physical appearance as for their tattoos, and the women who garner the most attention from photographers at the shows are generally the most attractive and/or have the most skin showing through their sexy outfits. It could be argued that, contrary to empowering women, tattoos, and the display of women's tattoos at the convention, contribute to women's further objectification. Just as many feminist scholars argue that fashion enslaves women by making them objects of display, in the same way tattoos put the (female) body on display. Tattooed women—particularly those with extensive tattoos—cannot avoid being the object of voyeuristic looking. And while both male and female bodies are on display at the tattoo convention, and even though the objective of these events is to show off tattoos to an audience that appreciates them, it often seems like an excuse for men to gaze at, and photograph, women's scantily clad bodies. These displays beg the question: Are these women controlling or subverting the male gaze?

Tattoo conventions are also becoming much more conservative in terms of new forms of social control. The National Tattoo Association, which hosts the largest annual conventions, distributes a set of "Conduct Rules and Regulations" for their conventions that prohibit public disrobing, facial piercings, facial tattoos, and other displays that would challenge a middle-class sense of decorum. (Of course, no one abides by these rules, and the display of genitals and

all manner of bones, chains, and other body piercings, is becoming more common at these events as young people, from the punk, gay and lesbian, and S/M subcultures combine highly visible tattoos with multiple body piercings for a particularly challenging look.) Furthermore, the NTA convention that was held in San Francisco in 1994 was the first smoke-free convention I've ever attended and may represent a new trend in social and bodily control.

Tattoo conventions are fascinating precisely because of all these contradictions. According to convention organizers and many participants, tattoo conventions are about two things: "promoting the Art of Tattooing" (from NTA literature) and providing an atmosphere of camaraderie and goodwill. One tattooist describes the first tattoo convention: "You should have been to the convention in 1976. Dave Yurkew put together this gathering, if you will, that allowed a forum for people to communicate within the industry. It had nothing to do with the public. Tattooists are little islands, with little groups of friends or cliques that are very limited, and we're wandering along this path with very little communication or connection to other groups. His point was to bring those together so that we could all be friendly. [It was the] International Tattoo Convention in Houston. The point was [to get] back to community, not competition" (Harry S., tattooist).

As I have discussed, it is debatable whether conventions are more about community than competition. Similarly, as I will show in chapter 4, the second convention goal, promoting the "Art of Tattooing," is a major point of contestation. What then, exactly is the definition of the "Art of Tattooing," and how is that art to be promoted? What is tattooing really about? Who controls which artists, and what type of art is to be featured?

## *The Popular Media*

Media texts on tattooing are the second major site in which community is articulated. Articles and books published in the mainstream print media, as well as tattoo magazines and books published within the tattoo community, serve both to define the discourse surrounding tattooing and (in tattoo magazines in particular) to construct a feeling of communitas among their readers.

Journalists and scholars who write about tattooing are in a very large sense responsible for creating a new picture of tattooing within the minds of readers, a picture that today includes tattoo artists who have been trained in art school; tattoos that are finely executed, highly customized, and deeply meaningful; and a value system that stresses the sacredness of the body, a lifetime commitment, and a strong spiritual or emotional connection to the tattoo.

One way in which mainstream journalists create this particular picture of tattooing and of the tattoo community is by selectively interviewing members of the community about tattooing. In chapter 4, I will show how, through these articles, certain middle-class points of view are expressed while other views are silenced and provide a sanitized view of tattooing that is more palatable to a new, middle-class audience. Thus, middle-class readers learn through these books and articles that tattooing is no longer about bikers and sailors, but that it has been transformed into an elite art form dominated by fine arts–trained professionals. What they won't learn is that working-class men, for example, still make up a large number of tattooists. They also learn that tattooing is a permanent form of body modification and, thus, that individuals put a great deal of time and thought into their tattoos. But they won't read about the folks who go into a tattoo shop on a Friday night and, in about ten minutes, pick their tattoo off the wall.

The tattoo magazine, like the tattoo convention, caters to tattooed people and creates for its readers a sense of communitas through its ability to make tattooed readers feel that they are both different from the mainstream society and a part of something larger than themselves. Particularly in the magazines' editorials and in their letters-to-the-editor sections, this feeling that tattooed people form a community of marginalized brothers/sisters is evident. The following letter in *Tattoo Revue* expresses the writer's feelings of alienation in nontattooed mainstream society and expresses solidarity with other tattooed people:

In a culture of such diverse individuality, it is still amazing to note the reactions of "Society" toward people who collect a much underrated form of art—tattoos. It baffles the imagination as to why a colored pigment placed under the skin would change the personality of its bearer, yet after I received my first tattoo there were ac-

quaintances who viewed me as some hideous pariah. Did I become a raving demon from hell or is it that the needles puncturing my skin degenerated my intelligence to the point where I became a non-entity? Actually, neither. I'm the same person I was before I got tattooed. . . . This universal quote always soothes my savage beast and never fails to calm the storm: "The only difference between tattooed people and non-tattooed people is that tattooed people don't care if you're not tattooed." (Juanita, "Letters," *Tattoo Revue*, May 1993)

Like the mainstream publications, tattoo magazines also contribute to and help define the current public understanding of tattooing, an understanding often less generous than the one outlined by Juanita. This occurs through the magazines' editorial decisions about which artists or fans to showcase, whose letters to print, and what types of advertisements to run. Also, tattoo magazines debate with each other, thereby illustrating and defining the class-based borders within the community. For example, a woman writes a letter to the editor in *Tattoo Ink*, explicitly criticizing the biker readership of other tattoo magazines: "Finally a tattoo magazine with a young non-biker format" (March 1994), and the editor of *International Tattoo Art* takes a swipe at the biker tattoo magazines, writing: "Of course clients whose idea of getting an original tattoo is to glom the centerfold out of 'Ink Gland Weekly' don't do much to cultivate an atmosphere of creativity in the chair" (no. 2, 1992). The writer is referring to the tendency, which I discuss below, of young kids bringing tattoo magazines to tattooists to copy images, implying that this only occurs with biker magazines. (In fact, it happens with all tattoo magazines.) Chapter 4 covers the public war tattoo magazines are staging with each other through their pages, which, I believe, is a war over who controls both the art form and the discourse of tattooing.

*Commodification* ➻ One reason that media representations play such a large role in defining the tattoo community is that tattoos themselves have become so commodified, particularly through the growth of tattoo magazines and books about tattooing. Marc Blanchard, in an article on postmodern tattooing, says that "there is something in tattooing which escapes the flow of commodification" (1991:15). He goes on, "Because the body is there always, the image,

the writ of tattoo is not as reproducible, and even if the design for the tattooed image can indeed be mass produced, as has been possible since O'Reilly, it is the individual body which bears this image, thus making the replication of the tattoo contingent upon its siting on the body of a specific subject" (1991:15).

Blanchard ignores the role of the tattoo magazine in both the production of tattoo designs and in the choice of tattoos for individual consumers. Traditionally, customers selected a tattoo at a tattoo shop from the flash on the tattooist's walls. Today, tattoo magazines have become so prolific that many people pick their designs from tattoos represented in these magazines and bring the magazines to tattoo shops for the artists to copy. This has led to increased attention paid to tattooing in general, as nontattooed people can simply buy these magazines at the grocery store. It has also led to a tremendous increase in the speed that new designs are disseminated, both in the United States and globally, and it has resulted, as well, in a change in the way tattoos are chosen and executed.

Many tattooists welcome the increased interest in tattooing that the magazines incite. Terry Wrigley, a columnist for National Tattoo Association's monthly newsletter, wrote the following, about a letter critical of tattoo magazines that was distributed at an NTA convention in Texas in 1988:

> Not so long ago, I received an unsigned letter that was all against Tattoo Magazines. At the time, I tended to agree with the writer, that the magazines gave nothing to the art except tit pictures and took a lot from it. But lately, I've been forced to change my mind about this. There's hardly a day that goes by that we don't see at least one person eagerly clutching a tattoo magazine and wanting some design, (not always a good one). So, these magazines are stimulating interest in tattooing even if it's not the way we'd all like to see it stimulated. But, they all have one thing in common, a back page advert for tattoo equipment from a supplier who sells a "how to tattoo" book yet who once said you can no more learn tattooing from a book as [you could learn] brain surgery. (NTA newsletter, Sept.–Oct. 1992)

For Terry, and I presume other tattooists (many of whom display the magazines in their shops), the only downside to the proliferation of tattoo magazines is the ads for tattoo supplies (because this

leads to an abundance of untrained tattooists). But in general, he feels that the increased interest in tattooing is a very good thing.

Other tattooists feel differently about the magazines and about the magazines' impact on the business. One old-time tattooist had this to say:

> It's just the tail wagging the dog with those magazines. There's not a day that goes by at least in my shop when a customer doesn't come in with that magazine in his hot little hand, wanting me to do something out of there. It's got to be exactly the same as it is in the magazine, they won't grant me any freedom or latitude with it. So basically they feel like they're doing something original by picking something out of a magazine instead of off the wall. And I don't know what the circulation is of those magazines, but it's worldwide, and they don't approach the tattooist and go "gee, I'm looking for this and what can you do for me," it's just them bringing you in a picture and saying "put this on me." . . . The kids see something in the magazines and they take it as the Holy Grail or the Gospel and they bring it right back to you [and say] "that guy, he didn't have anything good on his walls. Everybody else is getting that stuff. I'll get this in the magazine." He's probably one of eight thousand that probably got that same magazine and saw that same picture. It's just the tail wagging the dog. It's bigger than those magazines. The business of tattooing isn't the magazines, that's just a little extension of this business, but because it's a magazine, because it's circulated through the mass media, it becomes the tail that wags the dog. (Tab M., tattooist)

Tab's critique is dead-on correct. I can't count the number of times I have seen people request a "custom" tattoo from the pages of a tattoo magazine, and I have also seen very poor copies of well-known, one-of-a-kind pieces. This commodification has led to tattoos becoming, once again, more formalized, in that there are less choices and more orthodoxy in tattoo design as individuals choose their tattoos from magazines (and increasingly off the Internet). This is ironic because while tattooists and their customers are promoting more customized work, tattoo magazines allow a reader to replicate *another person's* customized tattoo on his or her own body. Tattoo magazines claim that they exist to promote creativity, but in fact they play a part in stifling it as they become, in essence, the new

flash. An East Coast tattooist and magazine editor agrees, saying, "The dynamic of reinforcement that has been created by the various tattoo publications is powerful. The magazine that I have been working with has good intentions and is selling very well. . . . All of the magazines have been influential in mainstream tattooing" (interview with author).

Another tattooist agrees, but finds the alternative often much worse. "I get a lot of that [kids coming in with the latest magazine, saying 'I want that']—I'm not crazy about it. But it's better than the kid who walks into the fucking tattoo shop and pulls out his wallet and he's got this crinkled piece of paper that he's had in there for two years and he uncrinkles it and you can't even tell what it is and it's something that his friend drew when he was drunk and he wants that on him. You know it's better working with some slop out of a magazine than that. Not much better, but a little bit" (Sully T., tattooist). Everyone wants a custom tattoo today. So rather than picking a well-designed but standardized image off a wall (because that suggests a lack of creativity), more people today have a tattooist copy someone else's custom work from a magazine, or worse, will bring in their own (or a buddy's) "artwork" to tattoo. (If the self-designed dress Demi Moore wore to the Academy Awards a few years ago taught me anything, it is that design matters should be left to the professionals.) Clearly, the presence of tattoo magazines has significantly changed the business of tattooing, for better or for worse.

## *Internet Newsgroups*

A new way for some members of the tattooed (and pierced) community to come together as a separate community is through the Internet. One Usenet newsgroup that has formed to deal specifically with tattooing, piercing, branding, and other forms of body modification is known as rec.arts.bodyart, or RAB, and is accessible to those with Internet access. It was established in 1991 and at the time of this writing (1995) is estimated to have 57,000 readers worldwide, with 1,374 messages posted in a recent month (Teshima-Miller 1995). While the members of this cybercommunity are certainly not representative of all people with tattoos (given the fact that members must be computer literate), RAB does, like the tattoo

convention, provide another space in which community is realized. From the FAQ (Frequently Asked Questions) file on rec.arts.bodyart comes this statement: "Most importantly, r.a.b. offers a community and sense of belonging for those interested in bodyart. There are many regulars on r.a.b. who, through their personalities, serve as jester, shaman, den mother, baby, etc. etc. Most of all, those on r.a.b. are living, breathing, ALIVE people who love to celebrate their bodies through decoration" (Teshima-Miller 1995).

Lani Teshima-Miller, the past maintainer of the FAQ, explained the newsgroup this way:

> I've always been very positive about that kind of thing [tattooing], but it really wasn't until I started reading the newsgroup that I got really interested in expanding on them and getting into the larger pieces. Part of that for me is that living in Hawaii, there's a sense of isolation, and unless you hang out at the tattoo shops and you're a biker, you don't really get to meet a lot of people, they don't have conventions. So having that community online really gave me the opportunity to meet people who were in similar situations. More than anything, it's had a big influence on me, and I certainly spend a lot of time on there. It's come to the point now where we're starting to get together as people instead of just being faceless, names online. We had another get-together in San Francisco earlier in March, and they just had a get-together in Washington this summer. . . . The newsgroup itself is about three years old so it's come to the point where it's got its own identity and things like that.

Lani's statement is fascinating because tattooing has been, until now, a visual art. Any sense of community that had been found through tattoo conventions and tattoo magazines was found, in part, through locating other individuals through their tattoos. Rec. arts.bodyarts has provided people a means of attaining community without that visual link and illustrates to what extent the tattoo community is realized through discourse, rather than through shared signs.[11] A "lurker" (someone who reads other people's posts but who does not post himself) to RAB said to me, "It's interesting the way strangers can be so supportive of each other on the Net, they may never meet each other, but they're still there for each other. You see that on other [news]groups as well. The difference in this

case [on RAB] is it often involves physical pain and that's something that you don't see elsewhere on the Net" (Greg K.).

RAB is an important form of community for the individuals who belong to this group and seems to attract a large number of gay and lesbian members, who, like the writer below, feel alienated from the mainstream tattoo community and the spaces where it comes together, i.e., the tattoo convention and tattoo magazines. The following writer posts a message to RAB about attending a recent tattoo convention:

> I THOROUGHLY enjoyed being able to meet folks that I have seen running around r.a.b (hey Paula, Linda, Paul, Adam, Brian, Kevin) and making many new friends and extolling the wonders of this group. The most difficult part for me was the attitude and general feeling of the participants. I sometimes forget, living in the insular multi-faceted world of San Francisco, that many parts of these United States are less than friendly if you are not a het white male. Many a racial slur was to be heard as well as the obligatory "faggot" thrown my way. I counted no less than 6 T-shirts that said "It's a white thing, you wouldn't understand," as well as a scad of rebel flags, variations on Nazi symbolism and of course the ever present Armed Services (take your pick) logos. What struck me the hardest was that here I am, a Native American queer sitting in a hotel built on Indian (reservation) land filled with mostly white folks some of who can't stand me because I am a Native American queer, and I have to be friendly and tolerate the ignorance and fear that they carry around in their hearts . . . Thanks to those who stopped by and said hey, I saw the post on r.a.b. and that is why I am here. Made me feel connected to the group even when I couldn't read or post. (Benny)

Here is a situation where Benny, a gay Native American with tattoos, does *not* feel a sense of communitas with the other tattooed conventiongoers; in fact, he feels excluded from their community. But Benny *was* able to experience community through chatting with fellow RAB devotees who attended the convention and came by to say hello. Another person (identity unknown) writes about rec.arts.bodyart (RAB): "r.a.b. provides safe space for bodmodders who don't fit into other categories easily. How many of us hang out as tattoo shop groupies?" For all these individuals, this news-

group represents communitas, while hanging out in tattoo studios or going to tattoo conventions—which are attended not only by educated tattooed and pierced people (like themselves) but also working-class folks and bikers—do not. Even as the organizers of the conventions and editors of the magazines try their hardest to put a clean, "middle-class" face on the art form, some individuals, like those who read RAB, still feel overwhelmed by what they see as the racist, sexist, and uneducated aspects of the community. Many young, middle-class tattoo fans associate traditional, working-class tattoo culture with racism, sexism, and homophobia and this is one reason why groups like RAB are important to this community.

## *Re-defining Community*

With a few exceptions, anthropologists, even those working in the United States, have traditionally focused their research on individuals who can be located within, or accessed through, a physical space —a factory floor, a cocktail bar, a neighborhood, a senior center. Today, however, more individuals are creating their own concepts of community, and in the last ten years anthropologists have begun to respond to these new formations (di Leonardo 1984; Dominguez 1986, 1989; Frankenberg 1993; Handler 1988; Martin 1987; Perin 1977, 1988; Radway 1984; Stacey 1990; Weston 1991). This body of work attempts to understand how nonbounded and non–face-to-face communities are created and maintained and how identities are constructed and manipulated within these communities.

For Benedict Anderson (1983), all non–village-level communities are imagined communities, in that members do not know each other and thus must imagine their connection to others in concrete notions like kinship. According to Anderson, all such communities must be understood with respect to the style in which they are imagined, i.e., via shared ties of kinship, citizenship, ethnicity, class position, rather than in terms of whether or not they are *real* communities. Communities like the tattoo community provide a model for just such an understanding, in that they do not even possess the quality of spatial boundedness that nations, cities, or neighborhoods have. Without geographic borders, shared ethnicity, or politi-

cal ideology, what holds the tattoo community together? In other words, how is it imagined? Are there factors other than tattooing that matter?

As our society becomes more mobile, technocratic, fragmented, and detached from traditional groundings such as family ties or religious affiliation, individuals seek out connections with others who share important aspects of their identity. According to Bellah et al. (1985), however, these connections should not be called communities because of the specificity of the connection. Rather, he calls them "lifestyle enclaves" because they are only concerned with one aspect of private life—a particular interest, value, or leisure activity—rather than with the whole of one's life (1985:72). For Bellah, "genuine" community must transcend the private and move into the public realm, otherwise it is not community. I reject this position. Life in the United States is no longer lived on a local level. Many people today experience their most important connections with people they know only through their computer modem, at annual motorcycle runs, or through reading a monthly newsletter. For many, the relationships formed in these new communities are more important than their more "primary" relationships with family or friends. To see oneself as a member of the gay and lesbian community, or to call oneself a part of the tattoo or biker community, is to refer to aspects of the self that are more than segmental; they embrace major aspects of one's identity.

Because of their lack of geographic boundaries and their emphasis on individual choice rather than on more traditional factors like occupation, religion, or ethnicity, the tattoo community and others like it operate differently than other kinds of communities studied by anthropologists. In operating differently, these communities have a need to express shared identity among members and to contrast that with outsiders who do not possess similar qualities. Tattoo conventions, motorcycle shows, and gay pride parades are spaces in which a sense of identity is shared and community is celebrated on an annual or semi-annual basis. That shared identity is achieved on a more regular basis through creating and consuming community-produced texts like magazines, World Wide Web sites, or Internet newsgroups. Here, individuals feel a sense of community by reading about others whose values and beliefs they share.

This is especially important for people who do not experience this community in their daily lives. The events and texts are also important because they tell and retell the story and the history of the community to members who are not always present to share it. "Who we are and where we come from" must be expressed, both to fellow members and also to outsiders, as a way of defining the community and crystalizing identity. Particularly if the community is a marginalized one, as many are, the narrative that is told is crucial in establishing a sense of the shared oppression of its members.

The establishment of boundaries is also an important feature of imagined and virtual communities because there are no hard-and-fast rules regarding membership. What does it take to be a member? Who decides? Who is definitely *not* a member? While criteria may seem simple—wearing tattoos, riding a Harley-Davidson, for example—they are not. Identity in a community depends in large part on the possession of an informal, and often unconscious, set of ideologies that extends well beyond superficial qualities. To be a biker is not merely to ride a bike—it is, for many, to love God and country, to respect the traditional roles of men and women, and to value the freedom to ride off into the wind. Status is an important feature of many such communities, but achieving that status may be difficult and may involve material aspects (money to buy a bike or a tattoo), amount of time spent in the community (old-timers usually holding a special status), personal qualities that exemplify the meaning of the community, or connections to other high-status individuals. Through establishing and maintaining boundaries, members of the community can keep pretenders out or those who would dilute the special meaning of the community and the bond that they share.[12]

The notion of community does not always entail a fraternal feeling of camaraderie extended to all, even when that is the intention. I argue that the tattoo community *is* intended to be a symbolic space where tattooed individuals, historically marginalized in the United States today, can feel safe among people with whom they share important values, even though they live in a society where tattooing is not socially sanctioned. Additionally, the idea of community, at least within the tattoo community, implies a notion of equality, a concept that has been diluted as the community has taken its cur-

rent, middle class–dominated shape. Here, middle-class values of competitiveness and individuality along with an elevated sense of aesthetics have been grafted onto a working-class tradition that, while never fully egalitarian, was not as preoccupied with status as the current community is.

# Cultural Roots

## The History of Tattooing in the West

Tattoos are the mark of the colonized other:

the difference between the colonizer and the colonized

is in the texture of the skin. — Marc Blanchard,

*Post-Bourgeois Tattoo*

Tattooing, for a large portion of the white working class, is as American as baseball, Mom, and apple pie. Yet North American tattooing originated not in America (North or South) but in Pacific island cultures like Tahiti, Samoa, and Hawaii, among people whose cultural values and practices were radically different from those who came to be associated with tattooing. The history of the tattoo's introduction to the West includes colonialism, appropriation, and cross-fertilization. This chapter outlines the history of North American tattooing up to the early 1960s, and focuses on the colonial context in which it was discovered, the display of tattooed people for entertainment and education, its art form and social practices, and the transformation of U.S. tattooing that occurred after the end of World War II.

# Captain Cook, Colonialism, and Tattooed Natives

The history of North American tattooing begins with voyages of discovery, colonialism, and missionary activity in the islands of the Pacific in the seventeenth and eighteenth centuries. It was during this period that tattooing was discovered among the people of Tahiti and later among the rest of the Pacific Islands by Captain James Cook and other European explorers. While tattooing had existed in Europe prior to the colonial encounters in Polynesia (Christian pilgrims, for example, had been receiving tattoos as souvenirs of their faith on pilgrimages to the Holy Land as far back as the early 1600s, and the Celts had practiced tattooing prior to the Roman conquest), it was through the early explorations of the Pacific that tattooing entered into modern European consciousness. Thus, the history of tattooing in the United States begins not in America but with the voyages of the Royal Navy to the Polynesian islands in the mid-eighteenth century.

Tattooing in Polynesia can be traced, through archaeological evidence, to at least the second millennium B.C. and has been found throughout all the islands (Gathercole 1988). Captain Cook, sailing with the British navy, gave the first accounts of Polynesian tattooing in 1769 when he discovered Tahiti and in 1778 when he encountered Hawaiians. Cook and his crew wrote and drew about the practice on subsequent voyages, and Cook was the first westerner to use the Tahitian word *ta-tu* or *tatau* when describing the practice (prior to that time, tattoos were known in the West as "pricks" or "marks"). The tattoos noted included lines, stars and other geometric designs, as well as figures of animals and humans, and were worn by both men and women. At the time of European contact, tattoos were primarily linear and probably served a genealogical function as well as a protective one (Kaeppler 1988). At least as far back as 1784, Cook's own crewmen started getting tattooed by the native people and thus played a major part in bringing the tattoo to Europe. By the nineteenth century, later voyagers noted that the designs included, in addition to the animals and plants found earlier, rifles and cannons and dates and words commemorating the origin and death of chiefs. These newer designs were probably introduced to

the Polynesians by Cook's crew. Also by this time, Western ship artists, using native technology, were tattooing the Polynesians, again with introduced designs. According to Kaeppler (1988), after the Hawaiians adopted Western weapons, their tattoos, now influenced by westerners, probably became solely decorative, as tattoos were no longer needed for protection. It is interesting to note the relative ease with which the British sailors and explorers were willing to acquire Polynesian tattoos and also the apparent enthusiasm of the Hawaiians and the Tahitians to augment their own tattoos with British designs. Without this early cross-fertilization, it is doubtful that tattooing would have been reestablished in Europe or seen as anything more than a primitive oddity.

Captain Cook's first visit to New Zealand was in 1769, and on that trip the ship's artist drew pictures of that island's native tattooing—the *Moko*. The moko is the curvilinear facial tattoo worn by Maori men and women as a sign of status as well as affiliation. The Maori had a tradition of preserving the tattooed heads of deceased persons of nobility in order, it was presumed, to keep alive the memory of the dead. The heads were also considered sacred because it was believed they continued to possess the deceased's *tapu*, or magical quality (Gathercole 1988). But in 1770, just a year after initial contact, Europeans became interested in these heads and began a heads-for-weapons trade that lasted until 1831 when it was banned by the colonial authorities. The trade became especially scandalous because during the tribal wars of the 1820s, when European demand for the heads was at an all-time high, war captives were probably tattooed, killed, and decapitated and then their heads sold to European traders (Gathercole 1988). As the traffic in heads escalated, the Maori stopped preserving the heads of their friends, so that they wouldn't fall into the hands of the Europeans. Evidently, it became dangerous to wear a moko, as one could be killed at any time and have one's head sold to traders (Eldridge 1990a). After European contact, the moko became associated with Maori culture as a way for the native people of New Zealand to distinguish themselves from the Europeans who had settled there.

Like Hawaiian and Tahitian tattooing, Maori tattooing was also influenced by European contact. Originally, the Maori applied their wood carving techniques to tattooing by literally carving the skin and rubbing ink into the open wounds. After European contact,

sailors brought metal to the Maori, enabling them to adopt the puncture method found in other parts of Polynesia (Eldridge 1990). The explorers played a large role in the initiation of the traffic in preserved heads: the first such head owned by a European was bought by Joseph Banks in 1770, a naturalist with Captain Cook's first expedition. European explorers influenced tattooing in other parts of Polynesia. For example, Marquesan tattooing included finely detailed linear patterns, yet after European contact, observers noted that it had moved toward creating heavy, broad, blackened areas, somewhat closer to the Maori style (Allen 1991). But the most lasting consequences of the contact between European explorers and Polynesian tattooing was not stylistic. While this contact resulted in the re-introduction of tattooing in the West, it also led to the destruction of Polynesian tattooing through missionary activity. The mission of these explorers, after all, was to learn about the native cultures and to pave the way for the later "civilizing" of these cultures, which would occur through missionaries, who would prohibit tattooing, polygamy, and other habits considered uncivilized.

Not only did eighteenth-century sailors return to England with Polynesian tattoos, they also returned with tattooed Polynesians to exhibit, initiating an entirely new form of cultural exchange. While tattoos and other forms of body modification have stood since the earliest encounters with Polynesians as a hallmark of the primitive,[1] the display of tattooed "natives" in pubs, dime museums, and fairs, helped solidify these notions of the primitive Other. This was particularly true within the context of world fairs, where native exhibits were contrasted with the highest achievements of Western society to both accentuate the primitiveness of the natives and to emphasize the civilization of the Western world. While these displays both reflected and contributed to colonial ideology, they were also influential in constructing a narrative about tattooed people as savages, a narrative that is later turned on its side when white tattooed people start to display themselves in sideshows.

Throughout the eighteenth and nineteenth centuries, the display of tattooed natives was a huge moneymaker for European businessmen. The first record of an extensively tattooed native person on display was Prince Jeoly, originally from the island of Meangis, just south of the Philippines. The Painted Prince, as he came to be known, was purchased by a European named Mr. Moody in 1691

(Allen 1991; Eldridge 1993) and was eventually sold to the French explorer William Dampier, who immediately sold him again to businessmen who exhibited the prince as a single attraction in pubs and other public places before he died of smallpox. Chuck Eldridge writes, "If it had not been for his untimely death only months later, he may have proved a financial gold mine for his master" (1993:5). Captain Cook's second expedition to the South Seas in 1774 brought back two tattooed Tahitians, Omai and Tupia, who served as interpreters and guides for Cook. Later, Omai was, like Jeoly before him, seen to have financial potential as a human oddity, and he was ultimately displayed publicly as well (Bogdan 1988; Allen 1991).

In the United States, the tradition of displaying tattooed natives did not begin until much later and started with exhibits of "native villages." In 1876, with the Centennial Exhibition in Philadelphia, native people for the first time were exhibited in the United States. At this and other fairs, fairgoers could observe Alaskan, Hawaiian, or Samoan families in an "authentic" cultural environment, as well as others not within the American colonial system, such as the Japanese. Although they weren't displayed as a sideshow at this time, native villages paved the way for human oddities like tattooed people and freaks to be shown at world's fairs and, later, on carnival midways. In 1893, the Columbian Exposition in Chicago had the first midway with exotic peoples from all over the colonized world on display, and by 1901, the first full freak show had arrived at the World's Fair in Buffalo at the Pan American Exposition (Bogdan 1988).

The world's fair, with its opposite poles of technology and primitivism, civilization and savagery, represented progress to the Western world (Enloe 1989; Yengoyan 1994). The natives displayed at these fairs, whether tattooed or not, were shown engaged in authentic—authenticated by anthropologists who participated in the construction of the Other for public consumption—primitive activities that by their very nature could be contrasted with the modern achievements of the civilized: architecture, imperialism, technology, science. They served not only to entertain fairgoers but also to highlight the enormous progress achieved by the West through technological advancements and world conquest and thus legitimate the imperialist agenda. As Yengoyan (1994) points out, the exhibitions not only promoted the colonial agenda but helped to

implement it because Christian missionaries visited world's fairs to learn about the cultures that they planned to "civilize."

Tattoos, in the colonial period from about the seventeenth century to the nineteenth century, were seen as marks of savagery, yet at the same time British sailors and others who traveled on the early explorations to Polynesia eagerly received tattoos from native practitioners. Thus, tattooing in this early colonial phase was paradoxical. Tattooed natives were seen as little more than savages, and they were brought to Europe and later the United States as exotic displays. Yet the practice of tattooing was removed from its exotic context and ultimately became a deeply ingrained part of North American working-class life. The origins of this transition can be found in the lifestyles of sailors and what this represented to many working-class men back home: adventure, travel, exotic lands and people, and a free spirit. Sailors and later carnies[2] were the middlemen through which the tattoo was transformed from a mark of primitivism to a mark of adventure. Early tattooists, through their enthusiasm for creating homegrown designs and adopting new technology, completed the transformation.

## The Americanization of the Tattoo

Even as tattooed natives were on display at world's fairs and dime museums, tattooing was being modified by early U.S. tattooists to fit a local sensibility emphasizing patriotism rather than exoticism. Early tattoo images were European and while tattooing was still administered by hand, technological advancements in machinery, design, and color quickly led to a new, improved, made-in-the-USA tattoo.

The first known professional tattoo artist in the United States (and possibly the West) was Martin Hildebrandt, who set up a permanent shop in New York City in 1846 (Parry 1971). Hildebrandt tattooed not only sailors but also soldiers on both sides in the Civil War (Sanders 1989) and was instrumental in establishing the U.S tradition of tattooed servicemen. After the Spanish-American War, a new clientele emerged: tattoos became a fad with European "high society" (and less so, with their North American counterparts) who, like the sailors, encountered tattooing on their travels to the Far

East. English tattooists George Burchett and Tom Riley tattooed, according to Burchett, dozens of English and European members of the aristocracy. Burchett writes in his 1958 memoir that the prince of Wales (later King Edward VII) started this trend, which lasted until the beginning of World War I.

Why did this fad end? Until the 1890s, tattoos were still administered by hand (using methods borrowed from the Polynesians), a process that was time-consuming and costly. Then in 1891 "Professor" Samuel O'Reilly patented the first electric tattoo machine in New York, based on the perforating pen invented by Thomas Edison. With the invention of the tattoo machine, which allowed the artist to use a number of needles simultaneously for outlining and shading, the true Americana style of tattooing was born: strong black lines, typically made with five (or more) needles; heavy black shading; and a dab of color (first black and red, and later, green and blue became available). Tattoos created with the new tattoo machine were less painful, cheaper, and easier and faster to administer, which greatly contributed to the spread of tattooing through the lower classes and to the subsequent abandonment of tattooing by the rich. According to Michael McCabe, the invention of the tattoo machine was important for another reason. He writes: "Early mechanical tattooing dove-tailed smoothly with the principles of the emerging pop culture dynamic in the age of the machine. . . . Patrons who were engaged in the most ancient of corporeal rituals were seduced by the mechanical aura of modernity to physically interact with the visual elements of their changing society" (1995: 50). The introduction of mechanical tattooing also helped explain the association of tattoos with carnival midways, as both the electric tattoo machine and the mechanical carnival rides represented the height of modernity to turn-of-the-century urban dwellers.

While tattoo forms were European (what Rubin 1988b calls the "International Folk Style") and consisted of many badgelike designs arranged on the body with no obvious relationship between them, the designs themselves were influenced both by what was popular with European clients (military insignia, hearts, banners, roses, memorial images) and by what was specifically relevant to U.S. citizens (primarily patriotic imagery). Asian designs (dragons, Chinese characters, "Suzy Wongs," tigers, etc.) also became popular in the

West as sailors received tattoos at Chinese and Japanese tattoo parlors before World War II.

While many types of men and women in the United States were getting tattooed at the end of the nineteenth and beginning of the twentieth centuries, most customers were from the military, especially the navy. As one old-time tattooist told me, "You know, they [servicemen] were great tattoo customers because you know, you can't have a criminal record, at least in the navy, air force, or marines. In the army, they had lower standards. [Laughs]" (Jimmy T., tattooist).

Times of war, from the Civil War through the Korean War, were always good for tattooists. Military personnel flocked to get tattoos that established their patriotism (military insignias, battle commemorations) and that would remind them of loved ones back home (tattoos such as "Mom" or the name of one's girl). So, most tattoo shops were located in port towns where sailors did not have to wander far to find one. While sailors remained for many years the tattooist's best customer, the navy did not approve of all tattoos. In 1909, the navy declared: "Indecent or obscene tattooing is cause for rejection but the applicant should be given an opportunity to alter his design in which case he may, if otherwise qualified, be accepted" (Tuttle 1985:11). While this ruling was ignored for many years, in the forties, simply sporting a naked lady tattoo would be enough to be refused entry into the navy. Many tattooists took advantage of this rule by advertising to correct (cover up) obscene tattoos, and many sailors returned to the navy with their formerly naked ladies clothed as nurses, hula dancers, or "Indian squaws."

Tattooists were typically working-class men with no artistic training. Some were sign painters, some learned to tattoo on the circus or carnival circuit, and many answered ads in men's magazines that promised easy money ("$500 in 5 days") for tattooing. For example, the Milton Zeis School of Tattooing, the first correspondence course on tattooing from the fifties, promised that tattooing was so easy "even a child can do good Tattooing" (*Zeis School of Tattooing Home Study Course*, courtesy of the Tattoo Archive). One old-time tattooist from Sacramento who learned to tattoo from such a correspondence course practiced his earliest tattoos on his mother. Other tattooists learned their trade by paying an older tattooist to teach

them. Percy Waters, a tattooist and supplier from the early part of the century, offered not only instructions on tattooing for a dollar ("a dollar well spent") but offered to help locate the new tattooist in a carnival or circus (Tuttle 1987). And finally, new tattooists could learn to tattoo by serving an apprenticeship with an established tattooist. For little to no pay, the apprentice would trace flash, cut stencils, clean equipment, fix machines, make needles, and run errands. While it is true that most tattooists in the early days were not good artists, a few notable names stood out: Cap Coleman, Paul Rogers, Percy Waters, Robert Shaw, Bert Grimm, Charlie Wagner, Sailor Jerry. Their designs became classics, and their influence on the modern tattooist can still be seen today.

In addition to tattooing, the tattoo supply business was also a lucrative trade for enterprising young men. *Popular Mechanics* and *Popular Science* were the primary vehicles used by tattoo suppliers for reaching potential new audiences. Both tattooing and the tattoo supply business were extremely competitive and artists tried to monopolize a particular city to eliminate competition from other tattooists. Suppliers would often resort to shady dealings to make money, as Percy Waters found out when he was told that a rival supplier had copied his entire catalog (Tuttle 1987). Furthermore, some artists/suppliers would sell damaged equipment to unsuspecting buyers and then charge extra to teach them how to fix and use the machines.

Typically, tattoo customers would select designs from sheets called flash hanging on the walls of the tattoo shop. These designs were drawn in a highly formulaic manner, and the same images would be found on virtually all tattooists' walls of the era, although often drawn with slight variations. Traditional designs would include pinup-style images of women, military insignia, ships, jokes, cartoons, fierce animals, knives, and skulls. The tattooist credited by some with being the first to market sheets of flash was "Lew-the-Jew" Alberts, a wallpaper designer and tattooist in the early 1900s (Govenar 1984). While tattooists did sign their own flash sheets, once a new design reached a tattooist he simply copied it, altering it slightly, and called it his own. For this reason it is difficult to determine the origins of most tattoo designs. Acetate stencils, cut from the sheet of flash, were originally used to transfer the design to the

body. The customer would typically have a limited number of designs to choose from, and customized work was rare. Because of the highly standardized nature of the designs, and because the choice of designs was so limited, many tattoos became classics, worn by a majority of tattooees in a particular social group. These tattoos, like other fads, changed with the times, but certain classics, like the rose, remain popular today. Most tattooists would have, in addition to their standard flash sheets, a "pork chop sheet," which was a sheet of cheap flash designs that sold for a dollar or less and provided a large part of the tattooist's daily income (and allowed the tattooist to eat pork chops, instead of hamburger). In the early days, before flash was mass marketed and what was being sold was often poor-quality work, some tattooists would copy especially nice or new designs from customers' bodies and add these to their own design collection.

## Carnivals, Dime Museums, and Circuses: The Display of Tattooed Westerners

Tattooed natives from the Pacific islands were displayed in Europe and North America from the seventeenth century to the twentieth century. In the early twentieth century the practice of displaying what were essentially slaves fell out of favor and they began to be displaced by tattooed westerners, who provided a different form of entertainment. But whether displaying tattooed native or westerner, these exhibits relied on the continuing association between tattooing and savagery in order to sell tickets.

*Freak Shows* ➡ Freaks, a term that includes "born freaks" (those with disfiguring diseases or disabilities, as well as native people) and "made freaks" (such as tattooed people; Bogdan 1988) were shown as single attractions in inns, taverns, and at local fairs throughout medieval Europe. Later, "marvel acts" such as sword swallowers or fire-eaters joined the show. Around 1840, however, human oddities were relegated to what is now known variously as the freak show, the sideshow, or in circus and carnival parlance, the 10-in-1, meaning ten separate acts in one location (Eldridge 1993).

Dime museums gave birth to the freak show as we know it, and later, freak shows moved into world's fairs, circuses, carnivals, and amusement parks.

Most museums at the end of the eighteenth century were created by early would-be scientists as educational enterprises and attempted to educate through entertainment. In 1840, P. T. Barnum became the proprietor of the American Museum, bringing the freak show to prominence (Bogdan 1988). It was here that the freak show became a part of the increasingly popular amusement industry. In the dime museum, tattooed people were exhibited alongside people with disabilities, natural wonders like wild animals, native people, and "gaffes," or manufactured fakes. Since people had never seen any of these curiosities before, managers and showmen were able to concoct bizarre explanations of their origins, stories that were morally and socially uplifting as well as purportedly educational. Tales of cannibalism, savagery, and the man/beast linkage seen in both primitive men and the disabled were told through these exhibits, and customers—white, civilized, and healthy—left the exhibits feeling good not only about themselves but about the natural order and their place in it. Donna Haraway, in her discussion of the creation of the American Museum of Natural History (1984), notes that the kind of scientific education found in nineteenth-century museums carried a justification for colonial domination and for maintaining the so-called natural hierarchies of race, class, and gender. Through the juxtaposition of native people, wild animals from Africa, and people with gross disfigurements—all labeled as natural wonders—the cultural and biological superiority of white (and she adds, male) America was asserted. That these exhibits, with their implicit message of social hygiene, were at the height of their popularity in an era of increasing, and increasingly threatening, immigration from southern and eastern Europe is no coincidence.

Although the human oddities were not originally the main attractions in these early museums, they quickly became more popular than the stuffed birds and dusty artifacts and provided acceptable entertainment (disguised as education) in an era when the church frowned on frivolous fun. From 1870 to 1890, the freak show was the king of dime museum attractions. At the end of the nineteenth century, the dime museum began to decline when their "scientifi-

cally" legitimated entertainment expanded into other ventures, like circuses, carnivals, street fairs, and world's fairs (Bogdan 1988).

Dime museums were urban, but circuses traveled to rural areas where they, along with the county fair, were often the only entertainment. Single-freak attractions joined circuses in the early 1800s, but the organized sideshow didn't get started until mid-century. The earliest traveling freak shows were traveling museums, and some museums joined traveling circuses as concessions. By the 1840s, though, the museum part of the circus became the circus sideshow, or 10-in-1, and was no longer independently owned and operated. By the 1870s, most circuses had a freak show, and they gradually faded out in the fifties and sixties. Carnivals were the rural, and lower-class, equivalent of amusement parks, and they grew out of the Chicago Exposition of 1893 (Audibert 1986). Early on, the freaks were exhibited as single pit shows, and were often second rate (i.e., geeks, wild men). Around 1904, carnival 10-in-1s developed, although during the first ten years of the industry there were no tattooed attractions or tattooists mentioned in the record.

In the twentieth century, with the discovery of Mendelian genetics, the rise of modern science, and the eugenics movement, born freaks began to be understood from a biological and cultural perspective and this began to adversely effect the attendance at the freak show (Bogdan 1988). Notions of pity, humane impulses, and the desire to lock away all undesirables led to its decline, as well as the rising middle class and their aversion to corporeal entertainment such as this. The use of the physically disabled in freak shows finally ended in the sixties when the American Civil Liberties Union brought attention to the plight of the physically disabled in circus freak shows. Without born freaks, the sideshows had to find something else to capture the public's interest, and tattooed attractions fit the bill perfectly.

*Tattooed Attractions* ➼ By the end of the eighteenth century, European seamen were becoming tattooed, some with small tattoos and others with extensive body decorations. As tattooed natives became more popular attractions at fairs and circuses, and it became clear that people were willing to pay to see them, a new type of freak was created and with it the rise of a new occupation for many people.

The first Western tattooed attractions were displayed simply on the virtue of their tattoos. Later, as competition among attractions became more fierce, the tale of "native capture" developed. Here the tattooed subject (or the manager of the show) would tell the crowd about how he had acquired his tattoos. These stories centered around his capture and forcible tattooing by savage natives (often said to be cannibals), the pain involved in the tattooing, and his heroic escape from captivity. Perhaps the first white man to use such a ploy was John Rutherford, who claimed that he had been captured and tattooed by the Maori in 1828 and was forced to marry a Maori princess (Bogdan 1988; Eldridge 1990). James O'Connell was the first tattooed white man exhibited in the United States (Eldridge 1993). His story alleged that he was shipwrecked in Micronesia in the late 1820s, married one of the chief's daughters, and was tattooed by natives. He had few tattoos, but at that time (in 1833 he returned to the United States and began his circus career) there was relatively little competition in this field, so he enjoyed a successful career.[3]

P. T. Barnum, of both the American Museum and Barnum & Bailey circus, was the all-time most successful promoter of heavily tattooed people. In 1873, Barnum brought Prince Constantine to the United States, where he became the most flamboyant and best known of all tattooed men. He had 388 tattoos, and he sold pamphlets describing them and his forced abduction by Chinese cannibal natives. Barnum even had doctors examine him, who pronounced that he was one of the most extraordinary specimens of genuine tattooing they had ever seen (Bogdan 1988). Another famous tattooed attraction was the Great Omi. As Horace Riddler, he had tried to make a living as a sideshow tattoo attraction, but by 1922 there was enough competition that his own tattoos were not spectacular enough to earn a living. So he wrote to English tattooist George Burchett in 1934, asking to be turned into a human zebra. His entire face and head and most of his body were ultimately covered with a heavy black curvilinear design, his earlobes were pierced and stretched, he filed his teeth to sharp points, and he had an ivory tusk inserted into his nose. Omi ultimately became the longest-running star attraction of Ripley's Auditorium Theatre and in 1940 moved to Ringling Bros. and Barnum & Bailey circus (Burchett 1958; Tuttle 1987). Omi's first paying job, however, did not go

as well as he would have liked. He had been hired by a small circus in France and found that he was billed as an animal and had to work next to the lions. In a letter to George Burchett dated September 1, 1935, he tells of his treatment: "I put in my resignation which they would not accept. When I was too ill to work they painted up a nigger with white paint and put him on in my place" (Tuttle 1987). It is interesting that Omi, a white man with black tattoos in the manner of a zebra, could be replaced by a black man painted with white stripes. Although the presentation of an African man (dressed in "native" clothes and exhibited in an "authentic" native village) was at one time exotic enough to bring in paying crowds, by this late date (the thirties) it was not good enough. Nor was a simple tattooed man enough of a draw. It became necessary to present much greater oddities to the public. Thereafter, Omi, and later his black substitute, was displayed as a man/beast.

Another way for these early entrepreneurs to make money from their tattoos was to work as a tattooist in the traveling shows. Early tattooists offered their services both to anyone who wanted a single tattoo and to aspiring sideshow exhibits. Charlie Wagner, for example, saw Prince Constantine in a New York dime museum and decided to get tattooed and be a tattooist (he later tattooed more than fifty freak show attractions). In the early part of the century, tattooists charged fifty cents to a dollar for a small tattoo. Bert Grimm, who toured with the Buffalo Bill Wild West Show, said that a tattooist could charge about thirty-three dollars in those days for a total body cover job, which took about six to eight weeks to complete (Morse 1977). Generally, the circus and carnivals employed tattooists during the spring, summer, and fall; during the off-season they wintered in the South, sometimes renting spaces in arcades or poolrooms (Govenar 1984). By 1932 there were approximately three hundred completely tattooed men and women who exhibited themselves in traveling shows and in urban dime museums (Govenar 1984). With these shows, tattooing moved inland from the port towns and was brought to areas where people had previously only heard or read about it.

In the late 1880s and early 1890s, tattooed attractions could command large salaries and could work wherever they wanted to, but this situation changed quickly. Competition began to increase and the proliferation of tattooed exhibits undermined the appeal of tat-

tooed freak. In the 1880s, however, tattooed women arrived on the scene and upstaged men completely. This was because they had to show their bodies (legs and thighs) to display their tattoos and during the Victorian period it was considered quite racy to see a woman's thighs. Another aspect of their appeal was that tattooed women were seen as docile and chaste, which was an exciting contrast to the idea of tattoos, which had only been seen on men. While men were tattooed on their hands and neck, tattooed women left their neck, hands, and heads free of tattoos to appear modest when wearing clothes—and so that they could have an alternate career when they retired from show business. While both tattooed men and women had a hard time making a decent living after the 1930s, women could use their sexuality to sell tickets (and pitch [promotional] cards and photos, a major moneymaker).

Female tattooed attractions told outrageous tales about how they acquired their tattoos, just as the men did. Irene "La Belle" Woodward, the first tattooed lady in 1882, said that her tattoos were required protection that she needed in the "Wild West of Texas" to escape the sexual attentions of hostile "Red Indians." Nora Hildebrandt, who also went on exhibit in the 1880s, reported that her 365 tattoos were crafted by her father under the threat of death by his captor, Sitting Bull (Bogdan 1988). Pitch cards and handbills promoting female tattooed attractions used the native-capture device to entice audiences as well. Most contrasted a modestly attired lady in a Victorian gown with a scene of the same woman being forcibly tattooed by savages. This contrast—the ladylike demeanor of the women against the story of their horrific encounter with natives (with its explicit sexual overtones)—was an integral part in selling these women attractions to the customers. The stories on the pitch cards also emphasized their chastity, femininity, and vulnerability, and popular accounts of the performers accentuated the refined nature of their tattoos (such as the patriotic and religious tattoos worn by one attraction, Artoria Gibbons) and outside interests. These women, then, were feminine and classy even though they wore tattoos.

Betty Broadbent was the most famous tattooed lady of all time. In 1923, when she was fourteen years old, she moved from Florida to Atlantic City to take a baby-sitting job and saw a tattooed man exhibited on the Boardwalk (Aurre 1982). Betty originally wanted

to be an artist, but as she needed money, she decided to turn her-self into a work of art and so got tattooed instead (Beal 1989). She took her savings to New York and had her tattoos done by Charlie Wagner and Van Hart over a two-year period (Aurre 1982). She got her first job in 1927 as the youngest tattooed woman in the world (she was called the Tattooed Venus) with Ringling Bros. and Bar-num & Bailey circus.[4] She estimated she had 365 tattoos. She began her performance in a floor-length satin or velvet robe, depending on the weather. The platform lecturer would announce, "And now, ladies and gentlemen, the lady who's different!" (Aurre 1982:27). She would then unzip her robe and reveal that underneath she wore a long bathing suit that came four inches above her knees, which allowed her tattoos to be seen by the audience. Betty said that hers was a respectable act, "not like those carnival floozies with one or two tattoos who would bump and grind" (Aurre 1982:27). When women were allowed to show more of their bodies, Bert Grimm tat-tooed Betty's upper legs, and her bathing suit was shortened further to display her thighs. In interviews with Betty and stories about her published after her death, her respectability and ladylike behavior was always emphasized. Betty was said, for example, to like grow-ing flowers and breeding fancy birds. Like the other tattooed ladies, Betty was presented as feminine and refined.

As the sideshow declined toward midcentury, tattooed ladies, like tattooed men, became outdated. Tattooed animals, tattooed dwarfs, tattooed fat ladies, and tattooed sword swallowers developed, and there was even a tattooed half-man and a tattooed knife-throwing couple. But the days of the freak show were numbered, and today the number of tattooed attractions at North American carnivals can be counted on the fingers of one hand.

## The Golden Age of Tattooing

Tattooing as a business evolved in twentieth-century North America in small spaces located alongside barber shops, in dirty corners of arcades, under circus tents, or on carnival midways. Al-though hidden away at the margins of society, the shops were never-theless a home away from home for many men: sailors, carnies, drunks, laborers, as well as younger boys who hoped to learn the

trade. Inside the tattoo shop was a unique world where ex-sailors swapped sea stories, young servicemen attempted to outdo each other with the grandeur of their tattoos, and others told stories about their travels and experiences. The talk was lewd and often revolved around sex. Legends about tattoos, too, were a favorite topic, and tattooists traded tales of the weirdest places/tattoos/people they had ever tattooed. For example, every tattooist was sure to have a few stories to tell about giving genital tattoos or about customers who had involuntary bodily eruptions (i.e., flatulence, ejaculations) while being tattooed, as well as tales about "advice" given on the care or removal of a new tattoo, such as the application of whale or shark semen.[5] Following is the story of one man's experience about acquiring his first tattoo in the early forties:

I was sixteen years old and me and my friend—he had one or two tattoos—went to get tattooed. At this time there was a bunch of tattoo parlors on Main Street (Skid Row in Los Angeles) and we went into some tattoo parlors. In those days you were supposed to be eighteen to get a tattoo so some of them wouldn't even talk to us and we finally found a guy, his name was Sailor Jack or something. I guess all tattooists are good talkers, maybe they're not, but anyway, this friend of mine, we both picked out the exact same tattoo [an air force tattoo], and then he starts telling stories like, "who's going to be first, somebody get the bucket," all these kinds of things like, "you're going to bleed into the water, you're going to be sick to your stomach." . . .

He shaves your arm, puts vaseline on it, and then takes this little acetate deal with all the lines on it, and then he puts it on. No sterilization or nothing. I think he put the needle in bleach between customers. It hurts like crazy and bleeds like crazy. I asked him, "How can you see through all that blood?" and he goes, "Well, when you're in bed at night and when you reach down under the covers, you can find it okay, can't you?" [Laughs] . . .

The tattoo parlors in those days were open all night. We'd go down 2:00 or 3:00 in the morning and sometimes we wouldn't walk out of there til daylight. We'd just go down and shuck with them. It was fun 'cause they could tell you all kinds of stories. . . .

We both got the tattoos and it was our first year in high school so naturally we wore our sleeves all rolled up and those were the

days where we wore Levi's, filthy Levi's. If you ever had to wash your Levi's, you'd throw them away. You wouldn't wear them to school anymore—once you washed them they weren't good anymore. Washing them loses all the color—they'd fade out. But you always wore real nice shirts and polished shoes. And of all things, like an army shirt. You'd wear them out, you wouldn't tuck them in, but then the teachers would make you tuck them in. Some teachers would make us roll our sleeves down, too. (Danny L.)

Where were women during this period? From the end of the days of the carnival ladies until the seventies, women were largely absent from the tattoo scene. Samuel Steward writes in his account of tattooing in the fifties, "When I finally discovered the trouble that always surrounded the tattooing of women, I established a policy of refusing to tattoo a woman unless she were twenty-one, married and accompanied by her husband, with documentary proof to show their marriage. The only exception to this was the lesbians, and they had to be over twenty-one and prove it. In those tight and unpermissive 1950s, too many scenes with irate husbands, furious parents, indignant boyfriends, and savage lovers made it necessary to accept female customers only with great care" (1990:127).

Women were rarely tattooed during this period because, again from Steward, "Nice girls don't get tattoos" (71). He writes that his female customers were "large lank-haired skags, with ruined landscapes of faces and sagging hose and run-over heels" (128). And when a nice girl *did* want to get a tattoo, there would be hell to pay from her husband, father, or boyfriend (thus his spousal consent rule). The tattooist, like the woman's other male keepers, took it upon himself to keep "nice girls" (i.e., attractive, middle-class, heterosexual women) from transgressing the class and sexual borders of the time and of turning into tramps.

Steward also writes of women who had already crossed these borders: "The lesbians were another matter. Whenever they came in they frightened the sailors and many of the city-boys out of the shop. I did not relish their arrival nor particularly want their business" (128). For Steward, and presumably other tattooists of the period, lesbians were tattoo-able, in that there were no angry husbands to contend with, and the women had already permanently relinquished their femininity. Yet they still posed a problem in the male-

dominated tattoo parlor, because their visibly tattooed bodies assaulted even the tattooed men's notions of convention. Ultimately, the presence of tattooed lesbians during the fifties attests to two things: the consistency of the practice of tattooing among lesbians (far predating the modern, and much more visible, use of tattooing in the gay/lesbian communities) and the fact that this practice did not, at that time, lead to the acceptability of tattooed women in general.

With the exception of Steward's "skags" and dykes, the tattoo culture of the forties and fifties was a masculine world. Sterilization was nonexistent, with a bucket of dirty Lysol water for cleaning the machine between customers and a dirty sponge for wiping down a customer's arm before, during, and after tattooing. Sometimes the bucket would be changed daily, sometimes on a weekly basis. The ink for the tattoos came out of a community ink pot and was not changed for each customer. Needles were not changed between customers and were changed only when they became so sharp that they cut the skin.[6]

One old-time tattooer tells the following story about his introduction to tattooing in the post–World War II period:

I was raised about 100 miles north of San Francisco and it was immediately after World War II, and I guess there was a lot of guys coming back with tattoos. There was a couple people around who had a couple of tattoos, but you know how kids are, they're looking for all these things, it's just growing up. I was enthralled with San Francisco and that's how I ended up going down to San Francisco and getting my first tattoo. I went down to see the bright lights and tall buildings and figured there had to be a lot more going on down there than where I was from. I was fourteen at the time, it was about 1947. So I went down to San Francisco and this was, you know, with the permission of my parents and everything, I wasn't a runaway or anything. So anyway, you don't wind up getting too far from the bus station [laughs]. So anyhow, there's a couple of things you could do. You could drink Coca-Cola, you could get your shoes shined, and you could just walk around and look around, you know. So I did that and I was in front of this arcade and I saw the magic word: T A T T O O I N G, so I went back there and I walked into this thing and the guy back there goes "What the hell do you want?" I

went, "uh . . ." and I looked around and I seen on the wall this heart with "mother" on it and I went "I want that." And by God, he put it on me. So that day, I picked out my life's work. I just went down on a Greyhound bus and came right back again. I was down there every chance I got. You know, the whole tattoo scene thrilled me to death. It was just a whole different world. Plus you know, it was in the arcade, and the tattooers, you know, had a lot of savoir faire. There were some interesting characters and they got into the history of tattooing and everything. There was a lot of salty characters that was in and out of there. (Lyle T., tattooist)

The period between the two world wars saw tattooing at its most popular and is known as the Golden Age of Tattooing. It was at this time that tattooing had perhaps its highest level of social approval due to its link with patriotism and Uncle Sam's fighting boys. As Benedict Anderson points out (1983), a nation inspires profound, self-sacrificing love, which can be seen in the willingness of its citizens to die for their country in times of war. This nationalist fervor can also be seen in the numbers of citizens, military and nonmilitary, who acquire patriotic tattoos during these times. The link between soldiers and sailors and tattooing was so strong at that time that it was assumed a man with tattoos was serving in the armed forces or had been at one time. As an army veteran told me, "When I was in boot camp, all these guys saw my tattoos and said 'Oh, you're a retread.' Retread means the guy's been in the service before and he has to come back and they make him go through boot camp again."

The system of traditional American tattooing that is both the most classic and one of the most universally readable of all tattoo types comprises the tattoos popular among the nation's servicemen from the beginning of the twentieth century through the end of World War II. Although it was not only military men who wore these tattoos, they were the most heavily tattooed population in the United States and were the most influential in terms of setting trends in imagery, style, and placement. Sailors in particular were the best tattoo customers among the services due to their long affiliation with the art, their travels to different parts of the world, and their frequent paychecks: twice a month as opposed to once a month for the army and marines (Webb 1978). Sailors were tat-

tooed in the United States, Hong Kong, Japan, the Philippines, and Europe, and for most a collection of tattoos commemorating their travels was a point of pride.

Sailors often visited tattoo shops in groups and competed with each other for the most, best, and biggest tattoos. The most popular designs were patriotic themes (flags, eagles, American slogans), military emblems (USN, ships, anchors), sea themes (mermaids, dolphins, whales), and "girlie tattoos" (nude women, hula dancers, harem girls, sailor girls, cowgirls, and geisha girls). The girls were patterned after many sources, including the Gibson Girl (Eldridge 1987), the *cheongsam* (mandarin dress) girl adapted from the movie *Suzy Wong* (Pinky Yun cited in Hardy 1985), as well as other stereotypical women of the period. The hula girl was placed on the upper arm so that by contracting the muscles, the sailor could make her dance. Other classic designs popular in the military included the rose of no-man's-land, depicting a military nurse's head emerging from a rose on a cross or anchor; homeward bound; rock of ages; and sailor's grave—images dealing with a sailor's most anticipated and most feared final days at sea—and death before dishonor, usually found on a snake-encircled dagger or skull.

Often a tattoo's reading is determined not only on the basis of the image used but on its placement on the body as well. Again, the military, and especially the navy, has the most elaborate tradition for this:

Every sailor worth his salt had big girls tattooed on the calves of his legs, a chest piece, or at least a crying and laughing baby with the words "sweet and sour" under them—"sour" under the head of the crying baby, below the nipple—"sweet," under the laughing baby above the nipple. After World War II, the idea lost its meaning and many soldiers had the babies put on their backs or legs. When you had gone five thousand miles at sea, you got a bluebird on your chest. When you'd gone ten thousand you got the second bird on the other side. When you made your second cruise you got a clothes line with skivvies and girls' stockings between them. If you crossed the equator you got a Neptune on your leg, and for security you got a pig on one foot and a rooster on the other, a charm that would keep you from drowning at sea. Turnscrews on the rear end (ships' props) would help you reach shore if you washed overboard, and

they usually read "40 knots no smoke" or "TWIN SCREWS — STAND CLEAR." (Webb 1985:10)

Certain parts of the body were heavily favored as tattoo sites for U.S. servicemen, while other spots were either prohibited or simply ignored. The primary areas on the body to get tattooed were the back; chest (and/or stomach); biceps; forearms front, side and back; and both sides of the calves. Except for heavily tattooed people (primarily tattooists or circus and carnival freaks), the thighs, sides, and under the arms were usually ignored. Facial and hand tattooing was prohibited for servicemen and was taboo for most other people with tattoos except, again, heavily tattooed people.

The classic American tattoo, whether the eagle or anchor of the sailor or the more universal vow tattoo (Mom or a girlfriend or wife's name), is a literal tattoo: one whose meaning is readily understood and agreed to by members of the community who are literate in the system (see DeMello 1991). These tattoos, found primarily on the bodies of working-class men, had almost universal appeal and readability. The images were derived from popular culture, the placement was visible, the lines and color were bold, and the liberal use of alphabetic script in tattoos (the word tattoo) made them extremely easy to read. The simplest form of the literal tattoo is the word tattoo, and the most basic form of the word tattoo is the name tattoo. Ed Hardy writes, "often the earliest 'homemade' tattoo efforts with sewing needle and India Ink, or the first . . . visit to a professional tattoo artists, express the initials or name of the wearer" (Hardy 1982b:50). According to Doc Webb, the classic "Mom" or "Mother" tattoo was the second most popular word tattoo, with sweethearts' names running third (Webb 1985).[7] Cartoon, joke, and lucky-charm tattoos were also extremely popular classic designs that are literal in this manner. And finally, perhaps the most literal tattoo was the identification tattoo. Servicemen, for example, often had their names, service number, rank, and date of birth tattooed on them.

Identity tattoos were popular outside the military as well. For example, after the Lindbergh baby was kidnapped in 1932, many worried parents had their children tattooed, and after the first Social Security card was issued in 1936, men and women flocked to tattoo shops to have their number tattooed on them (Eldridge 1989b).

In 1955, the assistant secretary of defense suggested that all U.S. citizens have their blood type tattooed onto their bodies in anticipation of a military attack on the United States, and many citizens evidently complied (Eldridge 1989b).

According to old-time tattooer Doc Webb, tattooing changed after World War II.[8] Not only had the price of tattoos gone up substantially but the sailors, who were the bread and butter of the tattooist's trade, had changed. The Pacific Ocean was no longer a hub of North American military activity, and many of the new enlistees were not planning a military career. In addition, in the fifties as tattooing's popularity began to wane among the mainstream population, even the navy began to counsel men to avoid tattoos (Webb 1985). While each new U.S. war after World War II brought another flight of enlisted men and patriotic citizens to the local tattoo parlor, between wars the demand largely dried up. The Golden Age of Tattooing had given way to the sixties.

## The Sixties and the Fragmentation of American Tattooing

Alan Govenar cites 1944 as the year that one of the first legal actions was taken against a tattooist: Charlie Wagner was fined by the city of New York for failing to sterilize his needles. (Wagner managed to get his fine reduced, however, by telling the judge that he was doing "essential war work" by tattooing clothes on naked-lady tattoos [Eldridge 1989a].) Soon afterward, William Irving was fined for tattooing a minor (Eldridge 1992). Before World War II, many states passed minimum age laws for tattooing, but during the war it was difficult to enforce as there were so many people being tattooed at that time (Govenar 1984). After the war, many municipal authorities began to take a closer look at tattooing, and newly tightened health and age regulations forced the closure of many shops across the country. By the sixties, many areas began to ban tattooing altogether, based in part on outbreaks of hepatitis, including cities in New York,[9] Oklahoma, Virginia, Massachusetts, Connecticut, Ohio, Arkansas, Wisconsin, Tennessee, and Michigan (Govenar 1984:76). Many ex-servicemen, too, began to regret their wartime tattoos as they realized at home that they were neither valued by

their wives and sweethearts nor by potential employers. Additionally, Govenar (1984) suggests that knowledge about the Nazi practice of tattooing Jews in concentration camps probably contributed to tattooing's downfall in the United States.

As the nation's military men returned to civilian life after World War II, the popularity of tattoos began to decline as did the powerful influence that the military had on the forms of North American tattoos. While the new middle class busied themselves with marrying, having children, and moving to the suburbs, inner-city and port-town tattooing fell to its lowest levels of popularity. Traditional American tattooing was still practiced among many working-class men in most tattoo parlors, but a new form of confrontational, biker style of tattooing was developing on the streets. Tattooing in this period became a form of defiance, a challenge to both emerging mainstream middle-class values as well as to the traditional form of patriotic and love-inspired working-class tattoo. While this was certainly not the Golden Age of Tattooing, it *was* the period that solidified postwar society's negative views of tattooing, views that continue in many areas today. Not only were tattooed outlaw bikers emerging as a subcultural group viewed with fear by the middle class in the late forties, but convicts and Chicano gang members, already practicing homemade tattooing, moved into the public eye (especially after the zoot suit riots of the forties brought so much media attention to the tattooed *pachuco* culture). This contributed to an increasingly negative image of tattooing and also to a splintering of the practice, wherein imagery, styles, and social customs became adapted to individual subgroups. As marginal groups began to wear tattoos in greater numbers (including hippies in the sixties and punks in the seventies and eighties), tattoos became the mark of marginality. Additionally, many of the "scientific" tattoo studies that linked tattoos with deviance (Briggs 1958; Goldstein 1979; Taylor 1970; Newman 1982), and which were based on studies of tattooed inmates, began to appear during this period, again solidifying the association of tattoos with deviant groups.[10]

*Biker Tattooing* ➤ Since the 1960s, bikers have emerged as possibly the one group most associated with tattoos in this country, surpassing even sailors in popular perception. The style and content of biker tattoos are radically different from traditional tattoos:

the tattoos are almost exclusively black and are done in the fine-line, single-needle style usually associated with Chicano and convict tattoos. This is no accident as many outlaw bikers acquired their first tattoos in prison and brought the prison style—either done by hand through picking or with single-needle rotary setups—with them to the outside. The biker tattoo imagery is also very different from traditional working-class tattoo imagery. It is not patriotic, has not been influenced by military motifs, and is often explicitly anti-social. Classic biker tattoos include Harley-Davidson motorcycles and emblems, V-twin engines, club logos, marijuana leaves, swastikas, skulls, and logos such as FTW; Born to Lose; Live to Ride, Ride to Live; and Property of [biker's name] on women bikers. For men and women, biker tattoos are located on public areas of the body, as they are not private expressions as much as they are public commentary. Men's tattoos are located on the arms (the goal is to be fully "sleeved out"), back, chest, hands, and head (very little on the legs, as bikers wear jeans when riding), while women's tattoos are on the breasts, hips, arms, and back and are easily exposed via halter and tank tops or by simply going topless at bike runs and other biker community events. Biker tattooing comprises a highly literal system of communication within the biker community, and, for those who recognize the imagery and slogans, it can also extend outside the community. (Most people recognize the antisocial sentiments behind, for example, a Fuck the World tattoo.) Furthermore, tattoos are an indispensable part of the biker image and can serve as a passport into the culture. For example, while bikers recognize my brightly colored tattoos as being very different from their own, I am almost always complimented on my "nice tats" when in their company.

*Chicano Tattooing* ➺ Chicano tattoos employ styles and methods similar to biker tattoos but are part of a vastly different social context. Chicano tattooing began with the pachuco gang culture of the forties and fifties in the barrios of California, Texas, New Mexico, and Arizona (Govenar 1988). These tattoos were originally done by hand with a sewing needle dipped in India ink. Classic Chicano tattooing uses black ink exclusively; fine lines to create the classic images of Christ, the Virgin of Guadeloupe, and women; and bold shading for the *locas* (hometown or neighborhood) and other word

tattoos. Today, Chicano and Mexican tattooists use color and professional machines for their tattoos, but many young people and gang members still wear the monochromatic, hand-picked tattoos.

Chicano tattoo art is very similar to other forms of Chicano art, such as mural and low-rider art, although certain images are limited to tattoos. Without a doubt the most classic Chicano tattoo is the small pachuco cross tattooed on the hand between forefinger and thumb. It was once used to identify gang members and to assert the solidarity of the group; to outsiders the cross represented crime and violence (Govenar 1988). To insiders, however, Chicano tattoos tend to represent loyalty to community, family, women, and God—very similar in theme to the nationalist designs seen among sailors, but stylistically, a world apart.

*Prison Tattooing* ➽ It is difficult to say precisely when prisoners in the United States began to tattoo themselves, but in Europe the tradition dates back at least three centuries (Hall 1988). In the United States, there is a strong similarity between Chicano tattooing and much of prison tattooing. The methods used are the same, with the tattoos applied by hand (or today, with rotary machines constructed out of tape recorder or electric razor parts combined with pieces of a ballpoint pen and earphone wires), using black ink exclusively. As with biker and Chicano tattoos, wearing prison tattoos marks one as being part of a specific social network that is on the fringe of mainstream society. For prison tattoos, that mark is especially stigmatizing. The most easily readable prison tattoo is located under the outside corner of the eye and is called the tear. A tear on a man's face is a sign of his imprisonment (or sometimes, of having committed murder), and more than one tear usually refers to more than one prison term. Although the United States does not forcibly tattoo criminals, political detainees, or members of marginal groups as other societies have done (e.g., Japan, England, Cuba, Nazi Germany), the tattooed tear acts as a way by which North American inmates voluntarily mark themselves. Rather than simply marking oneself as having been incarcerated, the tear visually expresses the convict's suffering.

Prison tattoo imagery incorporates motifs found in biker and Chicano tattooing, as well as prison-specific designs. Tattooing cuts across racial boundaries in prison, as Chicano tattooists sometimes

tattoo racist slogans on white supremacists. As one ex-convict told me, "The best tattooists in the joint are Mexicans." Other prison tattoos are drawn specifically from the experiences of prison life: Christ is often represented behind bars or with barbed wire instead of a crown of thorns around his head, or justice is depicted (either in human form or as scales) in a way that illustrates the inequities of the judicial system.

By the end of the sixties, tattooing in the United States had fragmented into different forms that corresponded to different social groups: servicemen, gang members, convicts, bikers, and working-class men and women. While tattooing was no longer associated with "savages" from the Pacific Islands, new tattooed savages had emerged to take on the roles once occupied by Tahitians, Hawaiians, and New Zealanders. Bikers, gang members, and convicts, while still a minority, were the public face of tattooing during this period, alongside a lingering association with sailors. Even as working people continued to get tattooed, tattooing increasingly became associated with deviants, criminals, and the socially marginal and this association was solidifying in the media, in scientific journals, and in the popular imagination. In chapter 3, I will discuss the historical and sociocultural changes that occurred in the United States in the seventies and eighties that allowed for yet another shift in tattooing and its public perception. During this time tattooing began to move from a marginal practice to one that became increasingly sanctioned by the middle class and whose influences, paradoxically, have moved toward the exotic once again.

## *Appropriation and Transformation*

### The Origins of the Renaissance

This one on my chest is my own design, for my

heart chakra. This one is a Japanese symbol and I sort of

turned it into a sun and put this around it. This one a friend of

mine designed for me, it's like a Maori skull, and I got my first

color piece done today. It's Baba Yagga: it's like a witch and

a cauldron and she lives in a house that jumps around

on a chicken's foot. She's like a legendary witch,

she eats little children. — Cindy

In chapter 2, I discussed how tattooing in the United States developed from an exotic practice found among the newly colonized peoples of the South Pacific into, first, a familiar aspect of North American working-class life and, later, into a symbol of marginality among the lower classes. In this chapter, I examine the emergence of the Tattoo Renaissance, a period marked by technological, artistic, and social changes. At this time, members of the counterculture began to wear tattoos as a sign of resistance to heterosexual, white, middle-class values, and new tattoo images began to emerge

that appealed to this younger, hipper audience. During this period tattooists also began to change, as young men and women with fine art backgrounds began to enter the profession alongside older, traditionally trained tattooists. These newer tattooists took their artistic inspiration from "exotic" cultures (initially Japan, later Borneo, Samoa, and Native America) rather than from traditional North American designs and in the process began to appeal to a middle-class audience. I uncover the ways this evolution has occurred by investigating the process of its appropriation and transformation.

## Sailor Jerry and Japanese Tattooing

While the transformations in tattooing did not appear to the public until the seventies, the change began much earlier, with the work of an influential tattooist named Sailor Jerry Collins. It was Sailor Jerry who first introduced Japanese tattoo imagery and style to U.S. tattooists like Ed Hardy, thereby directly influencing the future of American tattooing.

Tattooing in Japan can be traced through archaeological evidence to the Yahoi period (starting about 300 B.C.) where it seems to have originated in the form of facial tattoos. These tattoos were probably used for decorative and religious purposes, not unlike those found in other Pacific island cultures (Richie and Buruma 1980; McCallum 1988). Facial tattoos later (in the Kofun period from A.D. 300–600) took on a negative association and were used as a form of punishment, as well as to identify the untouchable classes, the *hinin* and the *eta* (Ritchie and Buruma 1980). The modern Japanese full-body tattoo—encompassing the front and back of the torso (with an untattooed "river" down the front where the *happi* coat would hang open) and the arms and legs—did not develop until the Edo period (1600–1800). This form of tattooing was practiced by a large segment of the lower classes, in particular by the firefighters, and was strongly disapproved of by Japanese authorities.

The imagery and style of the full-body tattoo was probably derived from the Chinese novel *Shui-hu Chuan* (known as *Suikoden* in Japanese), which was popular in the early nineteenth century. The version illustrated by Kuniyoshi showed scenes of legendary battles with mythical heroes and warriors that had creatures like koi, drag-

ons, and tigers tattooed on their bodies. These images were sur-rounded by highly stylized waves, wind bars, and flowers, includ-ing cherry blossoms, chrysanthemums, and peonies. The pictures from this novel, and from the wood-block prints of nineteenth-century Ukiyo-e artists like Hokusai and Yoshitoshi, came to form the iconographic vocabulary for modern Japanese tattooing.

During the modern period (from 1868 to the present), tattooing was forbidden for law-abiding Japanese citizens, although gamblers and the *Yakuza* (Japanese mafia) continued to wear them. It was also during this time that Japanese tattooing began to attract inter-national attention, as westerners—primarily sailors and other for-eign travelers—began to receive Japanese tattoos. With the defeat of Japan at the end of World War II, many of the previous govern-ment's laws were overturned, and tattooing was once again legal for Japanese citizens; yet by this time, it had moved so far under-ground that most "decent" Japanese citizens would not consider becoming tattooed. It was Western interest, then, that fueled the re-vival of Japanese tattooing, both for the Japanese and for westerners (McCallum 1988).[1]

Sailor Jerry (born Norman Keith Collins) started tattooing in the twenties in Chicago. Under the tutelage of Tatts Thomas, Collins learned his trade by practicing on drunks brought in from Skid Row (Hardy 1994). He made his home in Hawaii in the thirties, where he opened his first tattoo parlor. Collins developed an early interest in Asian imagery during his travels through the Far East (he served as a merchant marine in World War II and often tattooed at his ports of call) and through his peacetime exposure to other sailors' tattoos and incorporated dragons and other designs into his flash. He also had a strong interest in improving tattooing as an art form and felt that most U.S. tattooers were greedy, talentless copycats. Early on he sought out and began a correspondence with tattooists like Paul Rogers and Brooklyn Joe Lieber who shared his interest in improv-ing the art. At the same time, he spoke out against those he believed were hurting the field through their shady business practices and lack of talent.

But it was not until 1960, when he opened his last tattoo shop in Honolulu's Chinatown, that his interest in the Oriental style of tattooing really blossomed. He developed a trade relationship with Japanese tattooist Horihide (Kazuo Oguri) and Hong Kong tattoo-

ist Pinky Yun, whereby he would exchange American machines and needles for designs and advice. He was especially impressed by the Japanese use of colors and shading and their focus on the entire body as a canvas for sophisticated artistic expression. Ironically, while Collins developed a close business friendship with tattooists Horihide, Horiyoshi II, and Horisada, he also never forgave the Japanese for attacking Pearl Harbor and for what he saw as their economic takeover of Hawaii (Hardy 1982c). In fact, by his own admission, Collins wanted to "beat them at their own game" (27): to create an American style that was based on what he called the "Jap style of tattoo," yet one that reflected imagery from the United States. What he did was borrow the Japanese aesthetic style—wind bars, finger waves, full-body tattoos—to represent the history and pop culture of Americana: General Custer at Little Big Horn, the Alamo, the Spirit of '76, Rock of Ages, well-endowed mermaids, and other images inspired by the North American imagination. This was extremely innovative and reflected Collins's belief that what was exceptional about Japanese tattooing was not the central image but the background. While other old-time tattooists had been creating large-scale pieces since at least the forties, Collins was the first to achieve the unified look of the Japanese tattoo in the West by using images of wind and water in the background. While most tattooists in the United States resisted the Oriental influence and did not show an interest in Collins's work, a few did. Cliff Raven and Ed Hardy, who were critical to the transformation of North American tattooing in the seventies and eighties, noticed his work in the late sixties through tattooist Don Nolan, and all three developed important relationships with Collins (Rubin 1988b) that enabled them to learn more about the Japanese style of tattoo and how to incorporate it into their own work.

The introduction of Japanese tattoo aesthetics into U.S. tattooing is critical in the history of the Tattoo Renaissance for a number of reasons. First, while Asian designs like dragons, Chinese characters, cheongsam girls, and tigers had long been popular in the West through the Pacific navy practice of receiving tattoos in Eastern ports of call, these tattoos were executed in the Western style as a series of small, independent, badgelike designs placed haphazardly on the body. Japanese tattooing, however, was very different in imagery, style, and technique and in the way that the whole body is

used as an integral part of the design. Never before had non-native American tattooists created tattoos that utilized the full body and that were thematically and stylistically consistent as well. The second major reason why Japanese tattooing has been so influential in contemporary North American tattooing is because it is considered to be the polar opposite of U.S. tattooing. Unlike traditional American tattooing, which is seen as folksy and primitive, Japanese tattooing is thought to be modern, sophisticated, and linked to the more spiritual and refined East. At a time when tattooing was at its lowest point in the public eye, interminably linked with bikers, Skid Row drunks, and criminals, the Japanese tattoo offered not only a new repertoire of images but also new hope. It was, I argue, the introduction of the Japanese tattoo into North American tattooing that permitted the middle-class interest in tattooing to sustain itself beyond the early countercultural impulse.

## Countercultural Borrowings

In the early seventies, while the aforementioned tattooists were exploring Japanese work, the United States underwent its own transformation. The Vietnam War and the peace movement that it spawned, the Civil Rights and Black Power movements, the Stonewall riot, and the new women's liberation movement all shook the foundations of middle-class stability, as well as contributed to the changing face of tattooing in the United States. Peace symbols, mushrooms, marijuana leaves, zodiac signs, and other images of the sixties entered the flash of most street tattooists as hippies and other disaffected youth, following the highly publicized bikers, began to use tattoos as a form of rebellion. At the same time, many gays, and in particular kinky gays, were using tattoos for their own liberation as well. In addition, a number of hip, young celebrities began to publicly become tattooed, including Janis Joplin, Joan Baez, Peter Fonda, Flip Wilson, and Cher. Lyle Tuttle, who tattooed Joplin, said this about the period:

> Women's liberation came along, gay liberation came along, kids' liberation came along. Liberated people [were everywhere]. So then women started getting tattooed, and Janis Joplin, she got tattooed.

She ran around at concerts all over the world telling about it. She wrote the best advertisement for tattooing that could ever be written. She got up there, her and her chihuahua, one time and told them, "People who get tattooed like to fuck a lot." . . . I tattooed all the musicians. Bill Graham used to say that the biggest form of entertainment backstage for the musicians was showing their tattoos. Frank Zappa loved to kiss 'em — on ladies, of course. So the role models of the day [for young people] were getting tattooed. (interview with author)

Lyle Tuttle, although never a leader in artistic innovation like Sailor Jerry, nevertheless played a major role in bringing mainstream media attention to tattooing. He opened his shop in San Francisco in 1957 and was for many years the only tattooist in town. During the Vietnam era, he found himself tattooing increasing numbers of hippies as well as celebrities, and he took advantage of the new media interest in tattooing to launch the biggest pro-tattooing publicity campaign that the trade had ever experienced. Tuttle, his shop, and tattooing were featured in *Time* and *Life* magazines, as well as in countless local papers, and Tuttle made appearances on television shows throughout the seventies. When I asked him why he was so popular, and why tattooing became so popular during this period, he responded:

I think it was all about having a product and the right timing. Also, I was glib of tongue and I could communicate with the press. That's an important part of it. Because you know, a lot of tattoo artists are paranoid because of all the problems in the early 1960s, late 1950s, when tattooing was being banned in places. I communicated with the press. I believed in my product. I was not hesitant to ever climb out of my duds [laughs] so it was just a combination, and being in the right place at the right time and being the right guy. And I was quite quotable.

While younger tattooists were able to take advantage of the more relaxed social climate of the period and tattooing's emerging popularity, thanks to Tuttle, many older tattooists resented Tuttle's influence. Sailor Jerry, for example, felt that the publicity Tuttle brought to tattooing did the profession more harm than good (Hardy 1994). Today, Tuttle is himself ambiguous about the changes he helped

bring about. He says now, "I shot it in the foot." He told me the following story to illustrate his point:

> I was sitting in the airport and the fog was so dense that no planes were leaving that day, so I took off and went to a hotel and the next day came back again and here's all these people sitting around in the waiting room. And I looked around and there's one seat and it's right next to this nun. So I went over and sat down and I was sitting there reading this book that I had and she said, "Excuse me, young man. I noticed the tattoos on your wrist. They're very nice." So I said, "Well, thank you." So she says, "I have a niece who wants to go into tattooing. Do you know any suppliers?" [Laughs]

This story is not really true, but Tuttle says that "there's more truth than poetry to it." It illustrates the way that tattooing's popularity has skyrocketed in the years since the seventies. Not only had it become more acceptable, tattooing had become commonplace.

Because San Francisco was a major hub of antiwar and liberation activities, the tattoo designs that came out of Tuttle's shop were reflective of the changes in the social climate. In fact, tattoo designs probably changed more during the seventies than any previous period in U.S. history. Prior to this time, most of the tattoos found on the walls of tattoo parlors were masculine, both in terms of imagery (military icons, aggressive animals, motorcycle insignia), style (bold lines), and placement (for example, the ubiquitous bicep tattoo). But with the peace, gay, and women's liberation movements came new designs that were both more feminine and also appealed to middle-class tastes more than the classic working-class designs. Peace symbols; the yin/yang image; astrological signs; and animals like dolphins, butterflies, rabbits, and kittens (considered more feminine), began showing up on women's shoulders, breasts, and ankles, and also on young middle-class men's bodies. Because women have always been expected to uphold certain standards of refinement, tattooists created designs for them that were more genteel than those offered for men, and these designs were both influenced by and appealed to a middle-class sensibility. With the apparent liberation of women's bodies came the liberation of middle-class bodies in general and with it came a radical shift in the nature and social practice of tattooing.

# The Professionalization of Tattooing

The countercultural uses of the tattoo in the seventies and the prominence of San Francisco tattooist Lyle Tuttle played a major role in the burgeoning Tattoo Renaissance. Tuttle was influential for another reason, however. He was instrumental in updating the health regulations governing tattooing in San Francisco, and this was a primary factor in the increasing professionalization of tattooing. He realized that one of the reasons that tattooing had such a bad reputation was the poor sanitation practices of most U.S. tattooists at midcentury. The ban on tattooing in New York City, for example, was linked to the incidence of hepatitis being transmitted via infected tattoo needles. Thus it was clear to many that in order for tattooing to survive, and to attract new customers, health regulations would have to be tightened. Tuttle talked about getting a license in San Francisco in the fifties, an era when tattooists were suspect.

> I was the only tattoo artist in San Francisco at that time. See, San Francisco had a twenty-one [-year-old] age limit. So a lot of people just wouldn't operate underneath that kind of law. And it was tough to get a license. It was this old lady at the Department of Communicable Diseases who handed out the licenses and she hated tattooists. She liked me, for some reason. She said I was the only tattoo artist she had ever met who had clean hands. So I'd been down in Long Beach tattooing and I'd come over to Oakland and set up there and I finally decided to come on over to San Francisco. . . . I applied for a license and it was issued.

Ultimately, Tuttle worked with the Department of Communicable Diseases to write the new health regulations on tattooing in San Francisco, and he pointed out the technological innovations in tattooing that made better sterilization techniques possible.

> So we went through the guidelines of individual pigments and needle sterilization. . . . I built all my own equipment, and I built equipment for other people, and the number one thing with the equipment that had changed was the quick-change machine, so you could get the tube out and the needle bars. 'Cause anything that's hard to do you're not gonna do. So that was the thing that had to

change in the tattoo industry was you had to go to needle steriliza-
tion and you had to figure out ways to dispense individual pigment
for each customer, so you'd put each customer's ink in a little sterile
container. . . . I remember the resistance that everybody put up—
it was a pain in the ass. It was easier before. 'Cause you know when
I started tattooing, it was the sponge and bucket days. You worked
out of a community ink pot, and you didn't change needles and they
got awful sharp. As they wear, needles rub in the tube, so you start
getting a knife shape. It wears and it gets to the point that it'll get
so sharp it'll cut the skin. So that's when you changed needles, was
when they quit working.

Tuttle's efforts to improve sanitation for San Francisco tattooists
(like a similar effort by tattooer Doc Webb in San Diego) were im-
portant and helped bring tattooing into the modern era and to a
middle-class audience.[2]

Other talented tattooists with vision also contributed to the Tat-
too Renaissance. Arnold Rubin (1988b) uses the term "first Renais-
sance generation" to refer to these men: Cliff Raven, Don Nolan,
Zeke Owens, Spider Webb, and Don Ed Hardy, all born in the
thirties and forties, during the Golden Age of Tattooing. Of these
tattooists, Don Ed Hardy is probably the one individual who was
most responsible for bringing professional tattooing into the U.S.
middle class.

Hardy was born in 1945 in Corona del Mar, close to Long Beach,
California. He was intrigued by tattoo designs as a child and drew
tattoos on his friends, in his home "studio." He met Bert Grimm
in the midfifties and watched him work on the Pike (boardwalk)
in Long Beach. As he grew older, he moved from an interest in
tattooing to other forms of art and went to the San Francisco Art
Institute in the sixties and ultimately received a B.F.A. in printmak-
ing. In the sixties, Hardy first saw Japanese-style tattooing at the
studio of Samuel Steward (who tattooed under the name Phil Spar-
row) in 1966 and learned much of his early tattooing from him.
Phil Sparrow's influence on contemporary tattooing cannot be over-
stated. Not only did he help train important artists like Ed Hardy
and Cliff Raven, thereby popularizing the Japanese aesthetic, but
he was probably the first out-of-the-closet gay tattooist, influencing
a whole generation of gay tattoo artists and tattoo fans.

After opening his first shop, Hardy decided he needed to learn more about tattooing and later spent time with Zeke Owens in Seattle. From there he moved to Doc Webb's studio in San Diego in 1969 and later opened his own shop there, specializing in Japanese designs. By now Hardy was corresponding with Sailor Jerry, whom he had contacted through Don Nolan. Through Sailor Jerry, Hardy met Kazuo Oguri and worked in Japan with him during 1973. In 1974 he opened Realistic Tattoo in San Francisco, the first custom-only, by-appointment studio in the United States. Realistic Tattoo was to serve as a model for aspiring tattooists all over the country who were interested in stretching the artistic borders of tattooing, as well as in reaching a new, more lucrative clientele.

Although Hardy is perhaps best known for his Japanese work, he also developed an eye for other kinds of promising tattoo styles. In 1977, he met Jack Rudy and Charlie Cartright, two East Los Angeles tattooists who did Chicano/prison-style tattooing and was so impressed by their work that he sponsored them. In 1978, he met Leo Zulueta and realized the power of the Indonesian "tribal" work that Zulueta was doing and sponsored him as well, making tribalism the focus of the first issue of his new magazine, *TattooTime*.

In 1982, Hardy, along with Ernie Carafa and Ed Nolte, staged the Tattoo Expo on the Queen Mary cruise ship, where he also launched *TattooTime*. This was the first tattoo magazine aimed at the middle class, published with the intent to correct the negative, overly sensationalistic view of tattooing held by most mainstream North Americans. Even though at that time the National Tattoo Association was sponsoring annual tattoo conventions, this was the first convention that included lectures and slide shows, and after that year, the NTA realized the potential benefits of offering an educational approach to tattooing and began including lectures at their events.

While Hardy's own tattoo work has been hugely influential in the history of North American tattooing,[3] his larger influence has come from documenting the trends in tattooing in such a way as to make tattooing palatable to the middle class. The tribal style of tattooing that Leo Zulueta spearheaded is one example of this, as is Japanese tattooing. After Hardy publicized them in *TattooTime*, both became extremely popular among the new middle-class clientele and served as a counterpoint to the traditional, sailor-style tattooing that was still being practiced in most U.S. shops. Japanese and tribal

tattooing were seen as artistically sophisticated, visually powerful, and culturally and spiritually vibrant, while traditional U.S. tattooing was seen as outdated and ignorant. Hardy offers an explanation for why North Americans have become attracted to non-Western tattoos:

> A lot of people that get that black graphic [tribal] work get a very elitist take on it and see themselves as somehow more refined than people who get pictures of things on themselves. . . . They romanticize it and they project it onto other people—they exoticize them. I think that's just part of the thing. You know, there's a lot of stuff that's taken from other cultures. That's why the Japanese stuff was such a big hit. There's still a lot of Asian imagery in tattooing. Besides the fact that it has good design qualities. (interview with author)

His own perspective on tattoos has changed in recent years, however: "I used to be like 'Japanese is the only way,' and I'd be snobbish about cartoons and stuff. You know, I'm now enjoying the real retro, just thick-headed American stuff and appreciating the beauty of it. It's kind of a backlash to the over-intellectualized stuff."

While Hardy now loves the retro appeal of classic Americana tattoos, many middle-class tattooists and their clients do not, preferring to work with modern designs, i.e., those that did not develop during the first half of this century in the United States. While North American tattooing owes its existence to the Polynesian cultures from which it was taken, during the Golden Age of Tattooing, it was primarily a U.S. art form. Yes, it was influenced by Japanese and Chinese tattooing via the work of Sailor Jerry or Pinky Yun, but it retained an American flavor throughout. It has only been since the eighties that elite American tattooing has moved so far from homegrown images and has so completely embraced non-Western designs and images.

While most of the changes I have been discussing occurred among West Coast tattooists—due to both California's and Hawaii's proximity to Japan and to the social climate in the West Coast in the seventies—innovations occurred on the East Coast as well. Shotsie Gorman, who worked with Spider Webb, a radical avant-garde tattooist in New York, provides a counterpoint to Hardy's history.

Gorman was a Manhattan sculptor when he befriended another

sculptor named Mike McCabe. McCabe was himself tattooed and in 1973, after accumulating a number of Japanese pieces, decided to start tattooing. His relationship with McCabe influenced Gorman to become both tattooed and a tattooist. Gorman discusses his early days as a tattooist:

> I started tattooing out of my loft. I did my first tattoo on Friday the thirteenth in 1978. It was October. It created a lot of nightmares, that first tattoo. It was a period of transition, and the kind of psychic rubble, if you will, that it digs up, it was pretty intense. I really didn't know what I was doing, I really hadn't had any formal training, I only knew from watching, so I sort of struggled around for about four to five months. So I finally went to California. I was well aware of Cliff Raven, who was the most avant-garde and most professional tattooist that I was aware of in the country. Through seeing his work on various friends and through the minimal media exposure that he had gotten, primarily through skin magazines — actually, I think the first article appeared in *Easyriders,* and then he appeared in *Gallery* or *Penthouse* or one of the more popular T and A magazines. So I went up to California to beg him for a job and at the time he had like four or five apprentices so he didn't really have room for me and also I didn't really have that much experience, although I had a really good portfolio other than tattooing, but he gave me a lot of encouragement, so I came back to New York and on his recommendation, I went to see Spider Webb for a job. (interview with author)

It says a lot about the state of tattooing at that time that Gorman, an accomplished artist who wanted to learn to tattoo, would travel to California to try to work with Cliff Raven, one of the few artists experimenting with innovative designs. Raven's suggestion that Gorman return to the East Coast to work with Spider Webb was, in my opinion, a decisive factor in the creation of the East Coast thread of contemporary tattooing. Webb (whose real name was Joseph Patrick O'Sullivan) was a conceptual artist as well as a tattooist and is well known for his public performances involving sex, drugs, and rock and roll. He once, for example, staged a public "tattoo-in" in front of city hall in New York City to protest the ban on tattooing. Gorman describes his experiences working with Webb:

Anyway, he took me on, gave me the keys to the store, introduced me to a woman he had working for him, her real name was Ellen but he called her Original Sin. . . . Ellen at the time had very little experience, she was really green in tattooing and I really wanted to learn, and Spider had quite a number of years under his belt, something like twenty years of tattooing, but he disappeared on me. He was out buying a house in Woodstock, so he said, "OK, you're running the shop." I didn't learn anything more than I knew working out of my loft except that I had a much higher volume of trade so I became sort of self-taught. I picked up some things by osmosis. Every time Spider came in to work, I soaked up every move he made, and tried to emulate it. Then he came back, he had bought his house, and he fired me. I said "Well, I didn't even learn anything. When are you gonna give me an apprenticeship?" He said, "You're on your own now, get the hell out." And I was out on my own. (interview with author)

Like a lot of other tattooists in those days, Gorman ended up being somewhat self-trained, which, given his artistic background, worked out well for him.

The aesthetic that I developed came out of my fine art interest, it wasn't out of what Spider was doing. He was doing primarily comic book type of tattoo art, which, by the way, is making a major comeback these days, so Spider's work has really come to the forefront again. My interest has always been in late Renaissance painting and more realist kind of painting and my sculptural interest was always very abstract so I guess my aesthetic was kind of built out of my desire to take tattooing and blend it with my perception about what good quality art was. I felt that there could be a market for that kind of tattooing. I saw that there was an option for it because there wasn't much going on in tattooing. By that time, by 1980, I started to get around and go to tattoo conventions. There was one in 1979 in Philadelphia and I started going to every tattoo convention, every event. The first tattoo convention I ever worked in was 1981, and they had these competitions for designs, and I won four awards for my design work, so I realized there was interest in what I was doing. (interview with author)

Like Hardy, Gorman's training was in fine arts, and he was attracted to tattooing once he saw the potential for moving beyond classic styles and images. Also like Hardy, Gorman was first impressed by Japanese-style tattooing and, through developing his own style, has made a major impact in this field. Gorman's experiences were different from those of many West Coast artists of the same period, however, in that the cultural milieu of tattooing on the East Coast has remained more traditional and far less open to the kinds of stylistic innovations that California or Hawaii has supported.

Since the 1970s, when Gorman began tattooing and when Ed Hardy and others found that they could use their fine art training to influence tattooing, there has been a large influx of middle-class, art school–trained young people entering the field of tattooing. While young people have always been drawn to tattooing and the aura of the tattoo shop, this new group of artists came to tattooing armed with art school theory; a sensibility formed through painting, sculpture, or photography; and a desire to radically transform tattooing. Through these artists, stylistic innovations were rapidly disseminated, the borders of the technology were tested, and styles moved in and out of fashion with a speed never before seen in tattooing.

## Chicano Tattoos, Tribalism, and the Problem with Americana

The 1970s and 1980s saw, in addition to the Japanese influence on U.S. tattooing, the development of two powerful new tattoo styles — Chicano-style tattooing and tribalism — that would have a major influence on the shape of contemporary tattooing.

Chicano-style tattooing refers to the fine-lined, monochromatic style of tattoo that had been prominent among gang members and convicts since at least the 1950s but which had never been used in traditional North American tattooing. In the 1980s, however, it was discovered by and embraced by the middle class. Here, we have a U.S.-made, yet marginalized, style being incorporated into elite tattooing. Again, Ed Hardy played a role in this transformation.

While Chicano tattooing had been practiced in the barrios of California, Arizona, and New Mexico, it had remained an exclu-

sively street form of tattoo, immediately distinguishable from classic American tattooing (by the thin lines, lack of color, and different imagery used) and practiced primarily by hand. Freddy Negrete and Jack Rudy, from East Los Angeles, were possibly the first professional tattooists working in this style in the late 1970s. They, along with Charlie Cartright, perfected this technically difficult style, bringing it to mainstream prominence. Because of the use of single needles, this type of work was more finely detailed than traditional tattoos, allowing the creation of finely shaded, "photo realistic," portraits on the skin. Ed Hardy was impressed by the work that these men were doing, and bought Good Time Charlie's Tattooland after Cartright stopped tattooing. Later, Rudy and Negrete moved into a different shop together, still with Hardy's support. Hardy liked the style so much that he opened Tattoo City in San Francisco's Mission District in 1975 with Bob Roberts in order to focus on just this kind of work. Ultimately he became disenchanted with the street scene and closed the shop, preferring to focus more on the middle-class clients who visited Realistic Tattoo, his custom-only studio. Rudy, who now runs the Tattooland chain, has since become internationally famous for his portraits and is one of a small number of "tattooists' tattooists"—tattooists who are sought out for work by other tattooists. One young tattooist told me, "If I want something that looks like I've been in San Quentin for ten years, I'm going to go to Jack Rudy, because that guy does single-needle, black-and-gray, fine-line work that looks like it came right out of the penitentiary. It's a look and a style. Jack Rudy does the best of that" (Tony L., tattooist).

Today, it is rare for a tattooist to use heavy needles for outlines, unless he or she is specifically trying to create an old-fashioned, traditional look (or a tribal tattoo; see below). Chicano-style tattooing, and its fine-lined technique, now serves as the basis for many newer trends in mainstream U.S. tattooing. Indeed, it has made possible many newer styles of tattooing, such as circuitry-based tattoos. The only places where this type of tattooing is still not popular are in street shops that cater to military clientele. Most sailors and soldiers do not want this sort of work, and many old-time tattooists refuse to do it because they do not feel that it holds up over time.

Not only have the technical elements of Chicano tattooing been embraced by the middle class, but the imagery has been as well.

The Virgin of Guadeloupe and the head of Christ have become favored motifs among the young middle class, and the Old English lettered loca, or gang or neighborhood of origin, has been adopted by middle-class white patrons and is translated onto their chests, necks, and stomachs in a simulation of Chicano street life. Perhaps the appeal of this style to the non-Chicano has something to do with its mystique and powerful imagery. As one white tattooist said to me, "There's something mysterious in a way about street life, and that's what I would associate that [kind of tattooing] with the most, street life. You know, you get your name tattooed on your back, and you're hard core. You get your gang on the front, your loca" (Alfonso B., tattooist).

The last major influence on modern tattooing is known as tribalism. Tattoo designs borrowed from places like Samoa, Borneo, Hawaii, and New Zealand have, since the 1970s, been extremely popular among members of the S/M and leather communities, and in the 1980s they became very fashionable among punks and middle-class youth as well. The man most responsible for the mainstream popularity of tribal tattooing is Leo Zulueta, a Hawaiian of Filipino descent, who began practicing tattooing under the tutelage of Ed Hardy. Zulueta credits Hardy for supporting his interest in pretechnological tattooing, which at that time (the late 1970s) was almost unheard of among mainstream tattooists. I know of only two other North American tattooists, Cliff Raven and Dan Thome, who were at that time interested in exploring Pacific tattoo styles, thus Hardy's support was critical to Zulueta.

Zulueta and I discussed his role in bringing tribal tattooing to mainstream prominence in the United States, and he shared with me some of his feelings on its enormous popularity: "I was real fortunate. I started tattooing a lot of punk rock people on the scene, and they were more into the more esoteric styles so I was able to do a lot of work early on in this vein. I'm definitely proud to say that I had a big part in creating this whole thing. Tribal tattooing is extremely popular now. I mean you can't go anywhere into any shop and not see some sort of trace of it which . . . makes me feel proud to see that, that it has had such impact." When I asked him if he saw any contradiction in the fact that middle-class white kids are the ones wearing this style of tattoo, he had this to say:

No, not at all, because for instance when I met Ed Hardy in the mid to late seventies he had by that time put on probably thirty or forty big Japanese back pieces on people, and these were all white people from America, and I just felt that it was more of an appreciation for this type of art, rather than they were trying to say, "I have this big back piece and now I'm Yakuza from Japan." It was more of an appreciation. As far as Ed goes, he's very much a student of Japanese art, and he's really into it, so that to me gave me license to do what I do. I feel it's more from an appreciation standpoint. . . . I have a lot of trouble accepting [it] when someone says to me, "Isn't that kind of contradictory, you have this big Micronesian back piece on you when you're not Micronesian?" Well, let's put it this way, I know for a fact that none of these guys that have the big Micronesian back tattoos are alive. I know this for a fact. Now that thing is gone. The minute you take their language away, that's it. If you take everything from their culture away, that's it, it's gone.

Zulueta here maintains that while it may look like appropriation by the white people wearing these non-Western designs, he sees it as a sign of admiration for a culture that no longer exists. He also states that his own use of the designs is not literal and that he uses the imagery as a springboard for his own creativity, which I feel indicates that he *is* uneasy about the possibly cannibalistic uses of non-Western tattoo forms by westerners.

Now I'm American firstly, and I realize that my whole thing with all this is I'm trying to burn the candle for it. No matter what color I am, I don't think it has any bearing on it at all, or if I'm from Micronesia or Borneo or any of these places where I'm taking these designs. I've never tried to take any of this stuff literally, I try to take it from a symbolic standpoint, because I know that'd be horribly wrong and disrespectful. I try to use the ancient imagery and use it as a springboard to launch into my own thing, which I've done over the years. The stuff that I do, mind you, it doesn't have any specific symbolism. I mean I tend to use the spiral a lot, that's the logo for my shop. I think that's an eternal symbol, encompassing all different cultures all over the world from ancient times, so I don't feel it's a rip-off for me to use that symbol, and the reason I brought it up is it's one of the symbols that people are particularly drawn to and when people ask

me why, I say it's one of the ancient symbols that refers to eternity and the everlasting cycle and the perpetual thing.

Here, Zulueta touches on the spiritual uses of non-Western tattoos and continues by discussing why North Americans, in particular, need the kinds of tattoos that he creates: "I know that in some countries like New Zealand, that would be horribly disrespectful to take a tattoo pattern from the Maori and try to reproduce it today. But here in the West, I think people are looking for more of a roots, or spiritual, no more than spiritual. . . . Here in the West we live in such a cultural wasteland such that people tend to gravitate toward things from the past." In chapter 6, we will see that many people share these sentiments and use the same language that Zulueta uses here to justify, and provide meanings for, their tattoos.

Zulueta feels strongly about preserving this art form for future generations and is well aware of the ironies inherent in non-Micronesian people wearing Micronesian tattoos. But for him, many of the original practitioners of this art form are dead and their cultures stripped from them, and he believes his role is to keep it alive for just a little longer. When I asked him if he saw himself as a sort of "salvage anthropologist," he responded:

I don't want to get that literal with it because I don't consider myself any sort of scientist or big cultural hero or anything. I'm just doing what I'm doing because I've got such a big love for it. . . . Once again, I grew up in Hawaii and I never saw any tattooing in the native style there as a child. It was all in the Western style, but you can't stamp it out of the place. When I was growing up in the fifties and sixties you'd see all kinds of kids in elementary school doing handmade tattoos because it's just basically on the rock, you can't get rid of it, it emanates. There's a Polynesian term called *mana*, it's a thing that you just can't erase, it just happens to be there. However we further it—my thing is to come from a respectful standpoint and further it—that's great. When I'm dead and gone, I just want to be known for, you know, well, the guy was just trying to further this stuff. That's basically it.

Zulueta's use of the word "mana" is interesting here. This illustrates an idea that, at least for some people (like those indigenous to Hawaii), tattooing is instinctive. This essentialist notion has be-

come very powerful today among many who practice tattooing, but especially among those who align themselves with the modern primitivist lifestyle.

But tribal tattooing carries other connotations as well. Since the mid-1980s, young people who want to start tattooing often execute their first pieces in the tribal style, because they think tribal tattoos are easy to make (since they use heavy black lines and heavy black shading, without a lot of detail). Thus tribal tattoos have, in many ways, now become the mark of the amateur tattooist, one who tattoos Borneo- or Kwakiutl-inspired designs on his friends for no cost. This is one reason why punk tattoos are so heavily weighted toward tribalism. As Daniel Wojcik points out, punks in the seventies and eighties prided themselves on creating their own body adornments, so they cut and dyed their own hair, created their own fashion styles, and pierced and tattooed their bodies themselves (Wojcik 1995). Tribal tattoos, supposedly easy to execute, with their bold and abstract designs, were a perfect choice.

Although tribal tattoos were once the ultimate elite, non-Western tattoo, they have become for many (who know how to read such tattoos) simply a relic of an earlier era. This is illustrative of how quickly tattoo trends flare and then fade. One tattooist told me that when he sees tribal tattoos, rather than noting how innovative and original the wearer is, he thinks, "Oh yeah, you got those tattoos in the 1980s." Zulueta's response to this is ambiguous: "I do realize what you're saying because there is a certain amount of faddish, fashionable type of thing going on. There is that aspect to my work—it has gotten trendy, fashionable. It's a difficult thing for me to say, but it's really not a good feeling when I see a person sitting there and just getting it so they could go on down to the nightclub and be the big guy on the weekend." He continues,

> The tribal thing has had a tremendous impact on the tattoo world. You see bikers now with tribal stuff on their T-shirts, and tribal around their older tattoos, and you know, I'm not sure how I feel about that, actually [laughs]. It's really gotten mainstream. In some ways, it's disheartening, but in other ways, I'm proud to say that I have played a big part in that. You know thirteen, fourteen years ago when I was working in my first tattoo shop, these people would come into shop and say, "What's all this black stuff?" and I'd say,

"well, it's based on Polynesian art" and they'd go, "poly what?" You know, it really has opened up a lot of people's eyes.

Non-Western designs, technology, and styles have firmly uprooted traditional tattoo designs for most middle-class North Americans. There are aesthetic reasons for this as many of these designs simply make good tattoos, but there are political reasons as well, which I argue involve repudiating a working-class, white-bread past. In addition to tribal, Japanese, and Chicano styles, other tattooists are experimenting with Celtic designs,[4] Sanskrit lettering, Native American (especially Northwest Indian) images, and Egyptian art. Leo Zulueta speaks for many North American tattooists when he says, "Years ago when I met Ed Hardy I realized that there was so much more. Once I met him I realized it wasn't just the standard issue. And mind you, I have a tremendous love for classic Western patterns, and I have some of it tattooed on me. But nonetheless, there are more possibilities out there and I think the tribal thing has opened people's eyes to that in a big way. You don't have to get the old stuff anymore."

*You don't have to get the old stuff anymore.* Tattooists are no longer limited by Western imagery, and many have, in fact, completely repudiated it in favor of the more exotic, spiritual, or sophisticated non-Western designs.[5] Ironically, this would come as an unhappy surprise to Sailor Jerry Collins, who was the individual first responsible for bringing non-Western imagery and technique to U.S. tattooing. Collins wanted to *outdo* the Japanese by using their styles in a uniquely American way to express North American fantasies, yet what has occurred is that the fantasies expressed in traditional tattooing are no more. Where is today's version of the Rock of Ages or the Rose of No-Man's-Land? These classic American tattoos have been replaced by a more "authentic" tattoo, one which distances the wearer from his or her white, American, middle-class standing—a position that is simultaneously confirmed and rejected through the tattoos. It is confirmed because to wear tribal or Japanese tattoos is to mark one as middle class, educated, and artistically sophisticated; yet it is rejected, because for many the non-Western tattoo is a way to rebel against middle-class values. The irony here

is that neither tribal tattoos nor the Chicano tattoos that have recently become popular among whites originated in the middle class — tribal tattoos were first worn by punks and gays, and Chicano tattoos were worn by Chicanos and convicts. Yet they have become popularized through middle-class wear, and the tribal tattoo, at least for a while, stood with the Japanese tattoo as the ultimate middle-class adornment.

The repudiation of the lower-class roots of North American tattooing has brought it into the present and into the middle class. Without such a complete overhaul of the visual imagery of tattooing, it is doubtful that it would have ever appealed to the middle class, and thus would have remained where it began — as a working-class tradition. As Arnold Rubin puts it, "One can escape to a simpler time and more straightforward values by putting on the marks of a Maori chief, a North African courtesan, a pirate, an Indonesian headhunter, a Japanese samurai, an outlaw motorcyclist, a Scythian warrior, a Buddhist monk, or a twenty-first century time-traveler" (1988b:255).

In addition to borrowing tattoo designs from other cultures, a number of different tattoos have been created to *look like* non-Western tattooing. Mike Malone designed a tattoo style in the 1970s called the "Hawaiian Band" that is a tribal-looking design made to wrap around the arm. He writes: "the 'Hawaiian band' design thing I started doing in the seventies has gotten so popular — and I recently saw it on figures in this Herb Kane painting, he's a famous painter of Hawaiian historical scenes [and in] work in *National Geographic* and all that . . . and those designs have no historical basis, they just looked good to me. I make up a lot of malarkey about what the symbols mean in 'em and people love 'em. So there'll be a traditional Hawaiian tattoo style from now on anyway" (Malone 1991:65). Not only do native Hawaiians wear these tattoos, created by a white man in the 1970s, but Malone has seen his "Hawaiian" tattoo appear in the *National Geographic* as a representation of traditional Hawaiian tattooing! This is similar to the Peace Corps tattoos that developed in Samoa as souvenir tattoos for white Peace Corps volunteers but that later became popular with Samoans as well (Sulu'ape 1991). These are examples of how the natives and the colonizers influenced each other. This interaction began in the

eighteenth century when Captain Cook and his expeditions not only brought tattooing, and tattooed natives, home with him but also directly influenced Polynesian tattoo practices by tattooing the natives and introducing Western designs into the local iconography.

## *Tattooing Today*

In addition the changes in tattooing that have occurred since the 1970s—the increasing numbers of middle-class clients, the professionalization of tattooing, and the new reliance on non-Western images and styles—other elements distinguish traditional North American tattoos from those popular with middle-class customers. Two of these are flash and names. Contemporary tattooists prefer to do custom work, that is, using designs that have been created by them, usually with the help of the client, rather than using the flash taken directly off the wall. While there are still far more street shops than custom-only shops in this country, most tattooists who have started tattooing since the eighties try to do as little flash work as possible and encourage their customers to design their own tattoos. One college-town tattooist who prefers custom work says,

> Usually when they look at the flash, it's just "eye time," something pretty to look at. Your brain is already kind of formulating what you want. . . . More people want custom work. They want more individual stuff. Years and years and years ago, it almost didn't matter what you got, you just had the mark on you. Now, it's not so much having the mark on you, it's What kind of marks do you want? because there is so much to choose from. People are really crying out, "I am an individual, I want to be an individual. I don't want something that somebody else has. I don't want this flash crap on the wall because, if it's up here on the walls, eight hundred million other people have that design." (Troy S., tattooist)

A second, and related, change in contemporary tattooing is the current negativity associated with tattooing names. Names of loved ones were once a major part of a tattooist's daily bread and butter, but names are almost universally scorned today by custom tattooists. Names are seen to represent the impulsive, shortsighted, artis-

tically unsophisticated working-class customer, because only such a person would have one's boyfriend or girlfriend, or even spouse, tattooed onto their bodies forever. One tattooist who has a no-name policy described to me two scenarios, which I believe are commonly experienced by many tattooists, illustrating why he would in the first case and not in the second, tattoo a name on someone.

This is a fifty-four-year-old man who's been doing his particular career, whatever it might be, for the last twenty-three years. Two more years, he might consider retirement. He's got his wife that he's lived with for the last thirty-four years. He's got two kids that are married with their own children and gone. He's kind of short, stocky, drinks beer in the evenings when he gets off work and says "I want my wife's name tattooed on me." I don't talk him out of it. I say, "Yes sir, how would you like this tattoo?" I get a nineteen-year-old kid in here, who's, like, got this hot-looking blonde under his arm. He's kind of a macho-looking guy, and he pulls up in a 280ZX, or whatever, and he's like "Yo! Yo! Betty-Jo, right here on my chest, man!" I'm like, "Well, look. You got any tattoos?"
"No, I sure don't!"
"Well, uh, what does the girl really like, you know, what is she really fond of, some kind of an association?"
"She really loves unicorns!"
"Fine! Get the really . . . stupid unicorn on your chest!"
OK, cool. I've talked him out of the name. (Sam F., tattooist)

The following tattooist, a young, college-educated artist, said this about names, "There's such a fine line between decoration and desecration. Your body is a temple, so don't desecrate it by writing other people's names on it, like people do with spray cans [on walls]" (Kevin C., tattooist). This notion that the body is a temple to be decorated (not desecrated) is a common sentiment I have heard from a number of middle-class informants. But many working-class and traditional tattooists are not crazy about names either: "I've seen the guys with names . . . and I've covered them up. Tattooed them on, covered them up a couple of weeks later" (Tommy T., tattooist). For many tattooists working in small towns, rural areas, or near an army or navy base, a name tattoo is an integral part of the tattooist's trade. But for young or middle-class tattooists

or those who work on the West Coast or in a major metropolitan area, names represent an outmoded and unsophisticated approach to tattooing.

How tattooists enter the profession has also changed over the years. Although it once was typical for new tattooists to apprentice with an experienced tattooist, learning the trade slowly, young tattooists today order a machine and some basic equipment from a tattoo supplier and get started on their own. One of the reasons for this is the proliferation of young wanna-be tattooists and the shortage of older tattooists to train with. Additionally, many young tattooists come out of art school thinking that since they can already draw (or paint or sculpt), they do not need to learn how to tattoo — and certainly not from an old-timer. Many old-time tattooists feel that the decline of the traditional apprenticeship system is one of the saddest changes in modern tattooing. Many tattooists today, for example, do not know how to build their own machines, mix their own inks, or fix equipment when it breaks — all integral skills of the trade. These new tattooists must rely instead on the tattoo supply companies that sell finished machines (which start at $200 each for liners and shaders), flash, and ink to anyone who wants to buy it. These companies advertise in tattoo and biker magazines, and at tattoo conventions but unfortunately do not supply instructions with their equipment. The following tattooists offer their perspectives on this change.

All the tattooists today buy that stuff. I think it's common now. I mean it's rare that people are in this anymore who have a thorough grounding in all the aspects of pigments and aspects of how machines work. They don't know the equipment anymore — no one does. Even the guys here in my shop don't know. It's gone. There's just very few people left who know that stuff. (Norman P., tattooist)

Back then, tattooers were folk artists. You know. Of course, they're folk artists today, 'cause you just tattoo folks, but the old-timers, you know, they built their own tattoo equipment, and some of them were more interested in colors, in the pigments, than in equipment so they had a symbiotic relationship with each other. (Jack H., tattooist)

You know, it's like a mail-order art now. Before, they were craftsmen and they built their own equipment and made their own pigment

and everything. There was suppliers, but they were small potatoes compared to what goes on today. I travel a lot and I go to tattoo shops all over the world and a lot of them, they got suppliers' catalogs in their waiting room! You know, they haven't got a goddamn clue! (Larry H., tattooist)

Today, everyone wants to tattoo, and worse (according to older tattooists), everyone thinks they *can* tattoo. They do not realize the amount of work it takes to learn to tattoo, how a machine works, how to mix inks, and how to reproduce a drawing on paper that looks good on skin. While many people assume that the hordes of art school–trained graduates now entering the tattoo profession are a good thing, it is rarely acknowledged (for instance, in media accounts of tattooing) that their lack of technical training is a problem. One day, I had an exchange with Scott, a tattooist in his midthirties, who was alarmed at the number of people tattooing today.

Scott said, "It's changing a lot. You know, everybody is getting tattooed these days. When I first started out—I haven't been tattooing that long, I've been tattooing thirteen years—but when I first started tattooing, you know I knew all the people who were tattooing in the country, and now I don't know hardly any of them anymore. It's OK for these young people to get started and everything, but shit, there's just a million people tattooing and everything. I'm surprised YOU don't tattoo! You probably will next year!"

"Actually, I did do a couple of primitive tattoos on my ex-husband, who's a tattooist, a few years ago," I responded, embarrassed. I didn't want him to think that I thought I was a tattooist, or that tattooing was easy for me (it's not).

"Well there you go, you tattoo, too! You probably tattoo better than I do!" he said with a laugh.

I got my first tattoo in 1977. I had just turned eighteen years old. I was in the navy—I had joined at age seventeen. It was a small one. I got two small ones to start with for the first couple of years that I was in. Then I went to Japan. I was stationed there a couple of years, and I didn't get any tattoos there. At that time it was very hard to find a tattooist in Japan and so I waited and when I got out of the navy I went into the Merchant Marines and I got a chance to be at a lot of ports in America so I started getting tattoos on various parts of my body,

small ones, but I knew that I wanted to get a full bodysuit eventually. In 1982 I started talking to some tattooists and figured out that the way I was doing it was a screwed-up way, by getting them one at a time and mismatching, trying to get some here and there and connect it all together. In 1986 I became pretty close friends with Pat S. He's a very well-known tattooist from Albuquerque and he gave me some input on how to do this. He gave me a cohesive plan. I base my vacations on going to tattooists to get tattoo work, and I specifically only get the Japanese style because to me that is the real style of tattooing. Having been a sailor and having been to Japan, I just love the Japanese philosophy. I read extensively on Japanese myths, mythology, folk stories, any legends — to me it's fascinating. I pick out of those stories the elements that I really love or are really powerful and I try and incorporate them, only through artists who understand the philosophy. I'm not into fads, I'm not into New Age style or tribal or any of this other stuff that is very nice and unique and I admire it, but I myself only want hard-core Japanese stuff. I have a complete vision of what my body's going to be when I'm done and that is what I'm working toward. (Spade T.)

Spade started his career as a sailor, collecting American-style (small, independent, badgelike designs) tattoos at his various ports of call. Later, as he began to realize the potential in tattooing, he decided to focus on acquiring only Japanese work until he ended up with a full bodysuit and an entirely different approach to tattooing. This story, to me, embodies all the changes in tattooing in the United States that I have discussed in this chapter and anticipates some of the changes I will discuss in the next three chapters: how the meaning of tattooing has changed.

The transformation from traditional, working-class tattooing to the modern, middle-class-dominated profession is far from complete. I would estimate that the majority of tattoos given and received today are still based on North American images and flash. However, if your perception of tattooing comes from media accounts, you would probably think that tattooing today is an exclusively middle-class phenomenon. The next chapter examines how tattooing has changed in the public eye through media representations of tattooing and the participation of tattoo organizations.

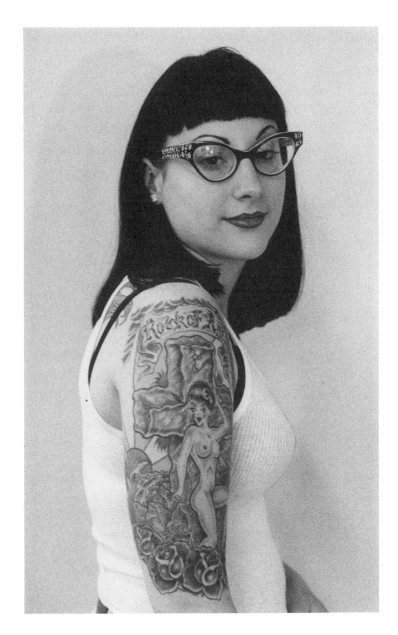

Sumer Barry tattooed by Don Juan. *Photo by Vida Pavesich.*

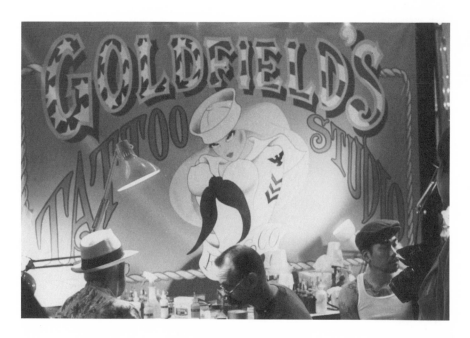

Tattooists and their wares. Goldfield's Tattoo Studio booth at Tattoo Tour, San Francisco, California, October 1997. *Photo by Vida Pavesich.*

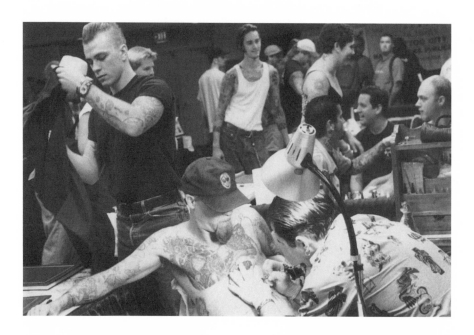

Tattoo Convention. Tattoo Tour, San Francisco, California, October 1997. *Photo by Vida Pavesich.*

Turn-of-the-century flash sheet by Gus Wagner. Collection of Alan Govenar.
*Courtesy of Paul Rogers Tattoo Research Center.*

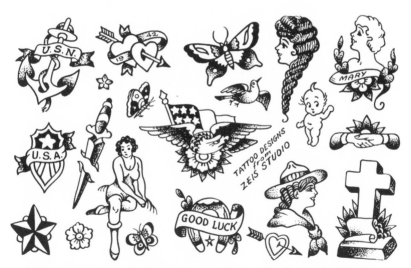

**HOW TO DO HAND TATTOOING**
Shave the hair where the tattoo is to be placed and rub a little Mentholatum over the shaved spot. Wet this place and take the paper stencil and press on firmly. You now have the outline ready to start with the tattoo instrument.
Hold the instrument in the right hand and hold like you would a pencil, placing the little finger right below the stencil impression, this giving the right position

for holding the needles. Stretch the skin tight with the left hand and you are ready to begin.
For outlining, hold needles almost perpendicular and puncture the skin rapidly but taking care not to dig into the flesh. For black shading and colors, hold needles on a slant and take care not to draw blood as it will make the ink come out.
Take everything slow and always keep your needles clean. After you have finished a tattoo, wash it off with cold water, then dry and rub Mentholatum over tattoo. It should take from 4 to 7 days to heal.

Page from *Zeis School of Tattooing Home Study Course.*
*Courtesy of Tattoo Archive.*

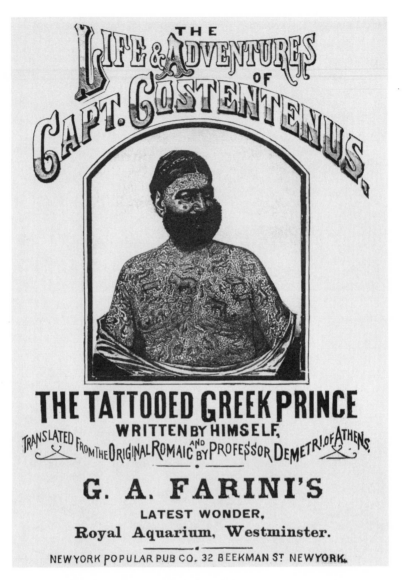

Cover of a handbill telling Prince Constantine's life story. *Courtesy of Tattoo Archive.*

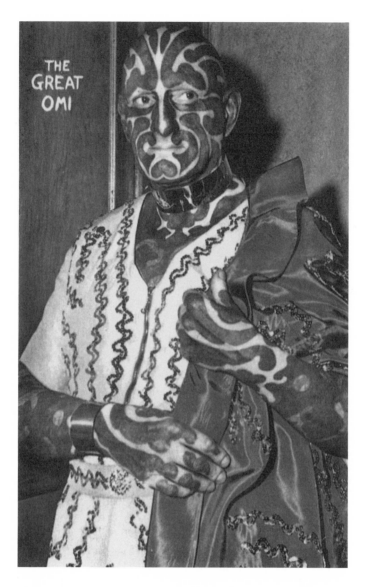

The Great Omi, tattooed by George Burchett in the 1930s.
*Courtesy of Tattoo Archive.*

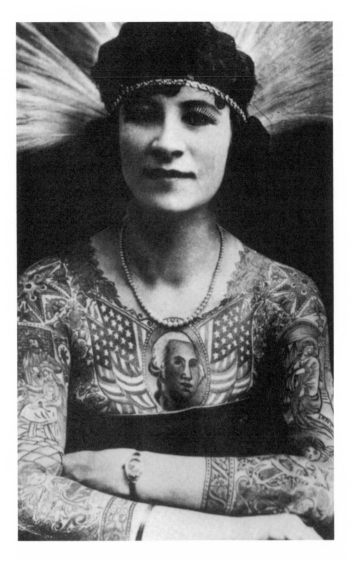

Artoria Gibbons, tattooed by her husband, Red Gibbons, in the 1920s. *Courtesy of Tattoo Archive.*

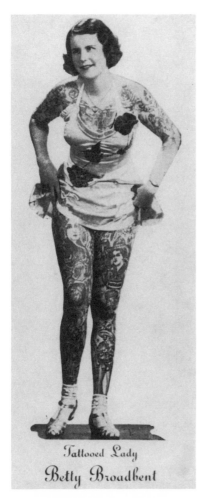

Tattooed Lady
**Betty Broadbent**

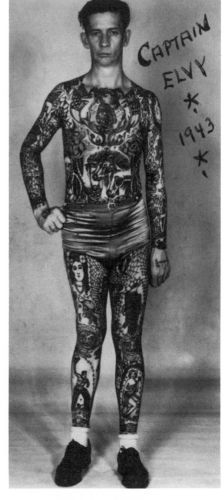

*(Above)* Betty Broadbent pitch card, 1940s. Tattooed by Charlie Wagner, Van Hart, and Bert Grimm. *Courtesy of Tattoo Archive.*

*(Right)* Mid-Century Tattooing. Captain Elvy tattooed by Sailor George Fosdick. *Courtesy of Tattoo Archive.*

BY: D. K. LEWIS
TATTOOIST
FOLSOM, CALIFORNIA

*(Left)* Flash created by prison tattooist Dave Lewis at Folsom State Penitentiary.

*(Below)* Contemporary Mexican flash sheet by Doktor Lakra. *Courtesy of Tattoo Archive.*

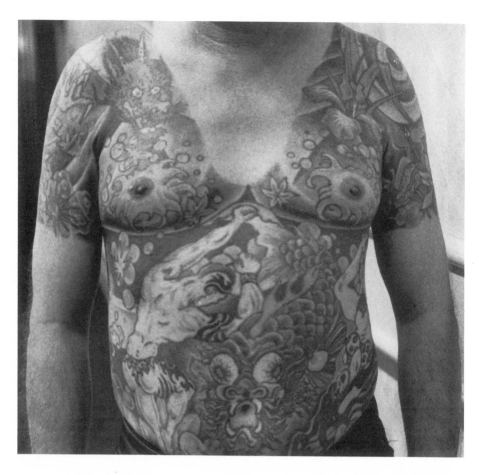

Tattoo by Cliff Raven. *Photo by Vida Pavesich.*

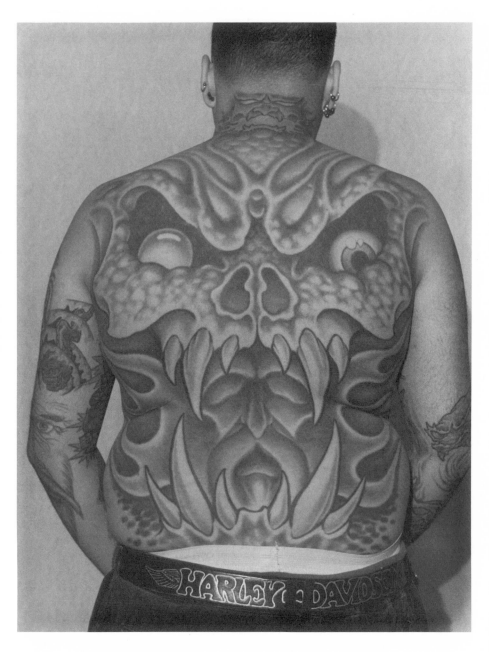

Tony Notoes tattooed by Jack Rudy.

*Photo by Vida Pavesich.*

Bill Ehlert tattooed by Da Wei Zhang.

*Photo by Vida Pavesich.*

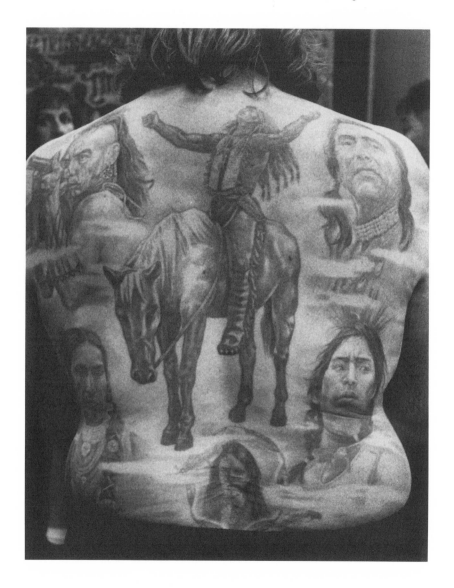

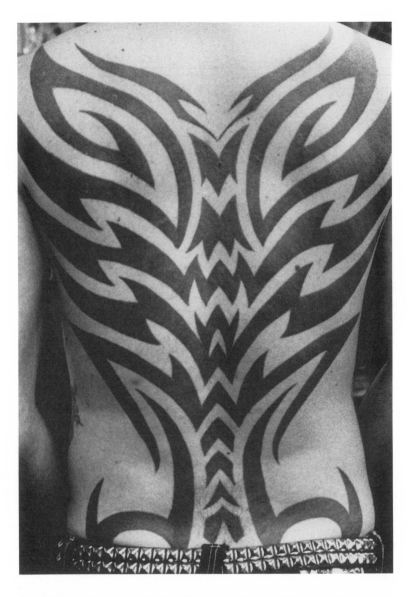

Jared Reynolds tattooed by Leo Zulueta. *Photo by Vida Pavesich.*

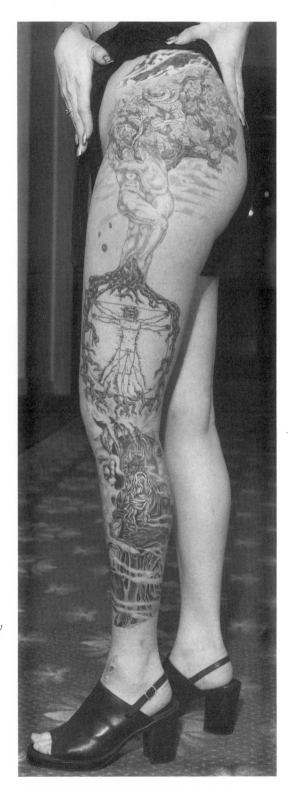

Ann Berke tattooed by
Vince Almanza. *Photo by
Vida Pavesich.*

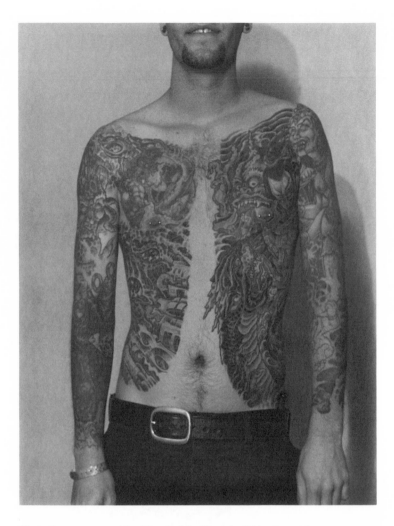

Chris Rupp tattooed by Tim Lehi. *Photo by Vida Pavesich.*

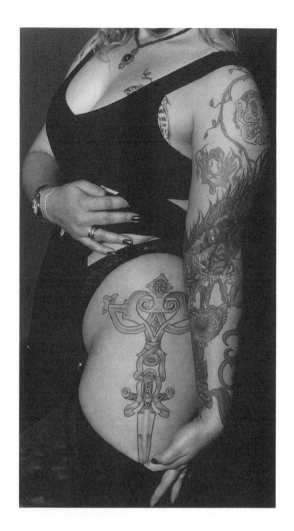

Jessica Hayes tattooed by Natasha Robinson and Tony Denning. *Photo by Vida Pavesich.*

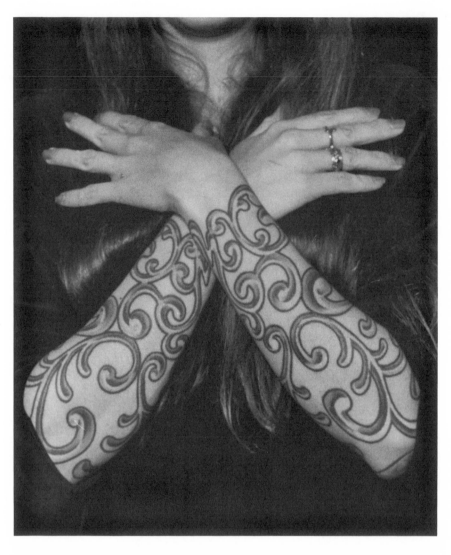

Andrea Bachtell tattooed by Mike Davis. *Photo by Vida Pavesich.*

# Discourse and Differentiation

## Media Representation and Tattoo

## Organizations

Tattooing is no longer the province of the weird. — Jon Anderson,

*Chicago Tribune, October 6, 1994*

Most are middle-class, educated and professional; family people.

— Joanne McCubrey, *Mountain Democrat, February 9, 1990*

As tattooing moved deeper into the middle class in the 1980s, new spokespeople emerged, including influential tattoo artists, tattoo magazine editors, and tattoo organization representatives. They began to define it in ways that increasingly emphasized the newer aspects of tattooing—its more sophisticated, artistic, and meaningful aspects and the increasing professionalism of a new generation of young, mostly middle-class tattoo artists. At the same time, these spokespeople worked to distance modern tattooing from its working-class history.

In this chapter I argue that the class basis and connotations of tattooing—both as art form and as social practice—have been transformed through media discourse. I will discuss the ways in which the mainstream press, tattoo magazines (both highbrow and lowbrow), and tattoo organizations all participate in creating a hier-

archy within a community that imagines itself to be antihierarchical. I argue that the media discourse (whether mainstream or produced by tattooists) is a controlling factor by silencing some voices while amplifying others. Media accounts of tattooing, perhaps more than any other form of discourse, have actually helped produce the conditions described in this book.

This chapter identifies the levels of stratification in the world of tattooing and concludes with a discussion of prison tattooing, which occupies the lowest level of the hierarchy and reflects the alienating lack of communitas within the tattoo community. I conclude that the tattoo community actually consists of two cultures, in two bodies, marked primarily by class and status.

## *The Mainstream Press*

The mainstream press exerts a heavy influence on the tattoo community and on the nontattooed who read about and see images of tattooing in women's magazines, men's magazines, local newspapers, and even the *Wall Street Journal*. All of these media ventures distinguish the new tattoo community from its origins through a highly selective and standardized presentation of what tattooed people are like.

*"Not Just for Bikers Anymore"* ➤ Standard magazine and newspaper treatments of tattooing tend to rely on some repetitive formulas and focus on four basic story lines: tattoo artists, tattooed people, tattoo-related events, and tattooing as a new and interesting trend. Most of the articles also use similar themes and rhetorical devices. Whatever the focus, the writer almost always asserts that tattooing is no longer a disreputable enterprise and that today's tattoo artists and customers are much more different than they were in earlier times. Here are just a few examples of how journalists emphasize the new respectability theme:

> This is no "underground" community, no dark den of drunken sailors initiating themselves into manhood via cheap, ill-conceived exercises in bodily perforation; it's just a group of people who delight in using their bodies as billboards. (Joanne McCubrey, "Walking

Art: Tattoos," *Mountain Democrat Weekend* magazine, February 9, 1990)

Tattoos, once the province of sailors, bikers, and convicts, have been moving into the mainstream, bringing new profits to tattoo parlors and even attracting attention from art museums. (Robyn Meredith, "Tattoo Art Gains Color and Appeal, Despite Risk," *New York Times,* March 15, 1997)

Tattooing, once only seen on bikers or drunken sailors, is the latest among middle-class, educated young women like McCray who wouldn't know a Harley from a Kawasaki. (Jennifer Bojorquez, "Body Images," *Sacramento Bee,* July 10, 1992)

Tattoo. What a loaded word it is, rife with associations to goons, goofs, bikers, tribal warriors, carnival artists, drunken sailors and floozies. (Jon Anderson, "Epidermal Dalis," *Chicago Tribune,* October 6, 1994)

Typical media accounts underscore the contrast between bikers, sailors, and convicts (who *used* to get tattooed) and educated professionals. Mainstream media rhetoric about tattooing blurs the lines between sailors, bikers, and gang members, who all wear different kinds of tattoos and who wear them for different reasons. By blurring the lines, the media create an image in which the stereotypical tattoo wearer can be easily defined as low-class trash and, by implication, easily disregarded.[1]

Returning to the process of differentiation found in mainstream press accounts, the next part in a typical article asks: Who gets tattooed today? Again, certain conventions are used repeatedly, the dominant one being the emphasis on the white-collar careers of modern tattoo wearers. Tattoo customers named in typical media treatments include a large number of doctors, lawyers, and Ph.D.'s. There are frequent mentions of tattoo artists who hold the prestigious Master of Fine Arts (M.F.A.) degree. Both artists and customers are portrayed as highly educated, thus emphasizing the new professional, upwardly mobile class base of the tattoo community. Below are some typical media descriptions:

Here [at the Living Arts Association Fourth Annual Tattoo Show] the biker has been joined by the doctor, the banker and the housewife in

the tattooist's chair. (Rachel Orvino, "Pins and Needles," *Sacramento News and Review*, June 18, 1992)

The new tattoo advocates are informed, articulate and no stranger than anyone you're likely to meet. Indeed, you've already met them, since they represent every aspect of society, from mechanics and waitresses to doctors and lawyers. (Victoria Lautman [author of the new book *The New Tattoo*] quoted in "Epidermal Dalis," by Jon Anderson, *Chicago Tribune*, October 6, 1994)

Hardy shows slides of a St. Louis banker who has a tattoo of a hot-air balloon on his back and a Dallas doctor who is having scenes from a Wagnerian opera placed all over his body. (Mike McAulliffe, "Body by Hardy," *Fremont Argus*, February 19, 1990)

Sideshow tattoos adorn models and stockbrokers alike. (Eric Perret, "Urban Savages," *Esquire Gentleman*, fall 1993)

Finally, what typifies mainstream articles is the choice of people interviewed. Bikers and other non-middle-class tattoo wearers are usually not interviewed and are thus silenced by this exclusion. Those who are interviewed include students, secretaries, artists, teachers (although, oddly, doctors and lawyers are rarely interviewed), and other members of the middle class considered respectable. The interviews convey the idea that tattoos are meaningful, well thought out, and palatable from a middle-class perspective. The interviewees tend to emphasize themes drawn from self-help, New Age, or feminism discourses to explain their tattoos, as the following example demonstrates: "Wayne B.'s attitude toward tattoos is one of great mysticism. Every tattoo on his well-covered body means something to him. . . . 'For me, it's very spiritual . . . I wear them for balance in life and in the universe'" (Rachel Orvino, "Pins and Needles," *Sacramento News and Review*, June 18, 1992). Statements like this greatly influence how tattooing is currently defined and understood by the general public, and in chapter 6 I will discuss the importance of media discourse in detail.

After the mainstream press, tattoo magazines are the second most powerful means of differentiating the community of tattoo wearers by class and status. Although individual tattoo magazines have small circulations, their combined readership is large. Most people who think of themselves as part of the tattoo community read at least one tattoo magazine on a regular basis. The magazines are particularly influential because many are produced by fellow tattooists and tattoo wearers and carry much greater authority than do publications or articles produced by outside observers.

Tattoo magazines themselves can be divided into two broad categories: biker and nonbiker, or lowbrow and highbrow, respectively. I base this distinction not on the readership (as it is blurred in both categories) but on the editorial content, which is determined by the publisher.

*Tattoo* is one of the two leading magazines in what I call the biker (or lowbrow) category.[2] It is published by Paisano Publications, the same company that publishes *Easyriders* magazine (the world's leading Harley-Davidson magazine) as well as *Biker* and *In The Wind*. The other main biker magazine, *Tattoo Revue*, is published by Outlaw Biker Enterprises, which publishes the prominent *Outlaw Biker* magazine.

Among the most influential highbrow tattoo magazines (and also the first created) are *Tattoo Advocate* and *TattooTime*, both published by middle-class, professionally trained tattoo artists. Other highbrow tattoo magazines include *International Tattoo Art*, *Tattoo World*, and *Tattoo Ink*, all of which are aimed at a middle-class audience.

The highbrow magazines differ from the biker magazines in a number of important ways. Most importantly, all of the former seek to legitimate tattooing by investing it with middle-class cultural capital (Bourdieu 1984). By this I refer to the magazines' heavy reliance on references to the fine arts (painting, drawing, sculpture, photography, as well as literature and poetry), to academic disciplines (specifically, anthropology, philosophy, art history, and medicine), and to mainstream journalism. Many of the highbrow maga-

zines include fiction and reviews of books and videos. Virtually all include "academic" articles—either written by scholars with known interests in tattooing (Clinton Sanders, Alan Govenar, Tricia Allen, Mike McCabe) or by nonscholars with an academic perspective.

Many of the photographs found in highbrow tattoo magazines come from photographers well known outside of the tattoo community (Dianne Mansfield, Richard Todd, Peter Dasilva, Dale May). Magazine pages have high-quality photos of "fine art" tattoos, and the names of the tattoo artists are listed. *Tattoo Ink*, for example, prides itself on its policy "never to run a photo of any artist's work with an 'Artist Unknown' credit. It's taken some magazines years to make this a policy and others still flagrantly ignore it" (March 1994). In fact, the policy of crediting artists represents a huge leap from the days when tattooing was seen as a folk art or trade, to today when tattooists are considered to be artists who claim personal authorship over their work. As one reader notes in a letter to *International Tattoo Art,* "It really rankles my ass when I see how some so-called tattoo publications regularly fail to give adequate credit to the tattooist who did the work in the pictures they publish" (Malcom, "Letters to the Editor," no. 4, 1993)

In another distinctive policy, the highbrow tattoo magazines do not accept advertising from tattoo suppliers. The more professional artists think that suppliers encourage "scratchers" (untrained, unprofessional, and potentially dangerous tattooists) because suppliers will sell equipment to anyone who sends money, whether or not they are competently trained to tattoo.

Finally, the highbrow magazines (at least in the eighties and early nineties) have always *looked* different from the biker-oriented magazines. Besides the high-quality color photographs shown in the highbrow magazines, the paper itself has been of a higher quality, and newsprint is never used. Highbrow magazines also tend to use fewer sexually explicit photos, and motorcycle and biker tattoos are never seen.

By excluding working-class images from their pages (except when they become middle-class fashion, as traditional sailor images and gang-style lettering recently have become), by employing higher production values, and by naming artists and excluding commercial suppliers, the publishers of highbrow tattoo magazines widen the chasm separating the classes within the tattoo community. As

Bourdieu writes, "Art and cultural consumption are predisposed, consciously and deliberately or not, to fulfill a social function of legitimating social differences" (Bourdieu 1984:7). The function of the highbrow tattoo magazines is clear: to define and legitimate the differences between contemporary, middle-class versus working-class tattooing.

*TattooTime*, published on an irregular basis since 1982, was the first of the middle-class tattoo magazines to appear, and it is aimed specifically at an educated audience. The editor and publisher, Don Ed Hardy, is a fine art–trained tattooist with a B.F.A. from the San Francisco Art Institute. He maintains that *TattooTime* is not a "fan magazine." In other words, it is for readers who take tattooing very seriously. The photos are extremely high quality, the articles are serious, and there are no advertisements, letters to the editor, or fan interviews. The emphasis in *TattooTime* is on the art, history, and cross-cultural perspectives of tattooing. *TattooTime* includes articles on historical figures in North American tattooing (Sailor Jerry, Paul Rogers, Pinky Yun, Bob Shaw), classic American tattoos (name tattoos, Christian tattoos, sailor tattoos, Rock of Ages tattoos, dragon tattoos), and tattooing styles from around the world (Borneo, Samoa, Hawaii, Japan) as well as showcasing contemporary artists and styles.

*TattooTime*, unlike the other highbrow magazines that have emerged since the mid-1980s, does not criticize traditional tattoo styles and thus does not explicitly contribute to the differentiation of middle-class tattooing from working-class tattooing, but it does contribute to the current elitism surrounding middle-class tattooing. The price of a single issue of *TattooTime*—twenty dollars—narrows its readership to those of an upscale socioeconomic status, and the production values, artists featured, and educational content clearly illustrate its middle-class appeal. But beyond its highbrow aesthetic, *TattooTime* has contributed to a middle-class discourse around tattooing in another respect: *TattooTime* was the first magazine to treat tattooing from a cross-cultural perspective, and thus it was the first to suggest that readers use non-Western images in their tattoos. Through its coverage of art and culture from Borneo, Japan, and Samoa, *TattooTime* conveyed—however unintentionally—to its readers that the values and mythologies of these cultures may be appropriated to provide meaning for their own tattoos.

In a discussion of *TattooTime*'s influence on tattooing, publisher Hardy refers to his magazine's introduction of foreign cultural influences:

I think that the magazine was a spark, it was a way to alert people to the potential of what tattooing was. I meet people all the time who started tattooing because they saw *TattooTime*—Freddy Corbin started tattooing because he saw it. Mike McCabe in New York started tattooing because he saw it, too. Those are the kind of things that make me feel good, having that impact. That issue number one, "The New Tribalism," you know with reprints and everything, there's probably twelve or fifteen thousand of those out there now, so it had a huge impact. In some ways I feel like I created a Frankenstein, but in other ways, I wanted some awareness of tattooing's potential, and I still feel that way. . . .

I had that first issue out at the Tattoo Expo I put together on the Queen Mary in 1982, and next spring I went to a tattoo convention in Reno or Arizona, that National [Tattoo Association] had, and people were walking up and saying, "Hey, check out the tribalism" I did, and I kind of went, "oh, shit." People liked having the jargon, they liked having the identifiable stuff. I guess in that sense I formalized it, even if it was just a half-assed shot in the dark, because no one had done it before, especially from inside of the business.

Hardy calls the magazine a "Frankenstein" because he first publicized tribal tattooing in the straight middle-class community, and it quickly spun out of his control. Although *TattooTime* initially was not widely circulated, the first issue, "The New Tribalism" (1982), has since become a point of convergence for many members of the new community. As Hardy mentioned, that single issue influenced a tremendous number of people to go out and create or receive tribal tattoos. It set the stage for the entire tribalism movement in tattooing and generated an accompanying "us versus them" exclusivity. Hardy also points out that his magazine was produced "from inside of the business." Here he reinforces the borders of the community, by referring to professional tattooists as "inside" and everyone else, by implication, as "outside."

The second highbrow tattoo magazine to appear (but the first with a regular distribution) was *Tattoo Advocate*. This was a glossy maga-

zine produced between 1988 and 1990 by Shotsie Gorman, a New Jersey tattoo artist. *Tattoo Advocate* promoted fine art tattoos and actively disparaged other, less sophisticated forms of tattoo, as well as the various biker magazines that display them. The language used in *Tattoo Advocate* had a strong New Age tone, and indeed, the magazine read like a bible for people seeking spiritual solace through tattoos. The articles focused on Buddhism, the occult, and tattoos from exotic cultures (i.e., those ostensibly more "spiritual" than our own) such as ancient Egypt. Some articles claimed a healing potential for wearing tattoos. Aside from the spiritual and healing realms, though, the range of themes in *Tattoo Advocate* was vast. There were articles on anthropology, on comic book art, on the forensic use of tattoos for identification—even one on Malcolm X, accompanied by a photo-realistic tattoo portrait of him.

In the first issue of *Tattoo Advocate*, editor Gorman stated clearly the goals of the magazine:

> Welcome to the first issue of *Tattoo Advocate*. It must be clear to anyone who has spent more than five seconds leafing through this journal that we have definite political views and a clear perspective on tattooing as an art form. . . . Considering the almost total lack of valid information on this topic, one begins to see that conventional wisdom on tattooing is formed by the same forces that create intellectual chauvinism and racism: prejudice bred by ignorance. . . . We seem to be the first to point out, to those intelligent enough to be curious, that this is a humanistic art. . . . It is possible that tattooists as a group of artists are contributing to the gestalt of consciousness transformation in our culture by moving it, in a more potent way, toward a more whole and tolerant sensibility than any other form of visual art. . . . Our focus will be on the emotional experience that leads up to getting tattooed, tattooing as a rite of passage. . . . Professionals in all fields will be solicited to contribute their views and we will attempt to research as many sources to qualify this material as possible. Researchers will be happy to note that *Tattoo Advocate* will be indexed every three issues for easy institutional reference. (spring 1988)

This editorial stance blends the editor's middle-class, progressive values with a perspective on tattooing that, at the time it was written, was not shared by most tattooed people. He says that tattooing

is a humanistic art form, that it is transformative, that it leads to a more tolerant sensibility, and that it is a rite of passage. Ten years later, Gorman's perspective is central to middle-class discourse, but that was not the case when *Tattoo Advocate* first appeared. This editorial was accompanied by a photo of Gorman in dress shirt and tie, which illustrates the new middle-class aesthetic.

In an interview with me, Gorman clarified his intentions in publishing *Tattoo Advocate*.

> I realized that the National Tattoo Association was doing nothing to really promote tattooing in a positive sense or to create a professional base. There were no organizations that were representing tattooists at the time. So what I tried to do was to set up *Tattoo Advocate* to coordinate legal, medical, and historical issues around tattooing, to become sort of a warehouse and to eventually hire a lobbyist and have lawyers available to answer questions. . . . In the last issue I tried to tackle the issue of patriarchy in art. The whole idea of that issue was to show that women had a major influence in the art form. . . . In each issue, I tried to juxtapose tattooing with mainstream art, so I showed painters who did paintings of tattooed people. That was never done before. *TattooTime* didn't do it till afterward.

Gorman clearly saw his position in the community as an advocate for tattooists and tattooed people. The "Letters to the Editor" section, like the editorials, reflected Gorman's middle-class bias.[3]

> Congrats on your child—I mean, of course, *Tattoo Advocate*. . . . Mainly, though, it's the content that grabs me. The artistic AND POLITICAL sensibilities are right up front where people can be made aware of them, and we're spared the photographs of guys with "F.T.W." inked across their butts. (Mike, "Letters to the Editor," no. 2, 1993)

> Your own "first attempt" at magazine publishing is astonishingly professional. The color separations are very good, and the visual impact in general is strong. . . . Your understanding of Lombroso and the rejection of various theories of "types" is on target. I wish your specialized effort every good success. (Prof. Irving Horowitz, Rutgers State University, "Letters to the Editor," no. 2, 1989)

The letter from the university professor added a particularly legitimating touch and dovetailed neatly with the magazine's scholarly articles and artistic photographs. This, together with the professionalism of the contributors, invested the magazine with middle-class cultural status.

*Tattoo Advocate* differed from other tattoo publications in that the editor openly discussed his progressive political and social beliefs, even though his were not the views of most members of the tattoo community. Gorman's liberal values were reflected in the editorials as well as in the magazine's advertisements against nuclear testing and factory farming and in support of animal rights. In the third issue of *Tattoo Advocate*, Gorman wrote about how various people reacted to his baby daughter, based on whether or not they knew she was a girl. He closed his editorial with this statement: "I don't want my daughter to be held back by simple minds, easy packaging of what a woman should be and how she should be treated. This issue of *Tattoo Advocate* is dedicated to all women who struggle against patriarchy. . . . Compassion for other humans and animals, concern for the earth, healing—both physically and emotionally—are the themes that kept re-occurring while interviewing the women for our various articles" (winter 1990). Gorman sought to link feminism, along with other progressive political ideas, with the emerging middle-class tattoo movement. It was an unlikely combination at the time. *Tattoo Advocate* did not enjoy broad support from the tattoo community, and despite its high artistic quality, it was forced to fold in 1990 after only three issues. In an interview Gorman told me some of the reasons why the magazine failed:

> I was ostracized by a lot of the community. [They said] It was elitist, too intellectual, there were too many words in my book. It was hardly intellectual, though. I tried to fill it with things that were interesting and provocative. As a result of that, I just got a lot of crap from people. . . .
>
> I was getting so much flak, so many death threats, from all the various sundry elements of the tattoo community, I just decided that if I couldn't get the funding I was going to let it slide. I was in really deep financially—I made some big mistakes, I published far too high quality of a magazine. I realize now that I should have

published it on cheaper paper, not quite so complicated color separation. I wanted to make an art object. I wanted to make a book that people would covet. . . .

That was one of the reasons why I had so much trouble—I was ahead of my time. If it came out now, it would be a hit. When I put together *Tattoo Advocate*, the awareness of tattooing was much more limited, so when I got to these big marketing guys, they would just be in a panic. They wouldn't know what to do with this magazine. "We can't put it in our mom-and-pop stand, because it will offend people." I said, "Come on, look at the magazine!" It's not a hard-core biker magazine, but they saw tattooing in that context.

Gorman was correct: He was way ahead of his time. In 1990, when *Tattoo Advocate* folded, the tattoo community was still largely working class. Many more middle-class people were becoming tattooed, but in 1990 their numbers were not large enough to support a regular highbrow tattoo magazine, nor did they wield the kind of influence they now have within the tattoo community. (*Tattoo Time* was also being published at this time, but it appeared sporadically and did not depend on advertising or a high volume of readers to stay in business.) Gorman's attempt at a quarterly middle-class tattoo magazine ultimately failed because it criticized and alienated too many of the working-class members of the tattoo community; that is, the people who were buying tattoo magazines and attending the conventions.

*International Tattoo Art* (*ITA*) was the next highbrow tattoo magazine to appear; it was first released in 1992 and was originally edited by a prominent East Coast tattooist, Jonathan Shaw.[4] Like *Tattoo Advocate*, *ITA* presented a picture of tattooing much different from the traditional image. For the editors of *ITA*, tattoos were considered spiritual, artistic, and deeply meaningful. In Shaw's first editorial, he wrote:

> Like a multi-faceted diamond, the world of tattooing presents aspects of the metaphysical, psychological, spiritual, poetic and artistic, and spans the spectrum from mundane to the esoteric. . . . In the modern world, the sailor's arm is no longer the prime medium for sharing ideas among tattoo artists and tattoo fans. It is with this in mind that we have created *International Tattoo Art*. . . . Much of what has been written about tattooing has come from outside the

profession by people who have little or no real knowledge of the subject. Some of us, however, are into tattooing for the long haul, and as far as I'm concerned if you ain't in it for the long haul, you ain't in it. (no. 1, 1992)

This passage illustrates both the editor's conceptualization of tattooing as being "spiritual, poetic and artistic" and how his magazine figured within this new understanding. Shaw, like Gorman before him, implicitly criticized other tattoo magazines for their "outsider" position and their lack of knowledge about tattooing. A letter in a subsequent issue of *ITA* reflected this insider/outsider distinction as well:

After so many tasteless attempts at tattoo mags and the last few very important years being documented by sideliners, outsiders, and ham and eggers, it's time someone within the community got their guacamole together to challenge the tyranny of those who are leeching off our tattoo culture. Hats off to you for attempting to portray tattooing in a way that does us proud, and mostly for showing us that this can be done from within the profession in a spirit of cooperation. We don't need bloodsuckers meddling in our business anyway. I always knew that something like this would be put together by someone like Shaw who's paid their tattoo dues the old fashioned way, by being there over the years, watching 'em come and go. (Five Needle Fritz, no. 2, 1993)

At that time, the other tattoo magazines in circulation were *TattooTime* (also produced by an "insider," Ed Hardy), *Tattoo*, and *Tattoo Revue* (once edited by Shaw). Neither *Tattoo* nor *Tattoo Revue*, both biker magazines, were produced by tattooists. Yet it is ironic that the people who published these latter two magazines were seen as "outsiders," "bloodsuckers," or "sideliners." In fact, both of these magazines grew out of the interest in tattoos among bikers who read (and wrote for) *Easyriders* and *Outlaw Biker*. These are the kind of people who still make up a large and vocal element of the tattoo community. That the editors of *Tattoo Advocate* and *ITA* would characterize these magazines as coming from outside "the community" illustrated how competing magazines have tried to assert control within the community, in part, by defining that community within increasingly narrow parameters. Here we also see the factionalism within the middle-class tattoo community.

ITA, like *Tattoo Advocate,* also opposed accepting advertisements for tattoo supplies. In the first issue's "Letters to the Editor," a lengthy letter criticizing scratchers was followed by the following statement from Shaw: "*ITA* supports the tattoo community and our commitment to professionalism within the community is more than mere lip service. Therefore, we do not accept advertisements from tattoo suppliers" (no. 1, 1992). Readers applauded this decision: "I want to compliment you on the high quality of your magazine. If you live up to your promise to never run ads from equipment suppliers, I promise to faithfully buy each issue. I believe that more and more, the responsible, professional tattooists are realizing that ads that make equipment available to anyone with enough cash are doing a great disservice to everyone—especially responsible artists and their clients. Leave that to the money grubbers" (Mr. Toad, "Letters to the Editor," no. 4, 1993).

The decision not to run tattoo supplier ads, shared by all of the highbrow magazines, provides another important step in defining the tattoo community. Professional tattooists, according to these magazines, are those who do not purchase tattoo machines from the backs of magazines and who do not teach themselves how to tattoo. The problem with this definition, of course, is that there are no schools in which one learns how to tattoo. The two ways that one can learn to tattoo are through teaching oneself or through apprenticing with a working tattooist. Traditionally, tattooists would learn either way, but it has now become a stigma among "professionals" to self-teach tattooing, and self-taught tattooists are now defined as scratchers. *ITA* and the other highbrow tattoo magazines that disparaged scratchers have created a new standard for tattoo artists to aim for, one that working-class people will increasingly be unable to reach.

*ITA* also represented itself as a source of scholarly material on tattooing. In a letter to the editor, an art history teacher writes to request information on tattooing (history, symbolism, client information) to include in her course on modern art. The magazine's second editor, Chris Pfouts, responded, "You've already ordered some back issues, Rosemary. Get the rest, which will give you two years of worldwide coverage on just the topics you're looking into" ("Letters to the Editor," December 1994).

In the same issue, Pfouts reviewed Frances Mascia-Lees's and

Patricia Sharpe's book *Tattoo, Torture, Mutilation, and Adornment: The Denaturalization of the Body in Culture and Text* (1992). This book is a collection of essays by anthropologists, feminist theorists, and literary critics who view the body as a cultural construction and who focus on how the body is represented in film, literature, and magazines, and how gender affects this representation. In the review of Mascia-Lees's and Sharpe's book, Pfouts wrote: "Great title, eh? Sounds like righteous research into body modifications and curious practices of the flesh from long ago and far away. . . . That great title, which is so alluring and exciting, hasn't got a fucking thing to do with the contents. I mean not jack shit, people. And the contents, from chapter to chapter, don't have anything to do with each other" ("Reviews," December 1994). Here Pfouts made a pronouncement about what is "acceptable" scholarship on tattooing and body piercing: work that looks at tattooing from a strictly historical and/or cross-cultural perspective. Anything that deviates from this goal is poor scholarship, according to *ITA*'s editors.

*Tattoo Ink* is another recent (1994) entrant into the tattoo magazine arena. Like the other magazines, *Tattoo Ink* displays its own scholarly and middle-class credentials in the choice of its editor-at-large, Mike McCabe, who is a tattoo artist with an M.A. in anthropology. In their second issue, the editors wrote: "*Tattoo Ink* is more than just a new tattoo magazine, we're patrons of the art—focusing our sights on clean, quality work and the diverse lot of people all over the globe who create and collect tattoos. We're offering a look at a lifestyle founded on originality and self-expression—not a '101 ideas for your tattoo'" (March 1994). Here the *Tattoo Ink* editors' understanding of tattooing is clearly defined: tattoos are for individuals who are original, not for those who lack creativity and just want to pick an image from a magazine to copy onto their bodies. The implication is that the readers of biker tattoo magazines such as *Tattoo* and *Tattoo Revue* (and especially the more photographically oriented magazines such as *Skin and Ink*) do not have the originality to come up with their own tattoo ideas. They have to copy ideas from magazines. The readers of the highbrow magazines are also presumed to be more intelligent: they appreciate articles on history, art, and anthropology.

Like the other highbrow magazines, *Tattoo Ink* tried to distance itself from the biker magazines and their readers. The "Letters to

the Editor" pages were key sites for this discourse. In the letters section in the second issue of *Tattoo Ink,* one reader wrote, "Finally a tattoo magazine with a young non-biker format" (Peter Marlow, March 1994). On the other hand, *Tattoo Ink* did not work as hard as some of its competitors to be scholarly. In fact, in its focus on artists, fans, and celebrities, *Tattoo Ink* resembled some of the biker magazines. But, like the other highbrow publications, *Tattoo Ink* gave itself a stamp of legitimacy by featuring hip, young contributors who are tattooists—and, therefore, insiders—such as Pat Sinatra, Michael Wilson, and Chinchilla.

*Tattoo World Quarterly,* produced by Dutch tattooist Henk Schiffmacher (a.k.a. "Hanky Panky"), is one of the newest tattoo magazines; it debuted in 1994. This magazine takes a quasi-academic approach to tattooing and focuses on international tattoo issues in particular. In the first issue, editor Hanky Panky introduces himself like this:

> I roam the globe in search of the truth about our art. I have visited almost every spot on earth to see what is left of, or what is alive in, tattooing. Expeditions into tropical rain forests, painful treks on mountain ranges, paddling white water rapids, fighting my way through dark alleys—if there is any tattooing going on, I want to see it, experience it. My body holds about 50 pieces from every culture and spot I've visited. Head hunters have made me an honorable chief, cannibals have cooked me meals—all this just to give you a magazine. Besides this, I write books and paint. (no. 1, 1994)

The editor positions himself as an authority not only through his years as a tattoo artist but also by drawing special attention to his cross-cultural tattoo collection and the experiences that they embody. His language ("head hunters," "cannibals") also uses a primitivist discourse that (as I will discuss in chapter 6) has become extremely influential among tattoo's new middle-class adherents. Such language gives the reader an ethnographic "I was there" sense.

The focus of *Tattoo World Quarterly* differs from the other highbrow magazines in that it looks at historical or cross-cultural subjects. *TWQ* has included articles on prison tattoos, religious tattoos, old-timers or folks wearing old-time art, and non-Western tattooing. It contains no interviews with artists or fans, nor are there features on tattoo shops, designs, or styles. Schiffmacher sees himself

as a sort of "salvage anthropologist" in the tradition of Franz Boas, which can be seen in this opening from his article on tattooing in Borneo: "In 1992, Anthony Kiedis [of the Red Hot Chili Peppers band], myself, and two companions made an attempt to visit central Borneo in search of whatever is left of the primitive tattooing among the tribes there" (April 1994). *TWQ*, unlike the magazines discussed above, does not explicitly position itself as a competitor with the biker magazines and does not involve itself in the debate about who the community is or should be, or what tattooing is. On the other hand, through its academic focus and scholarly perspective it does provide fuel for those whose agenda is to upgrade the status of tattooing and its adherents. Like *TattooTime*, *TWQ* offers a quasi-academic discourse that can be used to promote tattoo's new reputation as a fine art with cross-cultural connections.

All of these magazines contribute to the differentiation of the tattoo community into two strata: higher and lower. Although I understand these to be class- and status-based categories, the magazines are careful to represent the debate in different terms: insiders versus outsiders or professionals versus scratchers. In any case, one observes the process of differentation in the magazines' focus on how and when people become tattooed (for example, as a rite of passage versus a spur-of-the-moment decision); on the tattoos themselves (professionally executed and of high artistic value versus poorly executed by scratchers); and on the kind of people who wear the tattoos (middle-class professionals versus bikers and trash).

## *Tattoo Magazines* II: *Bikers Write Back*

It is not just the highbrow magazines that work to differentiate themselves from their competitors and try to establish a measure of control over the representation of tattooing. Biker tattoo magazines, too, are engaged in a process of imagining the competition and defining their own position within the community. Bikers, like their highbrow competitors, see themselves as the more authoritative group.

The most prominent of the biker magazines are *Tattoo* and *Tattoo Revue*. They differ from the highbrow magazines in a number of

ways, although in recent years they have begun to look more similar because they are competing for control of the same market. Biker magazines generally devote a section to photos of tattoos sent in by readers (sometimes with the artist credited, sometimes without). Most include a feature on "fans," that is, nonartists with tattoos. The dominant magazines of this class also included (at the time of this writing) both black-and-white and color photos as well as newsprint pages alongside the glossier pages.

*Tattoo* has been published since September 1988. Like its parent magazine, *Easyriders, Tattoo* can be purchased only by adults owing to its inclusion of photos of nude women. The content includes coverage of conventions, stories of fans or collectors and tattooists or tattoo shops, a section for reader's flash, and a feature called "In the Skin," which contains black-and-white photos of tattoos sent in by readers. Along with the ubiquitous ads for tattoo studios, *Tattoo* includes ads for tattoo equipment suppliers as well as cheap porn videos ("as low as $.19 each in quantity"). The magazine often prints letters from convicts (usually tattooists), sometimes accompanied by an example of the artist's flash. Indeed, many convicts have subscriptions to *Tattoo* (and *Tattoo Revue*).

*Tattoo* began as a biker magazine with a fairly limited readership but now has become much more mainstream, reaching out to non-biker readers. In recent years, the quantity of nude female photos has been reduced, and the editors now try to include artists' credits with all photos in response to criticism from the highbrow magazines and their readers. Like the highbrow publications previously discussed, *Tattoo* now aims to promote the art of tattooing and reach out to new, middle-class readers, yet it still includes many elements that appeal primarily to its traditional readership. For example, *Tattoo* includes examples of fine-art tattoos alongside biker tattoos, as well as information on prison tattooing and the kind of exploitative photos of women that would be offensive to feminist readers. While the editors of *Tattoo* seem unaware of these contradictions, such issues are often taken up by the magazine's readers in the letters to the editor.

For example, in the "Tattoo Mailbox" column of the June 1992 issue, Staci L. writes in to express her distaste at "biker-type" tattoos, which she feels are "ugly and unattractive" and project an image that "turns off many people." She also says the images occupy

a "disproportionate" amount of space in *Tattoo* (which is, after all, a biker-published magazine!). Over the next three months, other readers responded angrily to Staci's letter. Iden R. wrote as follows:

> Staci L., you ask that there be fewer biker-type tattoos in *Tattoo* magazine. You state that they are "ugly and unattractive." I am a longtime Harley rider so, sweet thing, you just pulled on my chain. My Harley, the Harley scene, and "biker-type" tattoos are all very meaningful to me—very much a part of my life. I appreciate jail-house tattooing as well. Biker tattoos, though admittedly often of a grim theme, are not ugly and unattractive to me. . . . I am strongly drawn to the very things about biker-type tattoos that you may not like. I am sure that my biker brethren can identify with this. (September 1992)

Reader Eric E. also responded:

> Staci L., if you don't like "biker-type" tattoos, then get yourself a fucking fingernail growers handbook to read. [Staci had also requested that fingernail art be included in the magazine] . . . So you think they are ugly and unattractive and project an image that turns off many people. All I can say is, "Fuck you and your long fingernails." Don't knock my favorite tattoo mag with your drivel about fingernails three inches long! Stick them up your ass. And the next time you want to see ugly, outlaw biker tattoos, send me your address and I'll make a trip to your place and give you a demonstration of something real. (September 1992)

These letters reveal the contradiction inherent in a magazine that promotes mainstream tattoo art while it also seeks to appeal to a readership of committed bikers.

Another *Tattoo* reader writes in to express his dissatisfaction with mainstream society's perception of him and his tattoos:

> I've been in the military for six years. Served in Panama and now in the Persian Gulf. I have 36 tats on my arms, chest and back. I've gotten so much shit in the service about it. Not allowed to do certain things because I don't "fit the military image." I almost missed out on coming to the Gulf because my commander is very much against my kind. I have been told that if I'm caught with my shirt off on duty, I'm out the door. On most military bases, I've been told to

wear long sleeves because of the image. My ink is not bad or offen-sive. I've had some of the best in the world run my ink. I just don't understand why these people can't just back off. Most foreigners I run into love my tattoos and ask where they can get it done. My per-sonal opinion is that I'd rather be serving with a few tattooed people than some little pencil-necks whose parents pulled a silver spoon out of their mouth after college, powdered their asses, and put them in the service to worry about how they look or when they can return home to tell their yuppie friends big war stories. (Kirk, September 1991)

This writer's letter can be seen as a statement about the increas-ing hegemony of the middle-class aesthetic, rather than simply a statement about nontattooed people frowning on tattoos. I see it as a sign that his "kind" of tattoo and the "image" it presents is not acceptable—even within the military, where soldiers have always worn tattoos. He may be a biker, as his language—"run my ink"—reflects biker tattooing. He finds that he doesn't fit in to the mili-tary, which he describes as being populated by "pencil-necks," or middle-class kids, whom he clearly finds distasteful. To Kirk, even the military is becoming yuppified, a fate that many *Tattoo* readers fear is happening to their magazine.

Another contradiction is expressed by bikers who, rather than challenge middle-class views align themselves with them on sub-jects such as prison tattooing or cleaning up tattooing's "bad image." The following reader, who identifies himself as a biker, is upset that the magazine, in keeping with its biker heritage, prints articles and information about tattooing in prison.

My wife and I really enjoy our tattoos. Going for more is never a closed subject. We also enjoy partying and long afternoons on our [Harley-Davidson] Softail. However, we also enjoy being home-owners, parents, and law-abiding citizens. Granted, there is some fine tattoo work that comes from the shithouse, but, being an en-forcement agent, I get a little pissed-off when I read this "Down Bro" and "Contempt for Society" shit. Most of these maggots are violent criminals that belong exactly where they are. Your magazine's theme is tattoos, not a slate for offensive assholes. (Ray, September 1991)

Ray's request that *Tattoo* limit its coverage to tattoos and skip information on prison seems unreasonable because biker tattooing (the magazine's original specialty) and prison tattooing are traditionally aligned in terms of style, imagery, and social practice. This next letter is from a convict tattooist who is concerned about the "bad image" that has been associated with "the art" of tattooing:

> As a caged inkslinger I take great interest in your magazine. It keeps me up to date, inspires me, and also I greatly appreciate it as an ambassador. By that I mean, it destroys the bad image that for years was associated with the art. Also, every time I see a beautiful woman like Paula, Lynn, or even the very attractive lass on page 40 of the May issue, I give thanks. They do more to destroy the stereotype than anything else. (Wizard, September 1991)

This last letter is interesting because this convict wants to help dispel the "stereotype" or "bad image" associated with tattoos but, as a convict, he is the bad image! I also question why photographs of nude women (all of the women Wizard mentions were photographed in the nude, regardless of tattoo coverage) would "destroy" stereotypes about tattooing. Wizard may be referring to the fact that, contrary to stereotype, women are now being tattooed alongside men.

The two letters above, by a biker and a convict, both promote a cleaner image of tattooing. Both illustrate as well the diversity within the working-class tattoo community, a diversity that is totally overlooked by middle-class critics who would lump both writers together as low-lifes or trash. Obviously, the readers of these magazines as they are represented in the letters to the editor do not represent a monolithic "working class" but instead demonstrate its fluidity.

Another debate often expressed in the pages of *Tattoo* involves the way in which tattooed women are represented. *Tattoo* features between ten and fifteen different artists and "collectors," both men and women, in its pages each month. The men tend to have a large part of their body covered with tattoos; generally a full back piece, both sleeves (arms), and perhaps some leg work. Women featured in the magazine, on the other hand, often have as few as two or three small-to-medium-size tattoos, and are very often shown nude, or at

least topless (even when the tattoos are easily visible while clothed). Recently, women have begun writing to *Tattoo* to complain about the abundance of female nudity in the magazine. One reader responds to this issue by writing:

> Your July 1992 issue Mailbox contained a lot of whining about female nudity and untoward sexuality in your magazine from people who claimed to love tattoos but not naked women. These individuals have the option of buying the latest feminist publications and reading them. Let them write to their spirit guides in Now's [*sic*] publications and ask them to cover tattooing for them Now-style. (Ray, September 1992)

This letter suggests that some readers fear an encroaching feminist influence in "their" magazines. In some of the letters that follow, we will see that feminists, along with "queers" and "yuppies," are the most heavily disparaged groups on the pages of biker-oriented magazines, one of the few forums in which bikers, convicts, and others considered low class can express themselves about tattooing.

*Tattoo Revue* is published by Outlaw Biker Enterprises and has been in print since 1990. It is a more upscale biker-oriented tattoo magazine, and it includes features on artists, interviews, articles on shops and conventions, materials from and about prison tattooing, and "Skin Stories," a newsprint feature that lets fans tell about their tattoos. Like *Tattoo*, *Tattoo Revue* also carries ads for porn videos ("200 video vixens, $.15 each") and tattoo equipment ads. As in *Tattoo*, the letters column ("News and Reviews") illustrates some of the tensions in the changing tattoo community. Again, these tensions seem to revolve around the conflict between the more established biker readers and the newer, middle-class readers.[5] Flex, a *Tattoo Revue* reader, writes (March 1993) to present another complaint about the yuppification of tattooing. His letter launched an emotional debate in subsequent issues, as the following letters illustrate:

> When I got home, I read Flex's diatribe on yuppie scum. If you were to see me anywhere but the gym or home you'd think I was a yuppie. I dress as though I were in the upper middle class. . . . What's more how dare you state the depths of your reasons for being inked and then go on to demean others? When inked do we all not bleed? . . .

And to all those "true artists" out there who Flex addressed his letter to, please don't refuse to tattoo yuppies. They may become your best canvasses. . . . You can't judge a book by it's [sic] cover. (Cecil, "News and Reviews," May 1993)

This is in response to the letter from the obvious knucklehead who calls himself "Flex" in your TR #24. First of all, get a real name. Secondly, how can someone who doesn't have the balls (and he questioned yours, Ed?) to look the way he wants to, because "uncool" people adopted the style, question anyone else's integrity? . . . How exactly does one qualify as being cool and hard enough to be tattooed? Because I know some extremely tattooed people (who have way more than the six tats you have!) who I wouldn't consider "cool," although they are good people. I believe a true artist would respect anyone's desire to be tattooed, no matter how small, silly or whatever the desired piece may be. Realize that tattooing is an art form, not a "way to be cool." . . . I'd almost like to see these images whose meanings "came right from the soul" all six of them. . . . Read a book or something, Flex, and stop getting your panties in a knot over what everyone else is doing! (Guy, "News and Reviews," July 1993)

Flex, I was wondering how much it cost to be a member of your club? A whole pound of flesh or would a specific number of square inches do? I was hoping I could obtain a copy of the guidelines regarding who I should and shouldn't tattoo? I know this would really help me in singling out the "Wannabes" and "Losers," like people who count their tattoos or the clowns just cruising for a fashion statement. I think you hung those boots on the end of your nose and they are blocking your view. (Mike, "News and Reviews," August 1993)

All of these respondents resent Flex's antagonism toward "yuppies," and their responses can be seen as representative of the changing readership of *Tattoo Revue,* or at least of a growing tolerance among its readers of the upwardly mobile middle class. On the other hand, as the following letter from a Flex-admirer shows, not all of *Tattoo Revue*'s readers are pro-yuppie: "I recently read a letter in your magazine, entitled 'First We Kill All The Lawyers' in which Flex (the letters [sic] author) raged on trendy tattoo receivers. I completely agree with him and seem to have a lot in common with him,

being an ex-skinhead and tattooed girl myself. I was wondering if you could put me in touch with him or print this letter so he can contact me" (Sully, "News and Reviews," July 1993).

Another issue that is debated in the letters to *Tattoo Revue* is the treatment of women in the magazine. Like *Tattoo, Tattoo Revue* includes photographs of seminude women, to which some readers object. But other readers write in requesting information on meeting the women who are featured: "On the cover of your Inkslingers issue you have a great photo of a lovely girl named Stephanie. Is there any way to get more photos of her and her tattoos? IS THERE ANY POSSIBLE WAY TO GET IN TOUCH WITH HER (please!). My salvation depends on it" (Dix, "News and Reviews," May 1993). The following letter, however, illustrates a different concern:

> I object to your treatment of pictures of women. I am one of the many readers who buy tattoo mags for photos of tattooed women. I am also keen on piercing, the same as many other readers. Since the art world of the media is firmly in the hands of homosexuals, who know that pictures of women sell mags but who are hellbent on destroying the pleasures of heterosexuals, they deliberately degrade the pictures of women. Why else are the tops of women's heads deliberately sliced off and the tops of men's heads always included? . . . Another annoying thing is when homosexuals make the size of the pic inversely proportional to the interest, such as in the same issue when Barbara was showing her tongue piercing—you ran the pic in black and white. (Ted V., "News and Reviews," October 1993)

Rather than being profeminist, as are some of the (presumably newer) readers who write in to *Tattoo* and *Tattoo Revue* opposing the objectification of women's bodies in the magazine, Ted takes an unusual (yet more traditional) stance, claiming that *Tattoo Revue* is now "firmly in the hands of homosexuals . . . who are hellbent on destroying the pleasures of heterosexuals" by denying him his full complement of female nudity. Here again, "NOW-style" feminists, "homosexuals," "yuppie scum," and "pencil-necks" are associated with a transformation within tattooing. I understand this transformation to be from working class to middle class, but in these letters, class is displaced onto discourses of gender and sexuality such that feminists and gays in particular are aligned (negatively) with the middle class. The readers of *Tattoo* and *Tattoo Revue* are concerned

to find that even within "their" magazines, control is slowly being taken from them by members of the middle class, and their hostility is apparent.

Still another issue that is taken up in *Tattoo Revue* is the question of "encouraging scratchers" by including advertisements for suppliers or by giving instructions on doing cover-ups. This is a relatively new issue to be debated within a biker tattoo magazine. *Outlaw Biker* and *Easyriders* commonly include how-to articles for those who want to teach themselves how to tattoo, and *Tattoo Revue* has always included advertisements for tattoo equipment. Two tattooists (contributors to one of the highbrow magazines mentioned earlier) wrote this letter to *Tattoo Revue:*

> For a "PROFESSIONAL TATTOO ARTIST" to write an article that shares the technique and process of a cover-up process is not fair to anyone in the profession. This should not be printed as public knowledge. Less [*sic*] it fall into the hands of the alarming number of ever increasing backyard scratchers. We all served apprenticeships to learn this stuff and IT SHOULD NOT BE AVAILABLE TO THE GENERAL PUBLIC. Your magazine is not a technical manual for tattooing, nor should it be. (From the professional tattoo artists at Mr. G, Chinchilla, Les Pain, Shawn, "News and Reviews," August 1993)

This letter illustrates the degree to which middle-class notions of "professionalism" within tattooing have permeated even the biker magazines, establishing ever tighter borders around the community.

Two new magazines, *Skin and Ink* and *Tattoo Savage,* have joined *Tattoo* and *Tattoo Revue* in the competition for control of the tattoo magazine market. *Skin and Ink* was started in 1993 and is published by Larry Flynt of *Hustler* magazine fame. While *Skin and Ink* is not really a biker magazine, it has a biker-style format in terms of its features (convention coverage, studio coverage, fans, and "Inked," a section devoted to photos of tattoos—many of which are of very poor quality—sent in by readers), tattoo supply advertisements, and pseudo-academic articles. The magazine reflects the movement, also seen in biker magazines, toward more contemporary aesthetics and values. Although the magazine showcases attractive, scantily clad female fans, the tattoo philosophies espoused by these women are usually very New Age. Lisa, for example, fea-

tured in the December 1993 issue, says that her tattoos "have em-
powered her with internal strength and a sense of spiritual well-
being." On a more conventional note, many of the male readers of
*Skin and Ink* write in requesting the opportunity to meet the women
who are featured. The next two letters are from the letters column
("Stamped!"), December 1993 issue:

> My main reason for writing is to ask about the cover girl, Jenny.
> I'd like to know a lot more about her. I can relate to every word of
> what she said about strength, pain, and in some cases, men. Being
> a man myself, I have trouble understanding why some men are in-
> timidated by strong women. I think it's only a sign of certain men's
> low self-esteem, insecurities, and weaknesses. Luckily, there are a
> few exceptions and maybe there is a way of hope for people like me
> and Jen. . . . Anyway, I was wondering if it would be at all possible
> to get in touch with Jenny so I can write or call her. It would be a
> dream come true! Please help me meet her. (George)

> One thing pissed me off, though—it's a quote from the Jen & Mela-
> nie article. Jen says "A lot of men are babies when it comes to getting
> tattoos or anything getting pierced." Wrong. For one thing, I've got
> more tats then [sic] her and for another, more body-piercing, too.
> But I still think she is a very, very attractive woman. Another thing,
> I wouldn't be one of the pussy boys she tries to pick up on. If by any
> chance she gets to read this, could you give her my address, so she
> can write me. (Damian)

*Tattoo Savage,* from Paisano Publications (publisher of *Easyriders*)
is a relatively new (1994) answer to the highbrow magazines. *Tat-
too Savage* includes photographs and articles on piercing and other
forms of body modification, S/M, alternative lifestyles, "fine art,"
"tattoo magic" as well as the usual collector and shop showcases.
Like the other biker magazines, it includes female nudity (like *Easy-
riders* and *Tattoo,* it can only be purchased by adults), flash sent in by
readers, advertising for tattoo suppliers, and motorcycle parapher-
nalia ads.

Because *Tattoo Savage* is directed toward people interested in
modern primitive body modifications like piercing and scarifica-
tion (practices popular in the gay, lesbian, and leather communi-

ties), it is a much more "pro-gay" magazine than its sister publications, *Tattoo* and *Easyriders,* which are marked by fairly regular queer bashing. Yet not all of *Tattoo Savage*'s readers are happy about the gay-friendly slant. One reader expressed his disappointment with the magazine's format in the spring 1995 issue:

> I bought two of your magazines to date and I have to tell you, they both suck! The "savages" and warriors you feature look like a bunch of bisexual Winnie the Poohs. I bet the whole lot of you are transformer faggots and lesbo-whores. It makes me wanna take a shit when I attend tattoo conventions and see you homos playin' dress-up, comin' my way. It wouldn't surprise me one bit if the majority of you "modern savages" run around with pink feathers stuck up your ass while you screw blow-up dolls with Madonna music blaring on the stereo. If you really want to shock the squares, why don't you use some of those child porn photos I'm sure most of you have at home? You fags suck!! (Disgusted, "Rebel Yell")

"Rebel Yell," like many who read *Tattoo* and *Tattoo Revue,* is concerned because the tattoo scene is changing from one that explicitly embraced conservative biker values, to one that welcomes feminists, gays, New Age practitioners, and yuppies. In his letter we see as well a new theme of "faggots" taking over not just the tattoo magazines but the conventions as well.

The discourses surrounding the tattoo community are by no means consistent, and nowhere is this more visible than in the biker magazines. Here, editors and readers are often at odds, and readers openly challenge other readers, disparaging tattoo styles and philosophies. Artists are not treated as absolute authorities in these magazines because many focus as much attention on fans as they do on artists. In addition, these magazines accept ads selling tattoo equipment and occasionally run articles on how to tattoo, again undermining the absolute authority of the professionally trained artist. This is strikingly different from the positions found in the highbrow magazines, where the discourse is strictly controlled by the artist/editor/publisher, as is the border between the communities represented by the different magazines.

All of these magazines illustrate the contradictions inherent

within the greater tattoo community. On the one hand, the community is differentiated into the biker, the mainstream (middle-class and working-class), and the elite elements. Of these, the two poles — elite and biker — are defined and the boundaries between them articulated by the tattoo magazines. On the other hand, the readership of the biker magazines, *Tattoo*, and *Tattoo Revue*, is changing from comprising primarily bikers to a more mixed group as the community slowly shifts toward the middle class and as feminists, yuppies, and gays join their readers. These magazines have also been forced to compete with at least five highbrow tattoo magazines for a market that they once monopolized. Both of these changes have resulted in the magazines' gradual movement away from biker (i.e., pro-USA, pro–working man, anti-elitist) values to include a version of tattooing that is more inclusive (of gays and women and non-Western tattoos) and also more elitist (with the new focus on fine art and professionalism).

## Creating Control within the Community

Reviewing the range of tattoo magazines clearly shows that the tattoo community is highly stratified and only masquerades as a support system for all tattooed people and that the magazines play a large part in defining the borders of this community. But tattoo organizations and tattoo artists also play an important role in differentiating the community into higher- and lower-status groups. For example, most tattooists I have spoken with are quick to emphasize or exaggerate the middle-class nature of their clientele. This is especially true among tattooists concerned about their reputations and the respectability of tattooing. When I asked Manny, a biker and tattooist from Tennessee, who his clients are, his response was typical, "It's just your basic everybody. I've done parties where I've only done lawyers, judges, and such. I've got a full back piece on a heart surgeon. I got a dragon ripping his heart out through his back. The guy told me not to tell anybody because he doesn't want his patients to know about it" (Manny E., tattooist).

But when I asked another working-class tattooist, who has been an honest and critical informant for me, whether his customers are all doctors and lawyers, he had this to say:

As far as doctors and lawyers [are concerned], a lot of those people don't get tattooed because they don't want tattoos, they don't need it. They'd rather spend the money on BMWS, or putting a pool in the backyard, or putting their kids through college, or paying the mortgage on their house, or improving on their golf swing or something. They don't think about tattoos, those type of people, they got other things to do, bigger fish to fry, and tattooing isn't one of them. People like that, a few are getting tattooed, but . . . most of the customers that I get are girls or guys that get tattooed and wake up and go to their job at the metal stamping factory or something like that and come home and watch TV and get up and do it all over again. . . . Look at these people, do they look like lawyers or doctors to you? Are they working on Wall Street or are they Ph.D.'s? I don't think so. (Mo P., tattooist)

Why then does Manny and so many other tattooists—working-class and middle-class—emphasize their middle-class customers to the exclusion of everyone else? By maintaining that one serves large numbers of middle-class clients, who are presumably more discriminating than working-class tattooed people, a tattooist improves his or her reputation and status as a professional artist. A college literature instructor named Ted told me the following about his experience trying to find a good tattooist in Sacramento: "I finally decided on Bill L. He seemed like a fairly normal person as tattoo artists go. He didn't seem like the biker type and he seemed perceptive to my design. In fact, while he was tattooing me, he was telling me about all the normal customers he has, such as high school teachers, and reassuring me that it was okay that I was there, because obviously I was not a biker type either." Here we see that Bill, the tattooist, used his experience tattooing "normal" people to make Ted, another "normal" (i.e., not biker) person, feel more comfortable about getting tattooed, thereby elevating his status as a middle-class tattooist.

*Tattoo Organizations* ➳ The National Tattoo Association (NTA) is the best-known tattoo association in the world and, due to its centrality, plays a major role in the continuing conflicts within the community.[6] It was started by East Coast tattooist Eddie Funk as The National Tattoo Club of the World in 1974, and it was origi-

nally financed by Flo Makofske and Don Eaker at National Tattoo Supply. Begun as an equipment supplier, NTA also added legal assistance, technical information, tattoo equipment, and a newsletter (since 1976) to its offerings to members. It now also provides members a certificate—suitable for display in one's studio—thereby adding the aura of professionalism to the tattooist. And finally, NTA hosts the largest annual tattoo convention in the world. Although membership[7] is divided among professional, elite tattooists, and the working-class street shop tattooists who made up its original membership, elite tattooists now enjoy the highest status within the group, whereas the organization's "hard-core" membership continues to remain working class. Here I particularly want to focus on the attempt by National, as well as other organizations, to redefine tattooing in such a way as to bring mainstream legitimacy to tattooists and tattooing.

Sociologist Clinton Sanders (1989) calls tattoo organizations "deviant organizations," whose purpose, like groups representing gays or the disabled, is to educate the public by assuring them that the behavior of its members (whom Sanders calls "disvalued social actors") is nonthreatening. Sanders interprets the organized activity of tattooists as an effort to expand their clientele and increase their reputation. Sanders elaborates: "Information directed at the general public by tattooing organizations and tattooists who have a vested interest in expanding the artistic reputation of tattooing emphasizes conventionally accepted values. Promotional materials refer to tattoo studios and tattoo art, display exemplary work exhibiting aesthetic content and technical skill, stress the historical and cultural roots of contemporary tattooing (especially classical Japanese work), and emphasize the academic training and conventional artistic experience of key practitioners" (1989:157). We have already seen how the highbrow tattoo magazines emphasize middle-class values of professionalism, artistic experience, and academic credentials for tattooists. As Sanders points out, the tattoo organizations do so as well, though to a lesser extent due to their strong working-class roots. National's promotional literature provides a good example of the strict control it tries to maintain over the public display of tattooing. Here is an excerpt from the "Conduct Rules and Regulations" for NTA conventions:

The following rules and regulations have been set up by the members of the National Tattoo Association for a multitude of reasons. One of which, is the fact that there may very well be a convention in your town one of these days. And, due to the fact, that we do have press coverage at these conventions we wish to take precautions against the wrong type of publicity from the media. We don't want to make headlines with the bizarre, we wish to make headlines with the ART OF TATTOOING. Something you and your family can be proud to say you are a part of.

If you cannot abide by these rules and regulations, we ask that you simply not attend. We don't wish to offend anyone, we simply wish to promote the ART OF TATTOOING and only the ART OF TATTOOING. (National's emphasis)

The specific rules listed include: no disrobing in halls, lobby, elevators, or other public places; no facial piercings with bones, chains, or anything else; no facial tattoos other than cosmetic; and no displays of genital piercings. Terry Wrigley, the columnist for National, gives his support for National's regulations in his monthly column in the NTA newsletter:

Seems this is to be the last [Tattoo] Expo allowed at Dunstable, the powers that be don't like the idea any more and looking at some of the objects who turned up there it is not surprising . . . the number of people who were what you could say "OFF THE WALL" nearly outnumbered serious tattoo enthusiasts. Like the little man in the plastic mini skirt and fish net stockings who couldn't keep his hands off his penis like some little boy dying to take a leak. In Glasgow, where I live, if anyone has anything hanging from their nostrils they call them snotters, in Dunstable they call it body art. . . . It demonstrates that National's policy of no facial tattoos or body piercings at National Conventions is correct. But freaks apart, the Expo was good. (NTA newsletter, Nov.–Dec. 1992)

Here we see National's traditional, working-class roots conflicting with newer, younger, and often gay members of the community, who blatantly disregard National's rules through their ostentatious display of facial tattoos, piercings, and S/M gear. Yet the kinds of displays that many middle-class members find objectionable—racist

tattoos and T-shirts; biker imagery; home-made, jailhouse, or otherwise "primitive" tattoos—are not mentioned in National's promotional literature, demonstrating that National's power base is still found in its more conservative, working-class members.

National's main competition, a new (1992) organization known as the Alliance of Professional Tattooists, Inc. (APT), has a different set of concerns from National, which is apparent in their goals as stated in their informational brochure: "Preservation of the art of tattooing within a rapidly changing world, and promotion of education, health and safety as they relate to tattooing are the foundations upon which we exist, ever reminding us to place principles before personalities." Like National, APT is concerned with the public image of tattooing, but this organization primarily works toward maintaining professional standards of health and safety within tattooing. This is important from a legal perspective, as there is increasing pressure in many states to regulate tattooing, ostensibly for health reasons. The position of APT is that it is better to be regulated internally rather than by county or state health officials; thus they want all member tattooists to use modern sterilization practices.[8] Kris Perry, a doctor with a long history in the tattoo community, lectures at APT events and provides hands-on training for tattooists in medical sterilization techniques.

By educating tattooists on health issues, and by assuring the general public that tattooing is practiced in a safe and professional manner, APT helps to ensure that the industry is not threatened by overregulation and that tattooing will win favor with a middle-class constituency. (Interestingly, Shotsie Gorman, publisher of *Tattoo Advocate*, was also a founder of APT and wrote the outline and bylaws for the organization.) While APT's concerns for safety and hygiene are to be commended, I also see in them a means to differentiate the modern profession of tattooing, with its rubber gloves and chemical sterilizers, from the old-fashioned street shop.

Some of the local tattoo organizations also engage in this type of public education (or "enlightenment"). A Sacramento group called the Living Art Association (LAA) organizes two shows a year and says this in its brochure: "Tattooing can not enter the mainstream and become accepted as a true art form until the public at large is enlightened as to what tattooing is really about. . . . Tattooing is an art form that can take on many different looks, and as such, the op-

portunity to experience it's [*sic*] variety of forms can be beneficial to all who choose to explore the possibility of Art that is truly unique." Here the LAA is concerned with tattooing entering the mainstream and being accepted as a "true art form." Again, I think most tattooists, working class and middle class, share a desire to make tattoos as artistic as possible. On the other hand, wanting to define tattoos as Art-with-a-capital-A seems to be another way to reassert boundaries within the tattoo community. An article from *Tattoo Enthusiast,* the Sacramento organization's first and only newsletter, states: "It is the intention of this publication to enlighten and educate the public of the many aspects of tattooing. If you want lots of color photos of girls and bikes then you may want to read elsewhere, since other media has already exploited this area" (spring 1990). Here the writer contrasts *Tattoo Enthusiast* with other magazines that simply titillate the reader with bikes and sexy girls. This article was accompanied by a photo of tattooist and biker "Wild Bill" and his wife, "Terri the Teazer," clad only in sexy lace underwear.

The National Tattoo Association has received quite a bit of bad press in recent years and has lost some of its power as the community has expanded beyond its original working-class base. There is a great deal of infighting now between the different organizations (primarily NTA versus APT) and among the tattooists who are associated with each organization, as different factions struggle to control the future of the community. Sanders discussed this conflict in terms of competing "factions centering around equipment suppliers and a few influential artists" (1989:83).[9]

Much of the quarreling today is over conventions, and this has been an area of contention since NTA began hosting tattoo conventions. In 1976, when Dave Yurkew organized the first World Convention of Tattoo Artists and Fans through his North American Tattoo Club, his was the only national convention. After the success of the 1976 convention, according to one informant, NTA's response was to "Wait to see what Yurkew was doing and then they'd set theirs up for the next weekend. So then they started doing that 'wid us or agen us, Hatfields versus McCoys' kind of thing so they'd call up all the tattooists and they'd say, 'look, you buy supplies from us. If you're a loyal customer we don't want you to attend Dave Yurkew's convention so we'll give you supplies for a discount price' and it became this little war" (Derek G., tattooist). Yurkew would go on to

host five more conventions, National's monopoly over the conventions essentially pushed Yurkew out of business.

Jonathan Shaw, a representative of the younger, anti-National faction, took a strong stand against National in a 1993 column in *International Tattoo Art*:

> As founder of the National Tattoo Association, Eddie Funk has perhaps done more than anyone to further the aims of professionalism in tattooing. Through the many great conventions he organized and hosted as the main man behind the scenes at the NTA, he spurred the growth of the community by encouraging enlightened contact between professionals, fans and public alike. While the NTA is no longer the respected authority it once was in the tattoo world, having succumbed to the pitfalls of absolute power corrupting absolutely, Eddie Funk, like the trailblazer he's always been, has moved on to bigger and better things. (no. 2, 1993)

National's secretary, Flo Makofske, defended National in a lengthy editorial that was printed in the NTA membership newsletter, the introduction of which follows:

> I think others are jealous of this organization and the camaraderie felt by the members. It is so strong that we even have a waiting list to join. Now that's saying something for this organization and its members—not any one member—but the entire membership. It has grown over the years and is something that each member can be proud of because he or she has been and is a part of this growth. However, I really believe that there is a group out there trying to destroy this organization because they cannot pull strings and make themselves VIPS in this profession through the NTA. So, they are trying to do it in other ways, like insinuating with undermining and detrimental reporting that the NTA is going to fall apart. (Jan.–Feb. 1993)

Makofske goes on to explain the origins of the fight between Shaw and National, blaming it on Shaw's ego and his need to be treated like a "VIP." I include the details of this debate because they illustrate not only the personality conflicts that have long been a part of the tattoo community but also the deep divisions within a community known for its camaraderie. As Makofske's use of the term "VIP" suggests, status is extremely important, although how status

is conferred is rapidly changing. For Makofske and other longtime National members, status belongs to old-timers like Bob Shaw (who had just died and, according to the editorial, "is someone special and respected in this business"), not elitist newcomers like Jonathan Shaw (no relation to Bob Shaw).

But today, others in the community see things differently. When I asked one elite artist what he thought of National's role in the future of the tattoo community, he replied,

> They're completely outmoded, they've been passed up. The convention thing has exploded and they resent the fact that they've been left behind. . . . You know, I belong to the Association, but they've had their head in the sand for so many years, and have been resisting all the change, and they don't run things as professionally as they should. . . . They're not very professional, they like to keep a closed shop. You know it's their family thing, but they're outstripped by the whole thing. They don't know how to handle it. You know, it's like the whole tattoo thing has spun out into another world, and they're trying to still go, "no, we just will do this, and not this," and they've got this big fat biker guy that's their pal who always runs security and this and that. It's just silly, they're just not very equipped to deal with the world as it is today. (Drew B., tattooist)

Another tattooist agrees with this perception of National as an organization working to maintain its control over the community by favoring its own kind: "There was a real desire to have an alternative to National because Flo runs National as sort of an ass-kissing contest for her, and everyone who is her buddy gets what they need and everyone who doesn't properly crouch down, doesn't" (Mark G., tattooist). Young, art school–trained tattooists see National as a relic, and many spurn its conventions in favor of smaller shows attended by other hip, middle-class people like themselves. This new generation of tattooists finds that it has little in common with either the old-timers who make up the history of tattooing in this country or the majority of working-class tattooists working in the street shops and their customers.

The analysis of symbols at the level of social action is inherently a political issue. Although individuals within a given society occupy different structural positions relative to each other, they have a group of shared symbols that they mostly all identify with. But there are other symbols that may be held by some members and contested by others, and conflicts between different groups are often clothed in symbolism. This is easily seen within the context of political battles fought on the grounds of class, race, or gender difference. Tattoo wearers in the United States are also engaged in a battle of sorts, and it too takes place on the level of the sign. This chapter concludes with a discussion of tattooing in prison, because the figure of the tattooed convict body starkly illustrates the struggles that have been detailed in this chapter.

Prison tattooists and tattooed convicts are the most marginalized individuals within the tattoo community,[10] occupying the lowest position on the tattoo hierarchy. Prison tattoos—due to the technology used to create them, the style in which they are created, their body placement, and the imagery portrayed—visibly express the wearer's social position as a convict. And hand-picked tattoos, which are often self-inflicted, are especially obvious, as they are often on a hand, face, neck, or lower arm and are thus difficult to conceal. By acquiring tattoos during his incarceration, then, a prisoner makes concrete his identity as a convict, and that stigmatized identity carries with him to the outside world once he is released.[11] While lately there has been a new interest in prison tattooing among middle-class tattooists and scholars,[12] this does not mean that prison tattooists have been embraced by the tattoo community at large. This fact is particularly ironic given the desire by convicts to make connections with the outside world. Although many prison tattooists see their ability to tattoo as a means of finding a straight job on the outside, most find that professional tattooists for the most part have no interest in hiring ex-convicts. Convict tattoos also have difficulty when they attempt to publish their designs in tattoo magazines such as *Tattoo* or *Tattoo Revue*. Whether they are rejected due to the quality of their work or because of the

return address on the sender's envelope, I do not know, but the rejection speaks to their low position within the wider community.

The following is excerpted from a letter sent out to three hundred professional tattooists from a convict at Folsom State Penitentiary in 1991. It was accompanied by a request to purchase a collection of prison-designed flash called "Convict Tattoo Pattern Book," the money from which would be "contributed to a good cause" (the prisoner's legal expenses). I am including it here because it is a poignant example of the attempts made by convict tattooists to experience "community" or "brotherhood" with fellow tattooists on the outside.

An Open Letter to All Fellow Tattooist, "Be Aware"[13]

In December 1983 my wife was pregnant in her 8th month with our second son. I was working part time in a tattoo shop for some extra money, I was also working as a welder and going to school. One night while working at the tattoo shop a so-called friend who was living with my wife and me came into the shop with two women. One of the women I knew, the other I didn't. The guys name was Ski, the woman I knew was Linda, and they introduced me to Windy. It seems Windy wanted a set of small roses wrapped around the nipple on her right breast along with a butterfly. I didn't think to ask her age because she looked 23/24 and she was with Ski and Linda. So I put it on, no problem, Ski paid me $70 for the work. Then Windy wanted a small bee at her panty hair line just above the hair as if flying into her bush, no problem, no charge, only took 15 minutes. Now remember, all she was wearing was a dress and pantys, the dress came off when I tattooed her breast and the pantys for the bee. Nothing happened sexually, although it was very tempting, no problem. They left and I never saw Windy again, until I was arrested Feb. 4, 1985 for contributing to a minor and tattooing a minor, she was only 17 years old. Along with that charge I was also charged with attempted rape, sexual battery (touching the breast) and sexual assault (tattoo gun) . . . If all that is not bad enough, Ski, who was suppose to be my partner/friend/scooter brother, the homeless guy I let move in with me and my wife, was out committing kidnap/robberies. When he got arrested he made a deal and told the cops I was the ring leader that set up the robberies and committed some of them myself . . .

Needless to say I was convicted. I got 19 years for the charges on Windy. 172 years for the robberies and 5 life terms for the kidnaps Ski did . . . I have lost my family, home, scooters, everything! I'm on my own now attempting to raise $17,000 to retain an attorney to get me a new trial. I'm still slinging ink, though. Life is a bitch, then we die. ("Grasshopper," prison tattooist)

Grasshopper remains in Folsom, and tells me that his wife has left him, his best friend stole his equipment and supplies, and he regularly gets busted by prison guards for tattooing, thus he spends quite a bit of time in solitary confinement.

The body has always been an important symbolic site in the struggle over the representation of cultural identity. This struggle occurs as the upper classes attempt to control the untamed impulses of the lower classes by regulating their activities and behaviors. Bakhtin (1984) writes of the grotesque body that is represented in carnival folk culture as a defecating, copulating, overeating, bleeding, and altogether excessive body. He compares this to the renaissance body that replaced it starting in the sixteenth century, which is a closed, laminated body whose generative and excretory aspects are hidden from view. As carnival and other ritual spectacles of the lower classes were gradually taken over by the state and reduced to mere parades, the image of the grotesque disappeared as well. Within the tattoo community, we can see a similar transition, as another kind of renaissance displaces the image of the working-class tattooed body—excessively, grotesquely tattooed—in favor of the more refined image of the middle-class body, which, even when tattooed, is elegant and disciplined. In the case of the convict tattooist, the legal prohibition against tattooing in prison combines with society's— and the tattoo community's—negative views toward him to make him the most marginal of figures and the tattooed convict body the most maligned of bodies.

But the struggle over the tattoo occurs on both sides of the cultural borderline. Tattooing has, until very recently, been the privileged form of the working classes in this country and particularly of the marginalized members of the working classes. Its use within this sphere can thus be seen as a form of class rebellion. To wear tattoos—especially visibly antisocial tattoos such as those worn by

bikers and convicts—when they are disvalued is to cause offense, to challenge dominant notions about how the body is to be seen and used, to contest the limits and boundaries placed on the body. Tattooed bodies, and especially the tattooed body of the convict or the outlaw biker, continue to operate as a sign of resistance to middle- and upper-class control, even as the tattoo itself is appropriated by the middle class.

But even as we have seen the (partial) incorporation of lower-class tattoo forms into the mainstream tattoo community, a border remains separating the forms and the people who wear and create them. This border emerges as a type of cultural politics on behalf of elite members of the tattoo community who wish to reconstruct the boundaries between the forms and restratify the tattoo world. As I have argued, this division is based on the artistic, technological, and social factors that separate the various forms of tattooing, and these same factors come into play with regard to how tattooing is represented in the discourse of tattoo magazines and tattoo organizations. Furthermore, the existence of lower-class tattooing is, to a great extent, what gives fine art tattooing its privileged position: the fine art aspect of middle-class tattooing is structured by its relationship to the lower-class form, i.e., by its *difference from* that form.

Through media publications that publicly denounce the lower-class tattoo forms and their representatives, through the tattoo organizations and their campaigns to clean up tattooing, and through the discourse and practices of tattooists, the middle-class promoters of modern tattooing are able to separate themselves from a tradition that is seen as negative, yet they are able to retain the symbol itself. As one tattooist said to me, "They're looking for pedigree or something. It's that snob appeal. . . . Maybe we should be more courteous to other human beings and not look at them to see if their tattoos are not the current rage or something. . . . They want to ask you where'd you get that and they make assumptions about what your associations are and it's like a goddamn country club or if you're a paid up member or something" (Alex M., tattooist). What is at stake in this battle is not just who gets to claim control over the culture of tattooing (although that is a large part of it) but also how tattooed people define themselves with respect to mainstream (nontattooed) society and to each other.

# The Creation of Meaning

## I

### The New Text

I would work at my studio in the trendy East Village in
New York City during the week and then I would go to New Jersey
to work at a production shop on the weekend. The short trip of
twenty minutes traversed much more than just spatial territory.
I would have to prepare myself for the real journey into a
new world of new values every time. It was very interesting for me
to shift gears back and forth between both value systems, different
aesthetics, different motivations. I enjoyed the passage a lot,
[it] kept me honest. — Mike T., tattooist

This chapter addresses the central issue of my research: how the
meanings associated with tattooing have changed in the past decade
and how these new meanings have emerged. Tattooing, as it has
been practiced in the working class for decades, serves a number
of specific functions and carries a particular set of meanings. It is
my position that the popularization of tattooing in the middle class
has necessarily been accompanied by a change in the functions and
meanings assigned to the tattoo in that context. This chapter first

explores the cultural context of traditional tattooing and how it has changed. It also focuses on how the new, predominantly middle-class members of the tattoo community created their own understanding of tattooing by borrowing from what are known as the "New Class" social movements of the seventies and eighties.[1] The self-help, New Age, feminist spirituality, ecology, and men's movements provided the cultural ballast necessary for tattooing to become a meaningful part of middle-class life and gave middle-class people's tattoos new meaning. Finally, I will argue that it is through the *telling* of tattoo experiences—what I call tattoo narratives—that the new meanings acquire real force and are transmitted to others. It is my claim that through these narratives, the middle class is able to legitimate and naturalize for themselves a cultural tradition that was once seen as exclusively lower class.

## *The Changing Context of Tattooing*

For the predominantly working-class tattoo population before the Tattoo Renaissance (hereafter, the renaissance), tattoos were not only visually different from those worn by many today, they also held much different meanings than they do in the modern tattoo community. As many writers have noted, motivations for becoming tattooed in the United States have traditionally included the following: marking affiliation with a loved one or social group, commemoration of a life event or journey, representing an aspect of identity, marking disaffiliation with mainstream society, or simple aesthetic reasons (Ebin 1979; Brain 1979; Sanders 1989). As I wrote in an earlier study, "Tattoos are fundamentally a means of expressing identity, both personal and collective. Tattoos inscribe a person's relationship to society, to others, and to him or herself, and they do so in a manner that is visible not only to the wearer but to others as well. Except when worn in private areas, tattoos are meant to be read by others. For this reason tattoos as identity markers are not merely private expressions of the need to 'write oneself,' but they express the need for others to read them a certain way as well" (1991:107).

The classic American tattoos worn by working-class men and sailors since the turn of the century (including vow, military, animal,

and cartoon tattoos) and the biker tattoos that have developed since the 1960s (Harley twin engines, "Live to Ride," club logos, and skulls) all represent relationships that are important to the wearer, interests of the wearer, or facets of the wearer's identity. In all of these cases, the tattoo chosen will derive its primary meaning from that which is being marked: a relationship, interest, or affiliation. For the most part, in North America tattoos were not originally imbued with a deep spiritual meaning, as they often are today.

As Sanders (1989) has pointed out, the social context in which a person receives a tattoo is often just as important as the tattoo itself because it often forms the individual's first, and most lasting, impression about his or her tattoo. People did not, and do not today, acquire tattoos in a vacuum. Choices are motivated not only by personal preference but often by peer pressure as well. Often, competition among the men gathered in a tattoo shop led to larger, more ornate tattoos being chosen than might otherwise have been. One former sailor told me that during the Korean War, "A lot of times I'd get a free tattoo 'cause I'd go with a guy who never got one before, and he'd be scared so he'd pay for mine. I got a lot of free tattoos that way."

For many men, the decision to get tattooed and the choice of a particular tattoo might have had more to do with the conditions of the period than with the customer's individual preferences. One reason for this is that prior to the influx of new design motifs in the 1970s, there were simply fewer tattoo designs to choose from, and most tattooists did not create custom tattoos for customers. Some tattooists limited design choice even further. Tattooer Charlie Wagner, for example, would decide in advance what type of tattoo he would apply on a particular day and that would be the only design he would offer. One day it might be hearts; another, eagles. If you asked for a heart, for example, on an eagle day, you would find yourself with an eagle tattoo anyway.

Another element that helped create meaning is the larger social context surrounding the people who got tattooed prior to the renaissance. Central to this is the social and economic marginalization experienced by many from the working class, but especially by bikers, who used their tattoos to express their contempt for mainstream society. Although traditional American tattoos as worn by sailors and working men did not tend to challenge North American

values (and in fact were extremely pro-USA, demonstrating a love of mother, country, and God), biker tattoos that developed in the 1960s did. Marijuana leaves, antisocial sentiments such as "Born To Lose," "Fuck the World," "13," "1%,"[2] skulls and death imagery all developed as bikers and other marginalized individuals began to use tattoos to assert, and challenge, their subordinate position in society.

Even the nonconfrontational tattoos worn by sailors and mainstream working-class men posed a challenge to middle-class society, simply because tattoos were disparaged by the middle class. According to one working-class tattooist:

> The appeal that I always had for it was because it wasn't something that your parents encouraged you to get involved with, it was something other than that, and I always thought that that was good, especially for people that basically can't identify with mainstream values or something. They need someplace to go and people to talk to that don't have to bitch about what their mutual fund did that month or the fact that the BMW needs new tires or some goddamn thing. That's not what tattooing's all about. It's about an expression for people that live in a world that offers them no expression and that treats them like dirt and shows them no gratitude. It gives them an opportunity to at least stand out and be a part of something that they feel that they can be a part of because they're not a part of anything else. (Terry T., tattooist)

For the sheet metal workers, machinists, and carpenters who make up Terry's customers, tattoos provide both a form of personal expression as well as a reward for, and an escape from, their daily lives. Additionally, tattoos provide an emotional charge that comes from getting something that is seen as disreputable, that is known to hurt, and that is not worn by their boss or foreman. The fact that tattoos have traditionally been seen by the public as shocking, subversive, and antisocial lent much to the meaning and function of traditional working-class tattoos.

Traditional working-class tattooing has one final attribute that has radically changed along with the artistic innovations introduced by tattooists like Ed Hardy and Leo Zulueta. It is my position that traditional working-class tattoos have been shaped by an image of, and a particular relationship to, the body that is different from that

typically found in the middle class. Following Bourdieu, we cannot understand the logic of an individual's inclination toward tattooing without understanding how that person inhabits his or her body. Further, how a person inhabits his or her body derives from that person's social position. Nancy Scheper-Hughes, in her discussion of the physical maladies of poor sugarcane workers in Brazil, writes, "From the phenomenological perspective, all the mundane activities of working, eating, grooming, resting and sleeping, having sex, and getting sick and getting well are forms of body praxis and expressive of dynamic social, cultural, and political relations" (1992:185). Thus the shanty workers of Scheper-Hughes's ethnography inhabit and experience their bodies in ways that are very different from those of their middle-class bosses, and the forms that their illnesses take are an example of this. I would suggest that tattoos, too, are a form of body praxis, and that men and women, gays and straights, and working-class and middle-class people will all approach tattoos differently, based on their own social positions. That one's "habitus" (per Bourdieu 1977, 1984) will affect one's choice in tattoos may seem far-fetched, nevertheless it is clear to me that for many in the middle class, choosing to mark one's body is a much more complicated matter than it once was (and still is) for many in the working class.

For example, one of the middle class's primary objections to tattooing has historically been that the body is inviolate, too pure to be disfigured. Additionally, tattoos are so *permanent*. The middle class has typically viewed getting a tattoo a sign of a lack of discipline and self-control, of an inability to consider the future. But for middle-class members of the tattoo community today, tattooing is every bit as permanent as it ever was. Yet today, this permanence is interpreted in positive terms. The body is now seen as a temple, and tattoos are used, as more than one person has expressed to me, as a way of *decorating* that temple. But tattoos are only viewed this way if they are artistic and well thought out; in other words, only if discipline and self-control have been exercised during the decision-making process. The following message posted on the Internet is an example of this attitude: "I have been interested in getting a tattoo for quite some time, and now I have finally decided on a pattern I would like. But I would want any permanent marks on my body

to be something akin to works of art, not just something any ink-slinging hack could whip out in a few minutes" (Bobby S.).

Compare this view to the way tattoos were typically acquired prior to the renaissance (and are still acquired in many street shops today). The classic approach to choosing a tattoo involved walking into a tattoo parlor with Friday's paycheck and picking a design off the wall that suited one's fancy. A World War II veteran told me how he acquired one of his tattoos during the war: "One night, we didn't have anything to do and we all went down about 2:00 or 3:00 in the morning and we went into this tattoo place and we only had five bucks between us. What can you get three of for five bucks? So that's how I got this rose. We got three of those for five dollars" (Dave F.). Another man recalls his experiences picking a tattoo design during the same period: "At that time, a lot of guys were getting skunks, they were just real popular. The black panther was real popular then, too" (Frank C.). These men's tattoo choices were based on economics and the types of images circulating through popular culture at that time. But neither man expressed a concern that he needed to receive a "work of art" on his body, or that he might regret his choice fifty years later (and neither has). For me, the ease with which men (and to a lesser extent, women) were once able to permanently alter their bodies indicates a conception of the body that is flexible and open. It also points to an aesthetic sense that is not bound by rigid standards.

All of these aspects—a desire to mark the body with symbols of affiliation, a flexible conception of the body, the social position of the wearers, and the social context surrounding tattooing—contributed to the prior text that provided the grounding for traditional working-class tattooing.[3] But the new, middle-class members of the tattoo community do not share this prior text. What then has enabled the tattoo to move into the middle class? Aram Yengoyan, in a paper on the development of traditions in Southeast Asia, writes that "the wholesale borrowing of foreign and distant ideologies into contexts not producing the prior texts does not invoke the intellectual and emotional sustenance required of action and political mobilization unless these foreign ideologies are culturally mediated, as was the case in Sukarno's Indonesia" (1992:10). For Yengoyan, cultural mediation is necessary to provide a basis for the compre-

hension of a new cultural form in its new social context. In the case of Indonesia, the cultural forms that were cast by Sukarno as symbols of a united Indonesia (the flag, the gamelan [orchestra], Bahasa Indonesian [language]) all had some historical relevance to Indonesians and were thus able to resonate. In the case of tattooing, however, the borrowed cultural form—the tattoo—could not be comprehended within the middle-class cultural system. There simply has not been a framework within which to interpret tattooing in a positive light. In order for tattooing to become acceptable to a middle-class audience, it was necessary for the working-class prior text to be disregarded and a new text created that is based primarily on the cultural system of the middle class.

This new text was created by recasting tattooing from an ill-conceived, spur-of-the-moment decision into a totally new artistic and cultural form. It is my argument that this new cultural form was derived from the social movements that emerged during the period when tattooing began to shift into the middle class, and it was these movements and their ideologies that provided the intellectual grounding for the new tattoo community.

Of course, it would be untrue to state that all working-class people, or all people who got tattooed prior to the renaissance period, held the same, fixed ideas about their bodies. They also did not all have the same motivations for becoming tattooed. Likewise, whether middle class or working class, members of the tattoo community today express a wide variety of motivations for, and feelings about, becoming tattooed. A sailor who received a tattoo in order to mark an important life journey, or a gang member who received a tattoo as part of a ritual marking entry into gang life, are not that different from today's fraternity members' being tattooed with the Greek letters of their house. Similarly, plenty of middle-class kids today take advantage of the traditional stigma associated with tattooing in order to rebel against their families or society. Their tattoos, then, function in a more traditional manner. I do not want to overplay the differences that I have outlined or imply that either class group or era (pre- and postrenaissance) is monolithic. But I do want to demonstrate the vast changes that have taken place in the last two decades within tattooing. These changes, while not totally due to middle-class participation, have certainly been strongly influenced by it.

I contend that the modern, middle-class understanding of tattooing is derived from a number of social movements that became popular in the seventies and eighties, including the self-help, New Age, women's spirituality, men's, and ecology movements. At this time, there was a turning inward among many in the United States such that much of the social activism of the earlier period shifted toward an emphasis on personal transformation. According to many observers, this was a moment of profound importance—a revolution of human consciousness that affected how people thought about relationships, religion, work, education, and the self. Tattooing began, for the first time, to be connected with emerging issues like self-actualization, social and personal transformation, ecological awareness, and spiritual growth.

Many of the ideas popularized in these movements could also be found, before their association with middle-class tattooing, as a central part of the body modification practices of the gay, lesbian, and S/M communities. For example, tattooing, scarification, cutting, and piercing have been used for years within the S/M community as rites of passage and as a means of gaining self-awareness and self-acceptance (Truscott 1991). In fact, since at least the 1960s, the leather and S/M cultures (with or without tattooing or other forms of body modification) have been seen as a path to enlightenment and a transformation of the self and thus predated by at least twenty years the modern tattoo community's evolution. Whether the straight, middle-class tattooed people borrowed directly from, or were even aware of, the tattoo practices and their associated meanings found in S/M, I do not know. But it is clear (as I will discuss in chapter 6) that many of the spiritual and therapeutic uses of tattooing that the middle-class tattoo community later popularized actually originated much earlier in the leather and S/M communities, and the fact that many individuals belonged to both the tattoo community and S/M scene contributed to this cross-fertilization.

*Self-Help* ➤ I use the term "self-help movement" to describe the burgeoning interest in pop-psychology and self-awareness that developed in the 1970s and that continues today. Self-help describes

a movement whose adherents use psychotherapy, twelve-step pro-grams, and other psychological techniques to become happier and to eliminate negative behaviors or attitudes such as codependency, depression, and eating disorders, or to achieve loving relationships with others. The philosophies of this movement are expressed in key books like *Codependent No More* (Beattie 1987), *The Courage to Heal* (Bass and Davis 1988), *Feeling Good* (Burns 1980), *I'm OK, You're OK* (Harris 1967), *Passages* (Sheehy 1976), *Your Erroneous Zones* (Dyer 1976), *The Road Less Traveled* (Peck 1978). They were also taught in workshops sponsored by groups such as Esalen, est, Silva Mind Control, Actualizations, Lifespring, and Dianetics. Self-help books, workshops, radio shows, and philosophies appealed to what Christopher Lasch (1979) called the "therapeutic sensibility." This refers to both the increasing interest in mental and emotional health, as well as to the power that is ascribed to the individual will in achieving this. In his 1979 book, *The Culture of Narcissism*, Lasch describes this moment as one of profound narcissism: "Having no way of improving their lives in any of the ways that matter, people have convinced themselves that what matters is psychic self-improvement: getting in touch with their feelings, eating health food, taking lessons in ballet or belly-dancing, immersing them-selves in the wisdom of the East, jogging, learning how to 'relate,' overcoming the 'fear of pleasure'" (1979:29). I would add tattoo-ing to Lasch's list of self-improvement techniques. That tattooing could have ever been seen as a tool for self-improvement, along the lines of yoga or Jungian therapy, would have seemed ridiculous to old-time tattooists. Yet today, many tattooists market themselves as modern-day therapists. The late tattoo artist Jamie Summers, for example, "was dedicated to helping others (and herself) achieve fulfillment through development of their psychic potential. Tattoo was 'just another medium' for accomplishing this objective" (Rubin 1988b:257). Summers, like many artists today, offered herself as a "guru" to her clients, designing their tattoos to align with their inner state of consciousness. Other tattooists share this perspective. As one southern California tattooist told me, to tattoo someone is "a healing, a laying on of the hands, it is a personal thing, you are touching them in very powerful ways that will last them for a long, long time."

Today, tattooing is thought to give individuals the means to work out their personal and emotional issues on their bodies; first, through tattooing personally meaningful images onto themselves and second, through interpreting those images within a therapeutic framework.

*New Age* �»  Next to the movement that I am calling self-help, what has come to be known as New Age is the most important influence on the current discourse surrounding tattooing today. The New Age movement arose around three interrelated elements. First was a period: starting in the late 1960s increasing members of the middle class began to experiment with Eastern religions and consciousness-transforming techniques, to explore the occult realm, and to seek answers through inward searching. Second was a changed value system that was seen as holistic and that espoused an expanded conception of human potential that could be used to revitalize society. Third were the borrowed practices and symbols employed by New Age supporters, such as Tibetan Buddhism, Neo-Paganism, astrology, tarot, numerology, Native American spirituality, shamanism, mysticism, transcendental as well as other kinds of meditation, and Eastern spirituality. Marilyn Ferguson's 1980 book, *The Aquarian Conspiracy: Personal and Social Transformation in the 1980s,* is the seminal text that describes the origins and philosophy of New Age—what she calls the Aquarian Conspiracy. She describes this "conspiracy" as a series of unconnected circles of individuals and organizations who share a certain vision of society:

The transformative vision was shared by individuals in many social movements—networks about madness, death and dying, alternative birth, ecology, nutrition. A web of "holistic" doctors, another of medical students and faculty on various campuses, formulated radical ways of thinking about health and disease. Maverick theologians and members of the clergy pondered "the new spirituality" that rose as churches declined. There were networks of innovative, "transpersonal" educators, caucuses of legislators, and a melding of economists-futurists-managers-engineers-systems theorists, all seeking creative, humanistic alternatives. . . . In the late 1970s, the circles began closing rapidly. The networks overlapped, linked.

There was an alarming, exhilarating conviction that something sig-
nificant was coming together. (Ferguson 1980:63)

This vision was also shared by increasing numbers of middle-class,
gay, and lesbian tattooed people, who saw in their tattoos the pos-
sibility for transformation.

Tattooed people, and especially those who embrace the modern
primitives (see chapter 3 and my discussion of tribal tattooing) dis-
course, see the tattoo as a key toward greater freedom, creativity,
individuality, spirituality, and self-realization. Tattoos today are be-
lieved to possess powers that would have astounded old-time tattoo-
ists like Sailor Jerry. For example, a tattoo is seen to be able to act
as a talisman in times of crisis; it can unify the body and spirit; and
the process of tattooing can be a rite of passage that counteracts
social alienation. All of these ideas about tattoos are new and all are
clearly linked to the New Age discourse. For the middle-class tattoo
community as well as the S/M communities who have used these
practices and ideologies for far longer, tattooing is a way to get in
touch with one's spiritual essence. In addition, the symbols favored
by many tattooed people today are derived from the philosophies
and religions that are a part of New Age philosophy, such as the
yin/yang circle, the chakra points, zodiac signs, Sanskrit writing,
Japanese characters, feathers, and drums.

*Goddess Religion* ➺ One particularly powerful offshoot of the New
Age movement is known variously as Goddess religion, feminist
spirituality, Wicca, Neo-Paganism, or witchcraft (the Craft). Since
the 1960s, there has been a resurgence of interest in various
occult teachings, including astrology, tarot, and numerology, to
name a few. Wicca, or Neo-Paganism, is perhaps the most influ-
ential of these, and has made the deepest inroads into middle-
class North American society, partially through its association with
mainstream feminism and environmentalism. Although there are
hundreds of types of Neo-Pagan philosophies and groups, both in
the United States and Europe, most share a similar worldview that
includes living in harmony with nature; revering the earth and its
creatures; believing in many gods (polytheism); distrusting mod-
ern society; and focusing on ancient rituals, myths, and symbols.
Modern Wiccans see themselves as continuing a religious tradition

that was once ostensibly worldwide and dates back to Paleolithic times. The "Myth of Wicca" (as Margot Adler [1979] calls it) can be found in the writings of Gerald Gardner (1954) and especially Margaret Murray (1921). Both of these writers claimed that European goddess-worshipping cults were part of an organized, worldwide fertility cult (as described in James Frazer's *The Golden Bough*) that has survived unchanged into modern times. While the idea of an ancient, universal fertility cult has been refuted by scholars, the writings of Gardner and Murray, as well as Robert Graves's *The White Goddess* (1966), helped fuel the modern Wiccan revival.

In the 1970s, Wicca experienced a second revival with the publication of Starhawk's seminal book, *The Spiral Dance: A Rebirth of the Ancient Religion of the Great Goddess* (1979). This book linked the Murrayite view of the "Old Religion" to modern feminism. Like other witchcraft practitioners, Starhawk promoted a worldview that linked humanity with nature and that drew heavily on Celtic symbols and rituals. But for the first time, Starhawk connected witchcraft to a uniquely feminine spirituality. Starhawk's Goddess religion draws heavily on the work of feminist "thealogists" such as Mary Daly (*Beyond God the Father* 1973) and Mary Christ and Judith Plaskow (*Womanspirit Rising: A Feminist Reader in Religion* 1979) who discuss the political implications of embracing a spirituality centered on a feminine, nurturing power, rather than on a masculine, controlling one. Like the men's movement of the eighties and nineties, Goddess religion is said to have the power to change society: "True social change can only come about when the myths and symbols of our culture are themselves changed. The symbol of the Goddess conveys the spiritual power both to challenge systems of oppression and to create new, life-oriented cultures" (Starhawk 1979:10).

Many tattooed people today embrace a Neo-Pagan philosophy that views modern society as repressive, alienating, and lacking in ritual. Contemporary tattooing also resembles Neo-Pagan philosophies through its appropriation of non-Western symbols and rituals that are considered more meaningful than those found in modern Western culture. Although both tattooed men and women are drawn to the Neo-Pagan ideas and images, straight women and lesbians especially wear tattoos based on feminist images (Venus of Wellendorf, the ankh, the astrological symbol for Venus); acquire

their tattoos in a ritualistic, "magickal" context; and discuss their tattoos using language borrowed from the Goddess movement.

*The Men's Movement* ➤ Just as some modern tattooed women draw on the beliefs of feminist spirituality by asserting that tattoos help the wearer to access her inner feminine strength, many middle-class tattooed men draw on the discourse of the men's movement to provide meaning for their tattoos. The men's movement is especially concerned with revitalizing North American culture (seen as morally and spiritually bankrupt) through borrowing rituals and myths from non-Western cultures. Some, of course, see it as a grown-up version of the Boy Scouts in that it allows straight middle-class American men to use ancient stories and rituals to re-mythologize their lives. (I specify straight men here because gay men who participate in the leather scene have been using the same kinds of rituals, myths, and tools that the men's movement popularized, and for much longer.) Leaders of the men's movement call for a return to the values of preindustrial and pretechnological societies and see within the myths and rituals of primitive society the hope for a new masculinity and a new world. The primary spokesman for this movement, Robert Bly, writes: "To judge by men's lives in New Guinea, Kenya, North Africa, the pygmy territories, Zulu lands, and in the Arab and Persian culture flavored by Sufi communities, men have lived together in heart unions and soul connections for hundreds of thousands of years" (1990:32).

Men's movement participants envision a world where men cooperate, share, and support each other. Repairing the lack of a soul union among men in Western society today is the goal of the modern men's movement. One focus for the movement, then, is to reintroduce initiation rituals for modern men, as it is the initiation received *from men,* or a man's "second birth," that is said to turn the boy into a man. Again, from Bly: "The ancient societies believed that a boy becomes a man only through ritual and effort—only through the 'active intervention of the older men.' It's becoming clear to us that manhood doesn't happen by itself; it doesn't happen just because we eat Wheaties. The active intervention of the older men means that older men welcome the younger man into the ancient, mythologized, instinctive male world" (15). Thus, for sailors or soldiers getting a tattoo at the end of boot camp, the

first tattoo was often seen as an initiation into manhood, like a trip to the whorehouse. These early tattoo experiences were a primary means for a young man to experience the company and world of older men. Through the 1960s, tattoo parlors were places where all kinds of working men could safely interact, without worrying about offending their wives or their bosses.

But what about middle-class men? Does tattooing today fulfill the kind of initiation ritual or second birth that, according to Bly and others, so many men lack? Bly says that the ancient practice of initiation is "still very much alive in our genetic structure" (36), and for many middle-class men and women being tattooed today, tattooing also is instinctive: it is in the blood, so to speak. Mechling and Mechling (1994), in their discussion of Bly's *Iron John*, unwrap the psychological basis of this text and point out the underlying Jungian essentialism, which is predicated on the notion that men can find within themselves an essential maleness, the warrior within, just as women are prompted to seek their inner archetypal female through their reading of the Goddess texts or the new books on the "wild woman" (such as Estes 1992).

Tattooing today, however, is not an exclusively male ritual, and the modern tattoo shop is no longer a site of working-class masculinity. The naked geisha girls, shimmying hula dancers, and military badges have been replaced in the custom studio by abstract "tribal" art, Japanese flowers, and Sanskrit writing. On the other hand, the *notion* of tattooing as a rite of passage is extremely salient for many men who are becoming tattooed today, although it is not seen as an initiation into manhood. Instead, the ritualistic aspect of modern tattooing has been highlighted, and tattooing has become a spiritual act.

*Ecology* ➤ Perhaps the oldest of the social movements I have discussed that has influenced tattooing is the environmental or ecology movement. Although environmentalism relates most fundamentally to the earth and to people's relationships with the earth, it has had a profound impact on more personal philosophies as well. Indeed, in some cases environmentalism has taken on the quality of a spiritual movement. Environmentalism and related movements such as vegetarianism or protection of animals' rights reflect a desire to achieve a more holistic and less destructive relationship with

the planet. Like the men's movement or Goddess religion, it borrows its ideal of the "perfect state" from non-Western cultures and from (supposedly) more environmentally conscious periods in U.S. history. Again, Western society is viewed as morally bankrupt in its commitment to capitalist, technocratic, and individualistic values, and other cultural traditions are sought that might provide a more healthy attitude toward the earth and its inhabitants. Non-Western, nonindustrial peoples and their habitats are hailed as environmental models for their subsistence-based (rather than commercial) traditions and people are encouraged to help maintain this "primitiveness" at all costs (Kalland 1993). Brazilian rain forests, Yanomamo shamans, along with Western endangered species such as whales and spotted owls have all been co-opted as symbols of the environmental movement, and their use as tattoo designs within the tattoo community reflects the power of their symbolic associations.

The ecology movement, like the other New Class social movements described above, provides a symbolic and discursive model for the tattoo community to follow. Most of these movements emphasize personal narrative as a means of healing the self and, more primarily, defining the self. All use symbols—Jungian, occult, primitive, or religious—to make abstract ideas concrete. Most share a rejection of modern, Western society and instead adopt the values, myths, symbols, and rituals of primitive societies. Many draw on essentialist ideas that seek to find in our past, or in our psyches, a more complete self, one that is somehow natural and connected to the earth. This essentialism is an important aspect of the mazeway (to borrow a term from Anthony Wallace 1956) of modern tattooed people, as many consider their tattoos to be rooted in instinct. Many also include what Marilyn Ferguson (1980) calls "psychotechnologies," which are the intentional triggers of transformative experiences and may include meditation, psychotherapy, body disciplines like yoga or tai chi, tattooing, piercing, or use of hallucinogenic drugs. All of these movements were popularized by middle-class, educated people who wanted to challenge (at least symbolically) the cultural conditions that gave them their power in the first place. And finally, most of these movements (with the exception of the ecology movement) are narcissistic in that they are completely focused on the self.

The popular understanding of these movements, as I have out-

lined them here, has been extraordinarily influential in the evolution of contemporary tattooing. Ironically, tattooing is a practice that modifies the outermost aspect of a person's body—the skin— yet now, as they are interpreted through the language of Robert Bly or Starhawk, tattoos are seen as representing the wearer's innermost self. What is even more ironic is the way that discourses popularized and commercialized by the middle class are used today to provide meaning for an essentially working-class folk tradition. As I will show in chapter 6, these discourses do more than this—they also serve to displace the contributions of the working-class men who pioneered the art of tattooing in this country and to invalidate the experiences of people whose tattoos were not acquired for their transformative power.

## Telling about Tattoos

Today, tattooed people—especially those who look like they should not wear them—are frequently asked about their tattoos and have thus created lengthy narratives to explain them. But this has not always been the case for tattooed people. As one tattooist who has been working since the 1950s told me,

> In the old days, everyone just said they were drunk, because they were ashamed of it. Somebody yesterday who I put a tattoo on, said her father had tattoos from the navy in the thirties, from Panama, and he always said that he wished he could get them off. My feeling on that is that the people are bowing to social pressure. I just think that people wouldn't be that unhappy with their tattoos if they had some kind of reinforcement. They get back home and the wife bitches at them. . . . So I think in the old days, which was even when I started tattooing, people just tended to hide the reasons that they got it. They couldn't just stand up for it because there was so much disapproval. (Charlie T., tattooist)

If people once felt the need to hide the reasons that they got tattooed, fearing social disapproval, this is no longer the case. Instead, people now feel the need to justify their tattoos and they do so in often elaborate terms.

I have argued that the consciousness movements discussed in

the previous sections have contributed to the creation of a new dis-course surrounding tattooing. Further, the narratives that tattooed people began to produce during this period were clearly derived from them. Through these narratives, we can see how people pro-vide meaning for their tattoos, meanings that are especially neces-sary within a middle-class context that traditionally has not viewed tattoos in a positive light. These narratives form the basis of the individual's personal understanding of his or her tattoo, just as the narratives of alcoholics or adult victims of child abuse provide those individuals with a particular history and identity that is shared with others who have been through similar struggles.

As in other types of narratives, such as those relating conversion experiences for Pentecostals (Lawless 1988), tattoo narratives have a stylistic coherence, and most contain very similar motifs. These motifs typically include why the wearer decided to get tattooed, how he or she came up with the design, the meaning of the de-sign, how long the individual had been thinking about getting one, the actual tattoo experience, and what it means to him or her now. Also like conversion narratives, tattoo stories centralize one experi-ence—the tattoo—and relate what changes have occurred in the tat-too wearer's life since that central, defining point. Tattoo narratives, however, are different from other types of life-story narratives in that they do not rely so heavily on memory and are much more self-reflexive. Tattoo narratives are especially constructed to *re-create* for both the teller and the listener not only the "facts" of the tattoo but the complex justifications for it. Furthermore, these justifications are constantly changing as the teller is exposed to other discourses that might further inform his or her narrative. Following is a good example of a tattoo narrative told by an English teacher:

I would be considered the middle class, not the tattoo type, the per-son you would not expect to be into that. In 1989 I decided that I wanted a tattoo but I wasn't sure what. I went to a few shops and I saw the standard flash and decided that none of that was really for me. Eventually I decided that I would have to create my own design even though I'm not particularly artistic. The good part of this is it forced me to look at who I am and what might express who I am rather than a standard Yosemite Sam or Tasmanian Devil type. What would symbolize me? And after some thought I decided, especially

since I'm interested in show business, that a star would be a good symbol, but what did that mean? I decided that what that symbolized was that we should all be the star of our lives, that we should not live for someone else, that we should all be the center, that we should be the star of our show. I don't mean that in an egotistical way, but if you live for other people you'll inevitably be disappointed because your feeling about yourself will be contingent upon how others judge you and whether you're doing enough for them and whether you're letting them down. (Gary E.)

Gary's narrative includes a number of common points: reassurance (to himself and to the listener) that he is not the "tattoo type," a disparaging statement about classic American tattoo designs (Yosemite Sam and Tasmanian Devil), and his justification for and symbolism of his tattoo. Gary's tattoo is very simple—a gold star the size of a nickel on his ankle—yet the meaning that he provides for it is quite complex.

Sometimes the narrative will also include the experience of "coming out" as a tattooed person to one's family and friends, as is demonstrated by Lin's detailed account:

My parents were the first people I told. I had the opportunity to tell a good friend of mine the night I got the tattoo but I didn't because I wanted my parents to be the first to know. We have a very close relationship and, even though I didn't tell them I was planning to get the tattoo, it would have been weird for me to tell someone else before them. I had no idea how they were going to react. My parents are such that either overreacting and wondering what the hell I did to myself or being absolutely fine with it would have been an expected reaction from them. When I spoke to them on the phone (we speak at least three times every week) the day after, I was very nervous and I didn't know how to bring up the subject. I'd hoped that they would ask me what I did the day before but, no go. So, I had to bring up the subject myself. . . .

They were surprised, but more of a "Can you believe her?" kind of surprise that was just like the surprise that they had when a TV show called me up and asked me to speak about an issue based on an e-mail I sent them. They've always been impressed by the way I set my goals and achieve them, no matter what other people say. To them, my tattoo was just a part of that. . . .

Of course, it would be a lie to say that they weren't a little shocked, but I told them all about the research I had done and what it meant to me, and I think that helped them understand more and get over the shock. I also think that a lot of the shock was due to the fact that I hadn't told them about it, but I explained that too.

Lin, a college student at a midwest university, continues by discussing how she told her brothers, and then her friends.

I told my oldest brother next. His reaction was "Way to go, kid!" It turns out that he's always thought of getting a tattoo himself, but he hasn't been able to think of a design that he would want. He was impressed that I had been able to do that and actually go through with it.

My other brother, the one who lives in London, I told via e-mail. And here I have to admit to a little childishness. I didn't get the tattoo for the shock factor (it's located on my right thigh and any pair of decent-sized shorts would hide it from view. I got it so I could see it and so I would know it was there, not so others could see it and say "You got a tattoo! Oh my God!"), but I had been gearing up for weeks for someone to act surprised (my parents told my grandmother, a little old matronly Italian woman, and even she wasn't shocked) so I wrote the letter to surprise him. I didn't save it, but I said something along the lines of, "Boy, what does it take to shock our family? I told Mom and Dad that I got a tattoo, which, by the way, I did, and they didn't even blink!" and that was all I said on the subject. He sent me back a surprised e-mail and demanded to know more. He wasn't angry or disappointed though, just miffed that I didn't include more details.

My friends were the only ones left to tell. This was a little odd in trying to figure out. Like I said, I didn't get it for the benefit of others so I didn't feel that I suddenly had to call up everyone in the world and say, "Hey! I got a tattoo!" but I wanted my close friends to know. To a certain extent, this meant figuring out who was close enough to know. I told one of my closest friends the next day (my best friend couldn't be reached until the next week or I would have told her right after my family) and, while he was a bit surprised, he had also been around while I kept looking through magazine racks trying to find things about tattoos so he realized that the clues were there if he only paid attention.

My best friend was a bit more surprised but I think this is because she doesn't know much about tattoos, so (I'm guessing here based on the fact that she's had a sheltered childhood) I think all she knew about tattoos was the only-drunk-bikers-and-rock-stars-get-them mentality, which my getting a tattoo put a lie to, so she not only had to deal with me having a tattoo but the whole idea of tattoos as a concept. She was very interested in the books and magazines I had so I think she was intrigued by the idea.

Another friend of mine was there when I told my best friend and she was a bit surprised as well. Her reaction was more along the lines of "Oh, really?" in the sense of "Hmm, how *am* I supposed to react to this?" We had been watching an episode of MTV's *The Real World* when one of the people on it got a tattoo (thus giving me the perfect opportunity to mention mine) so she was able to steer the conversation onto what was it like in relation to what we were seeing and therefore be more comfortable with it.

The last friend who was close enough for me to tell and important enough for her reaction was one who recently got some piercings. Her piercings are somewhat personal (one's for her twenty-first birthday) [and gotten] somewhat on a lark (she likes the shock value). I didn't mention why I got my tattoo, only that I got one, and she at first assumed it was for the same reasons as her piercings. Weeks later we got into a conversation about it and she said that she was impressed by how much deep thought had gone into it. (Lin T.)

Notice the various elements present in Lin's narrative. She includes her relationship with her parents (they are close), a statement about how well thought out her decision was ("all the research I had done and what it meant to me"), the support she received from family and friends and misconceptions held by friends about tattoos (only-drunk-bikers-and-rock-stars-get-them), how she was able to educate her friends about tattooing, and how she used a television show to focus conversation on the topic with another friend. She also emphasized the reaction that she expected to receive—shock, anger, disappointment—and was relieved that her family and friends were more open than she feared they might be. All of these elements signify how difficult the decision was to tell her family and friends because of the negative perception that tattoos held within her social environment. Lin, like many middle-class men and women today,

possesses both a tattoo narrative (which I did not include here), as well as a coming out narrative.

The shape that a tattoo narrative takes is in many ways a result of the questions that tattooed people are asked and the context in which they are asked. The narratives are dialectical in that they presuppose a questioner or listener who objects to, or at least cannot understand, the tattoo. As a tattooed woman, I can attest to many years of being approached by everyone from co-workers and students to strangers. They tended to ask similar questions: Why did I get tattooed? How did I pick the designs? What do they mean? The implication behind all of these questions is, Why would a middle-class woman disfigure her body in such a manner? Clearly, I should know better. However, sometimes tattoo narratives form in response to the questions that people do *not* ask about tattoos. These accounts are instead structured to counteract the unspoken assumptions present in a stranger's stare. This young university librarian's narrative demonstrates such a response.

> Now, I have been getting very interesting reactions about it. Actually, it's that I *don't* get any comments about it. I mean, it's strange. You'd think I'd get some comments, right? I got a few in the first couple of sessions I went on the [jogging] track. Most of them were "That's very pretty." And that was about it. Nobody wanted to discuss it at length or anything. They simply did not know how to approach the subject. Now, envision the situation. When I go down to the track, [I walk to it from where] I work on campus on the upper end. I usually show up in my business outfit (well, as business-y as you can get wearing comfortable L.L. Bean clothes), then proceed to strip down to my running outfit while we're having our meeting prior to the workout. They know I look very normal. I don't look like a tramp or anything. And the tattoos look very nice — not the old Popeye anchor type that people expect. I do catch people looking at it. In fact, that happened this week. I happened to look over my shoulder at the edge of the track, and a woman was standing there talking to her friend and obviously making eyes at my leg piece. Instead of just turning away, I held my sight on her for a second — and she looked up to meet my eyes. I started first, saying "Yeah, it actually goes up like this," pulling up the side split on my shorts to show her that it extended quite a bit more up. She kept saying something

like, "Oh, it looks so real!" So I told her how the artist had a fine arts degree and that many contemporary artists even had M.F.A.'s and things like that. But you see, I had to catch her looking at it. They would've never talked to me otherwise. (Tami T.)

Tami assumes that the woman surreptitiously staring at her tattoo —a Hawaiian orchid on her hip—thought that she was a "tramp." In response, she engaged the woman in a discussion about her tattoo and carefully controlled its direction so that the woman would know that Tami was not sleazy. In addition, Tami's response included a statement about the artistic credentials of contemporary tattooists, a common feature in middle-class tattoo narratives. In the case of this narrative, though, Tami did not mention her artistic background in fine arts to impress me (since she knows I am tattooed) but to impress the woman to whom she was speaking.

My own personal narrative has evolved over the years, but when I first started becoming tattooed (1986), it included many of the same elements that I have found in other women's stories. It originally went something like this:

My first tattoo is a dragon on my back. I got it because it's both my Chinese astrological symbol and I considered it as well my "totem." I felt that it gave me strength. I was going through a difficult time in my relationship and was unhappy with the direction my life was taking. So I quit school, got a job as a cocktail waitress, got this tattoo, and got my nose pierced—all in the same week. I felt that these decisions were instrumental in helping me to turn my life around. Later I got my second tattoo, an Eye of Horus on my arm, for similar reasons: it's the Egyptian god of rebirth and I felt that it would symbolically help me to get through another crisis in my life. The tattoos on my arms were based on the pagan elements: fire, earth, air, and water and were originally intended to include Japanese-style plants that are associated with each element (chrysanthemums for fire, peonies for water, cherry blossoms for air, and branches for earth). I felt that I needed to include all of them in order to have balance in my life.

I don't tell this story about my tattoos anymore. Although it accurately reflects what I was going through when I got many of my tattoos, it doesn't reflect where I am today. When people ask me

to explain my tattoos now, I just say that I like the way they look. But why do I no longer need to explain my tattoos in terms of their connection to my spiritual and emotional state? These days, I get tattooed because I think tattooed skin is more interesting than un-tattooed skin, and I am not ashamed of the fact that my tattoos no longer carry a deep, emotional significance. It could also be that I have worn my tattoos long enough that I am no longer worried about what people think of me—even when being accosted by an old woman in the produce section of the grocery store, who called me a "devil-worshipper" (which makes being seen as sleazy pretty mild).

It is no accident that tattoo narratives emerged in the 1980s, the period when the middle class began to wear tattoos in greater num-bers. According to Mechling and Mechling (1994), the 1980s was the "decade of the story" in that a number of prominent intellec-tual movements forefronted self-reflection and narrative as a tool for self-understanding. Thus the self-help and men's movements, as well as others, contributed to the modern discourse surrounding tattooing in two ways: by providing many of the meanings that are now associated with tattooing, and further, by providing the means by which these new meanings were articulated—through personal stories. In chapter 6, the narratives themselves will be forefronted as a means of understanding how tattooed people envision them-selves as individuals and as a community.

# The Creation of Meaning

## II

### The Tattoo Narratives

The most important thing [about my tattoos] is about me,

who I am, my identity. It reflects on what I am. When they

see all this, they know I like the mountains because it

reflects on what I like. — Codi

In seeking to understand how the meanings and functions of the tattoo have changed for many within the tattoo community today, I found that looking at tattoo narratives was an excellent way to get at what I was seeking. In this chapter, I present material from these narratives in order to demonstrate how people use the discourses of the liberatory social movements in order to provide a framework for understanding their tattoos, their community, and themselves.

Collecting the stories was relatively easy. People like talking about their tattoos and, as I have mentioned, are used to doing so because they are so frequently *asked* about their tattoos. The primary place where I gathered these narratives was at tattoo conventions where I would find the largest number of tattooed people together at one time. Since "membership" in the tattoo community is so vague, I wanted to limit my informants to those with a strong interest in tattooing. Because I argue that attending conventions is one of the key

rituals necessary for membership within the community, I knew that attendees would fit my definition. I also interviewed people via e-mail, typically after I had met them on rec.arts.bodyart, the body modification Internet newsgroup. As I argued in chapter 1, RAB constitutes another important space where community is created.

Even though the individuals interviewed for this chapter were both middle class and working class, my informant base was heavily skewed toward the middle class. This is partly because of the areas in which I chose to interview (tattoo conventions and Internet chat groups) and partly because of my goals. A primary focus of my research was to explore the ways that middle-class participation in the tattoo community has changed both the nature of the community and the meaning of the tattoo. For this reason, then, I especially sought out middle-class informants. I also spoke with many more women than I did men, although this was not intentional. It may have simply been that I felt more comfortable approaching women or that they were more open to talking to me than men were.

I tried not to direct the stories in any particular direction. I told people only that I was an anthropologist doing research on tattooing and that I was interested in people's stories about their tattoos. I also told everyone up front (if it was not already visible) that I was tattooed. I hoped that this would allow my informants to speak freely with me and would show them that I did not look down on them for being tattooed. Interestingly, even when the speakers knew that I was tattooed, many people still felt compelled to assure me that they were not trashy, that their tattoos were well chosen, or that their tattooist was not a biker. This aspect of the tattoo narrative is obviously indispensable for middle-class speakers.

I have organized the narratives in this chapter thematically in order to highlight the most common elements that I found during my interviews. (I have also shortened them considerably, both for space reasons and to emphasize the particular theme that I am addressing.) In these narratives, certain themes consistently emerged. In almost every case, the speaker stressed that his or her tattoo reflected his or her individuality. Another extremely common theme was that a person's tattoos were related to spirituality. Similarly, speakers emphasized that their tattoos were a tool for personal growth. In many narratives, wearing tattoos was a sign of the

body's sacredness. And finally, for many in the tattoo community, getting tattooed was a way to get in touch with one's primitive self.

These lofty notions—individuality, spirituality, personal growth, the primitive self—are, in my opinion, revolutionary. Working-class tattoos prior to the artistic changes of the Tattoo Renaissance, and before the development of the liberatory social movements, did not typically act as a vehicle for such expressions of the self. Today, however, they do. As Daniel Rosenblatt writes in a recent article on modern primitive body adornments, "In sum, individuals seek to express and reclaim themselves through the act of getting a tattoo; the design of the tattoo should ideally reflect some aspect of the self that is otherwise without public expression or is repressed by our society" (1997:310). The narratives in this chapter all illustrate the ways in which tattoos are used by my informants to, again in Rosenblatt's words, "talk about the self."

## *The Narratives*

*Individualism* ➻ To some extent, most of my informants emphasized in their narratives the individuality of their tattoos and how this was connected to their own personal uniqueness. This comes across in a number of ways, although the simplest is by stating that the tattoo was custom designed rather than taken from flash. Although many people's first tattoo may have been from a flash design, most (with the means to do so) move on to custom work for their second tattoo. The wearer of a custom tattoo—which is more expensive than a piece of flash, involves more forethought and planning, and requires a tattooist with the artistic skills to do custom work—is very proud that his or her tattoo is unique, and he or she will always point that fact out. Tattooists, too, will prominently display photos of their custom work in their studios to show potential customers their abilities. But in another way, simply having tattoos, for middle-class wearers in particular, differentiates them from the mainstream and contributes to their image of themselves as being unique. The following woman, tattooed with an Art Deco painting on her back, said: "[Being tattooed] separates me from anybody else. No one else has anything like what I have. I feel a little bit different

from Joe Shmoe on the street, and I guess inside it makes me feel special" (Dani D.). Having a tattoo should be, according to many in the community, linked to something personal and special about the person. The tattoo should indicate what is on the inside of the wearer, as Bonny, a graphic designer, points out:

> You know those guys who get their arms and stuff done and it's so out there, so open. I think tattoos are more like something within, so I don't always like to let them show; I like them to be a little bit mysterious. I enjoy the whole thing about tattooing, I think it's really good self-expression for artists. I don't see anything negative in it. People make it what they want to make it. I think it's great because there's so many different kinds of people and tattoos, so you can look at the tattoos and maybe get an idea of what that person is like, but I think it's nice. I think it keeps people beautiful, you know it's like on their insides, what they feel. (Bonny G.)

It is understood that traditional wearers of tattoos (or "those guys") do not feel the intimate connection with their tattoos that Bonny does, and their tattoos are not the personal links with the self that hers are. (Interestingly, Bonny is tattooed with images from B movie horror films like *Dracula* and *Frankenstein*—hardly the kinds of tattoos that one would expect to be expressions of a young woman's authentic self.) While I do not recall having spoken with others who felt that how much of the tattoo is exposed in public is related to how closely the tattoo speaks to the individual's character, Bonny's sentiment that the tattoo is—or should be—a reflection of what the person is *really* like is held by many.

*Spirituality* ➻ Next to individualism, I have found that spirituality is the most widely used discourse in the middle-class tattoo community. My respondents differed, however, in terms of how their tattoos expressed their spirituality. For some, the designs were religious and reflected the wearer's feelings about spirituality. For others, the process itself was seen as being spiritual. Often, the wearer was not religious but interpreted his or her religious design in a way that had personal meaning. Most of the symbols in the tattoos tended to be non-Christian and were drawn from the ancient world (primarily Egyptian or Celtic), from non-Western religions (African, Indian, Native American), or from a vague notion

of paganism, taken perhaps from astrology. These two women's accounts are examples of Neo-Pagan tattoos:

> This one I got because I wanted to get something on my stomach because I'm very maternal, and it's a balance between light and dark— that's why I got the sun and the moon. This is a chakra from the Tantra and in a lot of pictures you'll see they give the seven chakra points, and the center one is the sacral plexus. I enlarged it; it's usually only about this big [gesturing with her hands, she demonstrates a diameter of about two inches], but I enlarged it so it would go around my whole stomach so that when I got pregnant it would go with my body. (Angie U.)

> I got the sun about a year ago and it has the signs of the planets around it. And then I decided to get the moon to match with it. That has the astrological signs around it. I like the sun and the moon and all that has to do with that. (Delores F.)

On the other hand, biblical images are becoming more popular. Robin, a young punk from New York, explains hers as follows: "A lot of my tattoos, they're like of a spiritual essence. . . . [This one from] Genesis 3:13 is when Eve was tempted and she fucked everything up. . . . My first tattoo was a cross" (Robin T.).

For other people, becoming tattooed itself is a spiritual act, and the tattooing experience is viewed as ritualistic. This theme is especially common among adherents of modern primitivism. From this perspective, tattooing and piercing are ancient rituals that have been absent in modern, spiritually barren, North American society. The following eighteen-year-old with a tribal armband described her tattoo experience to me: "It was very planned out; it was a ritualistic thing for me. My girlfriends gathered around, and they all watched while I laid there, and I was the center of attention. At first I was in pain, but after a while I kind of enjoyed it, it was actually quite erotic" (Nikki W.). One woman, with an elaborate medieval back piece, maintained that there is a spiritual purpose behind all of her tattoos, regardless of the specific image. She said, "Most of my work is done because of spiritual reasons. . . . I think it is an extension of who we are." Tattooing in this case is an important part of these people's personal and spiritual identities.

The tattoo enthusiasts interviewed in tattoo magazines today also

focus on spirituality in their interviews. One fan described the function of tattooing in spiritual terms: "It's about healing, healing yourself and others with your work. Tattoos have a lot of power, and that can be transported through color, shapes, animal forms. . . . a lot of things in them can present healing opportunities. And that's what happens. Even if people come into contact and don't understand it, later they will have a healing. . . . The tattoo is a healing for the self" (Lisa, *Skin and Ink,* December 1993). Having religious tattoos is so common among many that it has almost become a cliché. Sally, a computer professional—whose tattoos all have deep meaning to her—experienced the dilemma of always having to come up with spiritual meanings for every new tattoo: "You get past a certain point where you say, Gee, what's my next one going to be, and when am I going to get it? So you get to the point where they don't have quite as much spiritual meaning as they used to" (Sally T.).

Many tattooists today also highlight their spiritual connection with the process of tattooing. Jamie Summers was an early practitioner of tattooing as a religious and magical ritual, and her clients took their tattoos *very* seriously. I spoke with a woman with an unfinished tattoo by Summers (it was started just before her death) who refused to have it completed. She saw in its blurry butterfly shape (Summers often did the shading on a tattoo first, followed by the outline) the spirit of the dead tattooist.

One prominent East Coast tattooist offers what she calls "ceremonial tattooing." This includes offerings of food, flowers, and gifts for the altar. Ceremonial tattooing is aimed at helping create the correct mental and physical atmosphere for the tattoo ritual. Another tattooist explained the connection between spirituality and tattooing to me in this way: "These people in here are way more spiritual than you would believe. There's very few things that you can do when somebody sits in your chair. Immediately you're putting your heart and soul into something that you really care about. You're creating a direction and it is simply where you're wandering on your spiritual path. So yeah, it's a very spiritual business" (Ezra B., tattooist). Lois, a southern California tattooist, goes even further. Not only is tattooing spiritual but the body can act as a reservoir for a person's deepest memories: "To me tattooing is a very spiritual process. I am coming to a deeper understanding of our bodies as

memory keepers—cellular memory if you will. Tattoos come from this knowledge and it is a wonderful path" (Lois P., tattooist).

Even biker tattooists now emphasize the spiritual aspects of tattooing. A Chicago area tattooist said to me, "People use spirituality in their tattoos simply because it's something that they believe in and they want a piece of their selves on them as a way of a means of expression. It's [tattooing] really truly probably no different than burning a piece of incense or lighting a candle in a pagan sense. . . . They didn't get that tattoo because . . . it's anything but something inside themselves. The marking of a passage of their life or whatever reason" (Jack B., tattooist). Jack's comments demonstrate, again, how the tattoo today is seen to reflect the individual's inner self. Implicit in these comments is the idea that the tattoo is not (or should not be) simply a fashion statement. It is both an expression of the deepest self, and it is a mirror into the soul.

An ongoing debate within the tattoo community concerns the connection between tattooing and spirituality. Rec.arts.bodyart provides a forum for this debate: as new members join they are often confused to find constant references to spirituality in the newsgroup's online messages. The following message is from a posting debating whether or not to include spirituality in the FAQ (Frequently Asked Questions file) for RAB: "You can't separate spirituality from piercing and tattooing without telling some people they are not welcome: I would be the first to leave [RAB] if such a prohibition was ever established. Thumb thru *Modern Primitives* and you'll find it chock full of references to spirituality. It's an important motive for a lot of people to be involved in this, regardless of whether it is for you or not. In short, if it doesn't interest you, you don't have to read it." According to the writer, disallowing a discussion of spirituality on the FAQ would be tantamount to excluding people from RAB. This demonstrates that for the writer and others, tattooing and spirituality are not just connected; they are inseparable. Another reader of RAB agrees, writing, "You might be surprised to have a higher number of r.a.b.bits who are into Eastern mythology, new age spiritualism, holistics, pagan, wicca, etc. etc. and fall outside of the traditional." This statement, while referring only to the community of "r.a.b.bits," can also be said to refer to the whole tattoo community today. It *is* surprising to see how many

people with tattoos today view their bodywork in spiritual terms. But once the influences from New Age mysticism, feminist spirituality, the men's movement, and the gay/lesbian community are taken into account, it makes a great deal of sense.

*Personal Growth* ➤➤ The next most dominant discourse found within the tattoo community today is that of personal growth through self-help and empowerment. This discourse is central to the modern understanding of tattooing and contends that tattoos are both intimately connected to the wearer in a deeply spiritual way and also have the ability to actually heal the individual—spiritually, emotionally, and physically. In my first two tattoos I experienced this kind of transformative power. I invested them with the ability to help me turn my life around in a way I felt I could not do myself. John, a merchant marine with an in-progress Japanese bodysuit felt similarly about his, saying, "I hope that (and my girlfriend will argue that it hasn't happened) tattoos, if they're good, and they mean something to the owner that puts them on, that they can help you in life, that they can serve as an inspiration. I know I don't always follow through on that but it's always in the back of my head. I get good tattoos that mean positive things and to me it's working because I'm putting my ideas down concretely and I'm backing them up" (John M.). Tattoos are a literal form of writing for this man. By concretely inscribing on his body artwork to inspire and motivate him, John's tattoos are an incentive to action. A young woman showing me her elaborate leg tattoo described how the designs were chosen to inspire and help her through life. She said, "The design I chose was that of a panther and an orchid. . . . Superficially, a panther is my favorite animal, and an orchid is my favorite flower. Getting in a bit deeper, to me they represented quiet strength, beauty, seeming delicateness but the ability to last through any trouble, a willingness to fight for what's important, protect what I believe in, and a match of two things that, while they don't seem to go together, do so very well" (Lady A.).

The transformative power of the tattoo is especially useful for individuals experiencing crisis in their lives. Women, especially, speak of situations involving domestic abuse, the breakup of primary relationships, or serious illness. These women see in their tat-

toos the power to handle such crises. This university administrator described her dolphin tattoo as follows:

> I do want to talk about one more piece, though. It's this dolphin on my back. . . . This was the first professionally done tattoo that I'd gotten, and I got it in my early twenties, and I got it because I had just broken up with someone who I'd been with [for] six years, and it was kind of interesting because I realize it in hindsight . . . but at the time I had this compelling desire to get it done, and I knew that it was something I wanted to get done. It's actually very symbolic for me — I used to scuba dive a lot and the connection with the ocean and dolphins being able to swim and freedom and all that [made it a good choice for me]. (Elaine T.)

While Elaine's tattoo represented freedom after a breakup, Gail's account, which follows, shows that for some women, tattoos do more than just represent freedom: they enable it.

> This tattoo here was when I was going through a very bad time in a marriage. This one became my shield. I became strong and I would have it recolored in when I started to feel weak and sliding back into disease and everything. . . . I ended up getting this wolf, which to me was power and strength over all the abuse and all the things that went on in my life. It was a sense of freedom. I have [a] tribal [tattoo] on my leg, which was something that was strong and a no-no in my family. Something bold and black and that's why I wanted it. To become myself. (Gail R.)

Gail, a practitioner of Wicca in her midforties, describes her Native American wolf tattoo as a shield. It has real power to her: she originally got it to cover her husband's name, and has it recolored whenever she feels weak. The following story, recounted to me over e-mail, also demonstrates how a tattoo can be used to regain control over a life that is escalating out of control.

> For a very long time I have been plagued/bothered/annoyed by illnesses and for the past two and a half years I had been plagued by one in particular. It's called Hashimoto's Thyroiditis. It's a virus that, in layman's terms, causes my immune system to think that my thyroid, which controls such important functions as my metabo-

lism, is a foreign body and attack it. This shuts the thyroid down and affects the rest of the body because of this. It's very simple to treat this, you just take a hormone pill every day to replace the hormones that the body is no longer producing. The difficulty for me in all this was that it took me a very, very long time to get this diagnosed. . . . I finally saw a specialist about a year after the symptoms started and he was able to tell me what was wrong. I was put on the hormone pills and my body began to heal.

. . . I was getting over all of this when I went to visit my brother in London. His fiancee was with him and the three of us were walking through Camden (sort of like the Village in Manhattan). There were places to get a tattoo there and at one point Sandra commented on how she might like to get a tattoo. I don't know what it was about this comment that caused this reaction, but this made me stop and think "What would keep me from getting a tattoo?"

. . . Perhaps it was the right time for me to hear that. The main reason why I got my tattoo is that so many things had happened to me in the two years before this trip to London (the illness . . . being the major one, there were a lot of other little ones as well) that were completely awful, completely permanent and that I had no control or say in their happening. My tattoo was something that *I* did, that *I* brought into being, and it was a *good* thing that would be with me for the rest of my life. (Alex A.)

Some people use their tattoos to both help themselves and to make a statement to others. Torrie, a college professor, described to me the terrible treatment she received at the conservative southern university where she taught. Her way of responding to that treatment was to become heavily tattooed and pierced, because she knew that her body modifications would be disapproved of.

I was saying, "fuck you, school, and I don't really care if you know I have a tattoo." I also at this time started getting pierced because basically I'm taking my anger out on this school. I'm doing this to please myself and because I knew it would freak them out, which gave me no small amount of pleasure. . . . Every now and then the tattoo will peep out, and I know that when I was teaching last year I was handing out some papers and one of my students saw my bracelet and he just freaked out and he said "I can't think of anything besides the fact that you have a tattoo," and the other students went, "Oh my

god!" I have my tongue pierced and I was licking an envelope and my secretary came in and she just kind of spit her coffee across the room. I suspect that had I not been here, I probably wouldn't be as pierced as I am. The fun part is knowing how irritating they are to everyone else. (Torrie P.)

Torrie's tattoos are also personally meaningful to her, outside of the reaction that they cause in others. She is an entomologist and all of her tattoos are of insects. ("I love bugs and I live entomology and I have plans now to maybe do a back piece with something like bugs crawling up my back.") She also says about her favorite bug tattoo, "I've kind of kidded people that the cicada is just like me because it's small, harmless, and makes a really big noise 'cause I'm always stirring up trouble."

*Sacredness of the Body* ➡ Another way that middle-class people in particular explain their tattoos is by emphasizing how sacred their bodies are—they would not dream of putting just *any* design on them. Additionally, some people emphasized that their tattoos are a way to care about their bodies. A woman with birds and bees tattooed on her back told me, "It's gotten me to take better care of my skin. I started eating real good again; it turned me around." And a woman who posted to RAB described a group of RABbits who attended a tattoo convention together:

> Out of the dozen of us, six of us are vegetarians, none of us smoke cigarettes, so we're walking around [the tattoo convention] trying to look cool, but we're not really fitting into the whole stereotype— probably just being more involved in your body and what you put into it, being in control of your body, etc. I think the high rate of vegetarianism among the attendees has more to do with the fact that we are: Higher educated, or appreciate education; Computer geeks (no smoking around computers!); More enlightened about general wellness; More spiritual about our bodmod. (Julie T.)

Julie maintains that RABbits tend to be more health oriented because they are educated computer professionals (i.e., they are middle class) and that their spirituality contributes to their healthy outlook. The next quote is from an ongoing discussion on RAB about why contributors to this newsgroup tend toward vegetarianism:

"One last attempt at connecting body-arted people and being veggie: both do to one extent or another require you to be aware of your body, etc, and perhaps those who pay attention to what their body wants to eat also notice where it wants holes and ink." This last person feels that not only are tattooed people more connected to their bodies in terms of taking better care of them but that they know when their bodies "want holes and ink." Not only is the body made central here, it is also given agency.

Closely related to the sacredness of the body is the amount of time and effort put into the decision to become tattooed. Again, I emphasize that for middle-class tattooed people, in their narratives at least, there is a definite focus on how much thoughtfulness was put into deciding to get, and then choosing, a tattoo. While many working-class people no doubt feel the same way, in the middle-class tattoo narrative, this concern acts as a device to convince the listener that getting a tattoo was no spur-of-the-moment decision. The following statement was made on rec.arts.bodyart about the amount of time the writer spent planning for his tattoos: "I spend ages trying out things with the design, drawing on myself, having the design on the wall, finding an artist I like, etc. until I'm sure the design's one I'll stay happy with, and will work on my body" (Dan P.).

Maddie, a college student from New England, gave me a detailed look at how long it took her to simply become *accustomed* to the idea of getting a tattoo.

Now then, I was always aware of tattoos since childhood and had a lot of fun with those free ones you got in boxes of Cracker Jacks (much cooler than the cheap plastic rings) even though they were utter garbage and I could never get them on right. However, the idea of my actually getting a tattoo never even crossed my mind. For some reason, it was just something that I "didn't" do. I guess because at that time (and here I'm speaking of the time from childhood until, say, high school) it never occurred to me that tats were something that someone could plan out and enjoy. I only knew of the "got wasted and what the hell is this on my arm?" type of tattoo. When I thought of that kind of tattoo (the accidental kind) it was very unappealing to me. The idea of getting a tattoo didn't scare me but given what I knew about tats, I figured I had better things to do with my time.

Also, I didn't want to do some spur-of-the-moment thing and have some weird picture stuck on my skin forever. Far too icky.

Because of her middle-class background, Maddie was simply unable to imagine ever wearing a tattoo. So how does a nice suburban girl begin to entertain the idea of getting a tattoo? For Maddie, it involved a growing awareness that it isn't just bikers who get tattooed.

> I don't know when I became aware of the idea that tattoos are actually a serious thing that someone can take pride in. If I had to make a guess, I'd say high school. . . . I think that my previous fun with the idea and the fact that I was becoming aware that it was not the horrifying experience that I had been told it was began to come together in my mind to form a "Hey, this is something I could do" thought. But by that I only mean that I had realized that I did not have to become a Hell's Angel to get a tattoo—not that I immediately started planning it. For some reason, there was still a mental block in my mind. Yes, this was something that I could physically do, but it wasn't the sort of thing that I would do, if that makes any sense.

Once she decided that she could actually see herself wearing a tattoo, the months of planning for Maddie's particular tattoo began.

> I began to do research on tattoos. Although I knew a lot of people got them, I didn't want to go into it blindly. I looked at some books while on vacation and when I came back home I did even more research. This was quite difficult to do in Stamford, "far, far too white," Connecticut. Finding magazines on tattoos proved very difficult a task. Fortunately I was able to find books in the library (one of which was humorously old and outdated. I shudder to think of the methods it suggested for how to treat a healing tattoo) and some in a local bookstore (one of those superstores which have books on everything).
>     . . . I also spent a lot of time thinking about the design. A few ideas presented themselves based on some of my current interests. I thought about getting a spiderweb with some bats, for example. (I forget some of my other ideas. The spiderweb one was the first that came to me. This was based on my interest in Anne Rice books and the supernatural. The other ideas, like I said, I can't even re-

member. If that's not a good example about why you should really think about what design you're going to get, I don't know what is! Imagine me with one of these forgettable designs inked on my body forever!) But, taking the advice of my research, I abandoned any idea of a design based on current interests. I went back into my mind and thought about what I liked, what I am like, and why I was getting the tattoo. I wanted to get one that said something about me as a person, reflected my interests, my personality, and was a good design all in all (I'm not very artistic as far as painting and the like goes so it was hard for me to come up with a design idea that actually looked nice). (Maddie A.)

(Of course, even the most thoughtful, educated, and sophisticated people are impulsive sometimes, too. Angie, who described her tribal sun, moon, and chakra tattoos to me in great detail, also mentioned another tattoo: "I have a really crummy one down here that I got in a bathroom somewhere, which is going to be a cover-up. Not something I would advise.")

Finally, almost everyone I spoke to was quick to emphasize that their tattoos were worth it—the time, the trouble, the pain, and the expense. Again, the focus was that their bodies are important, the decision was well thought out, and the tattoo represented a permanent commitment. A heavily pierced and tattooed body piercer said, "It was very expensive but it was worth the price and the pain." And an ex-marine with a full bodysuit told me, "Some people freak out, but the question that really pisses me off is, What did it cost? The cost doesn't matter. Whatever that artist decides to charge me, they have a good reason for charging that. I don't bargain shop. Whatever they want, I pay. I get tired of people gauging something on what the cost is. If they knew what I've got into it, why they would freak out. 'You could buy a car for that, you could put a down payment on a house.' Well, if I wanted those things I could do it but I desire a full bodysuit. I don't like trivial things in my life. That's the way I look at it" (John Y.).

*Women's Motivations* ➤ Although both middle-class men and women seem to favor equally most of the above narrative themes, women—working class and middle class—are much more apt to explain their tattoos in terms of healing, empowerment, or control.

I have not had any straight men report to me that they acquired a tattoo as a means of regaining control over their life while undergoing a crisis,[1] but many women's narratives, my own included, show that this is a powerful motivation for becoming tattooed. For some women, the tattoo is an important step in reclaiming their bodies, and the narrative in which they later describe this process is equally important. As feminist scholars have shown (Bordo 1990; Butler 1990; Gaines 1990; Grosz 1990), the body is both the site for the inscription of power and the primary site of resistance to that power—the body entails the possibility of counterinscription, of being self marked. One can argue that women, through marking their bodies with tattoos and through the narratives that they construct about them, are working to erase the oppressive marks of a patriarchal society and to replace them with marks of their own choosing.

Even though I am arguing that many of these narratives recall themes that have been popularized by the middle class and may have more resonance to middle-class audiences, working-class women have more experience than their middle-class sisters in using their bodies to destabilize dominant notions of power, whether through clothing, makeup, or hairstyles. It is not accidental, then, that working-class women have worn tattoos for much longer than middle-class women. Angela McRobbie, who studied English working-class girls of the 1970s, showed that these girls used their sexuality to disrupt the middle-class environment of the school. She states, "A class instinct then finds expression at the level of jettisoning the official ideology for girls in the school (neatness, diligence, appliance, femininity, passivity, etc.) and replacing it with a more feminine, even sexual one" (McRobbie 1978:104). I suggest that working-class women are less likely to accept the idea of the quiet, pale, and bound female body, and that tattoos have long been a sign of that rejection within the working class. But regardless of class position, heavily tattooed women can be said to control and subvert the ever-present "male gaze" by forcing men (and women) to look at their bodies in a manner that exerts control.

If this is true, it would not be the first time that women wore tattoos in order to take charge of their own bodies. On the most basic level, the tattooed ladies of the early part of this century got tattooed as a means of earning a living. These were independent

women who made the decision to take care of themselves, on their own terms. Both Betty Broadbent and Artoria Gibbons, well-known tattooed ladies from the 1920s through the 1960s, became tattooed as a means of earning an independent living in an era when it was difficult for women to support themselves. Another tattooed attraction, Irene Libarry, said, "I figured that if I lost my legs and lost the use of my body, as long as I had my hands and my eyes I could always make a good living for myself" (Morse 1977:66). While she never lost the use of her limbs, Irene was aware that a woman at the turn of the century had very little opportunity to make a living for herself, and her tattoos could provide for her even in the worst of circumstances. Today, of course, women do not get tattooed to make a living, but for many, tattoos are still considered a sign of personal independence.[2]

*Modern Primitives* ➤ All of the above themes—spirituality, personal growth, power—come together in the final discourse surrounding contemporary tattooing known as "modern primitivism."[3] Modern primitivism originated in the practices and ideologies of the sexually radical leather and S/M scenes and later moved into the straight, mainstream tattoo community with the publication of the Re/Search volume *Modern Primitives* (Vale and Juno 1989) and the first issue of *TattooTime* (1982).

Fakir Musafar, a former advertising executive from South Dakota (he found the name "Fakir Musafar" in an early *Ripley's Believe It Or Not*), is said to have originated the term "modern primitives" in 1967. He described its meaning as follows: "a non tribal person who responds to primal urges and does something with the body" (Vale and Juno 1989:13). In the S/M community, modern primitive referred to a host of sexual, sartorial, and cultural practices involving ritualistic body modifications like cutting, piercing, and tattooing. But more than that, this community originated a set of ideas that went beyond the erotic and that paralleled many of the themes found in the tattoo narratives I have been discussing. S/M (like tattooing) is seen as a vehicle for personal transformation, a basis for greater spiritual awareness, and a way for participants to reconnect with their physical bodies (Thompson 1991).

The term "modern primitive," both in its original use by S/M adherents and in its more widespread use today, also implies a cri-

tique of contemporary Western society, which is seen as alienating, repressive, and technocratic and that lacks ritual, myth, or symbol. By rejecting modern society through participating in the primitive rituals of tattooing, piercing, or scarification, participants feel that they are aligning themselves with societies and worldviews that are more pure, authentic, and spiritually advanced than the traditional Western outlook. This view is the central text for the S/M magazine *PFIQ* (published by Jim Ward of Gauntlet Enterprises). Since its first issue in 1977, *PFIQ* has consistently featured articles and photos on body modification practices in non-Western cultures, and many of the interviews with Western practitioners have emphasized the primitive source of their body alterations. In an article titled "Piercing: The Primitive Touch," Jim Ward writes: "To 'primitive' people, piercing is an integral part of life—like toilets, heated buildings, automobiles and television sets are to us. In their societies, piercing marks the passage from one phase of life to another. It denotes status and personal accomplishment, just like the ownership of material things does in our own culture. . . . Piercings are personal and permanent, a 'forever' part of one, and cannot be easily discarded, forgotten or ignored. . . . Their possession, therefore, generally has more meaning than the civilized accumulation of 'things external' " (1979:9). Here, primitive body modification is favorably contrasted with the ownership of material things in "civilized" society. He goes on to write, "I think we are, now, finally, at the end of a long, 'Anti-Body' period. People have 'had it' with man-made religions and the promises of ultimate, inner satisfaction by human control of the environment. . . . Whether the present day critics of piercing (and this includes tattooing which is nothing more than a specialized form of piercing) like it or not, such natural expression of life is on the way back" (11).

The modern primitive movement first documented by *PFIQ* was, in the late eighties, brought to mainstream awareness through the publication of *Modern Primitives* (Vale and Juno 1989). Like *PFIQ*, this book looks at the tattooing, piercing, and other body modification practices of westerners (many of those interviewed in the book are participants in S/M) and links these practices to those of primitive peoples. For many people who bought this book, it was the first time that they saw photos of a white man's bifurcated penis, Ndebeli women wearing collars around their necks,

an Indian sadhu with coconuts sewed to his body, and Fakir Musa-far hanging from meat hooks driven into his flesh. For most main-stream westerners, images like these are shocking. (I know that the first time I saw these pictures, I was in a tattoo studio waiting to begin work on my first large-scale tattoo, and the images made my stomach clench with fear.)

In the midst of all of these primitive pictures we find photos of and interviews with tattooed people, making explicit the connec-tion between tattooing and primitive people and practices. Musa-far, for example, states, "Sometimes the tattoo artists in primitive cultures were shamans. They envisioned the marks, tattooed them on the body, and then the person who got the tattoo was whole, complete" (Vale and Juno 1989:8). As we have seen, many contem-porary tattooists envision themselves as shamans, too. For many readers, this book was the impetus not only to get tattooed but to get tattooed with non-Western designs. Further, readers were en-couraged to see in their tattoos a primal instinct and even a magical force. As Musafar said, "The purpose of the tattoo is to do some-thing for the person, to help them realize the individual magic latent within them" (11).

Men's movement guru Robert Bly writes of the initiation rituals of the Kikuyu of Africa (1990), Greg Stafford writes of the vision quest of the Lakota and the shamanism of the Huichol Indians (1991), and Peter Wilson writes of Melanesian cargo cults (1991). All claim that modern men can benefit from these rituals. Just as the men's movement promotes a return to the primordial mas-culine self through the adoption of initiation rituals derived from primitive tribes, members of the modern tattoo community who embrace this philosophy find this connection to primitivism as well. Tattooing has become for many a vision quest; an identity quest; an initiation ritual; a self-naming ritual; an act of magic; a spiri-tual healing; a connection to the God or Goddess, the Great Mother, or the Wild Man. For members of the tattoo community who see their tattoos as connecting them to ancient or primitive cultures, the reality of those cultures is not important. Rather, it is the ideal-ized version of primitive cultures—considered closer to nature, in harmony with the spiritual realm, egalitarian, nonrepressive—that provides the appropriate image.

The final source for the modern primitivist movement, and the

one most responsible for popularizing it within the mainstream middle-class tattoo community, was the first issue of Ed Hardy's *TattooTime*. This issue, called "The New Tribalism" (1982), was devoted to the documentation of tattooing in tribal cultures such as those in Borneo, Samoa, New Zealand, Hawaii, and Native America and included photographs of the tattoos that were being worn among people in the West in imitation of this style. The work and philosophies of Leo Zulueta and Dan Thome, for example, first came to public attention in this issue. "The New Tribalism" issue (which predated the publication of *Modern Primitives*, but which was not as widely read as *Modern Primitives* until the late 1980s) was extremely influential in not only creating and promoting a new tattoo style, tribalism, but also in discussing—for the first time— the tattoo community in terms of a tribe. The concepts of "tribe" and "tribal" have since become, within certain circles, a metaphor for the modern tattoo community, incorporating as it does notions of both community as well as the ideology of modern primitivism. *TattooTime* does not, however, actively promote the primitivist lifestyle and does not discuss the related body modifications represented in *PFIQ* or *Modern Primitives* (thus ensuring its appeal to a more mainstream audience). But the first issue did spark much of the interest in neoprimitive tattoos, as well as provide the anthropological and historical background for the new ideology.

The primitivist philosophies borrowed from the S/M movement have found a new home in the mainstream tattoo community. Today, even outside the modern primitive circle, tattooing is aligned with primitive and tribal practices, and this is seen in the language ("archetypal," "ritualistic," "primal," "instinctive," "pagan") used in many of the narratives I collected. As in the spiritual narratives discussed earlier, a connection is made to New Age or Neo-Pagan religion, but on a much deeper level. Mark, who has tribal sleeves, a kelp forest on his back, and plans to get a rain forest and a Celtic cross on his chest said, "The tribal [tattoo] ties back into the old ways, the back-to-nature kind of thing. The first people, the Celts, were into tattooing, and I'm going to get a Celtic cross over my heart that'll separate and divide my rain forest. I'm just heavy into nature, I guess I'm almost pagan, that's why I'm getting all this stuff" (Mark L.). Mark identified himself as pagan and saw the Celts as being "the first people." He also made the connection between a

tribal tattoo, derived from the designs of non-Western people, and a "back-to-nature" philosophy. That nature and tribal peoples are intimately connected is also evident in the following narrative by a former student of mine.

> I designed my own tattoo and it consists of religious symbols from around the world. It's an armband that goes around my arm. There's an Egyptian hieroglyph, a Mayan hieroglyph, the Venus of Wellendorf, a cave painting called "the sorcerer," an African drum, a cave painting of a dancer, and that's about it. [It's] all the symbols I could be really proud of, and I had a connection to all of them in my heart, and it's something that I don't regret at all. I wanted to feel that I was part of an earth-tribe-clan-thing. I felt like I was connecting to more ancient cultures. (Nikki P.)

Nikki showed me the various religious symbols on her arm, taken from books on anthropology, dance, women's spirituality, and witchcraft. She linked these symbols, all taken from other cultures, with the earth, and saw herself as part of this "earth-tribe-clan-thing."

In these accounts, the concept of "natural" has many meanings. It can refer to the earth, to tribal or native people, or to an instinctive or intuitive practice. In the following account, taken from an alternative weekly newspaper, Blake, too, sees tattooing as being related to ancient societies and emphasizes its "intuitive" nature. "Blake, another piercer at Body Manipulations, has long earlobes stretched by weighted earrings. 'Culturally speaking,' he says, 'all primitive societies have done things like this since the dawn of time. It's a basic, intuitive practice. I share with primitive peoples a certain ideal in my life. I am practicing ritual. It's a religious practice'" ("Hooked," Shoshana Marchand, *The Bay Guardian*, May 27, 1992). For Blake, tattooing is intuitive not only for primitive people but to *all* people, although modern westerners have evidently lost this important ritual.

This essentialist perspective is especially found among individuals who felt that they had no choice in getting tattooed—for them, it was an innate impulse. Not coincidentally, many of the people I spoke with who felt this way were also pierced and were thus more closely connected to the modern primitive movement. One Asian American woman tattooed with tropical flowers told me,

"I've always been interested in body art. When I first found out that you could do something with a sewing needle and a little piece of thread it was when I was a sophomore in high school." She then showed me the homemade star on her pubic bone, and continued, "I did those completely sober, completely conscious and aware that that was something that I wanted to do. I just did it in my own room, when my parents were out watching TV in the living room."

A former sailor told me that his tattoos were less instinctive than genetic, as tattoos literally run in his family:

> I have relatives all the way back to the 1920s who have been sailors, and I knew from the time I was four or five that I was going to be a sailor, and I knew early on that I would be tattooed. When you're in second or third grade and you're coloring your arms up with ink pens at school and the teacher's asking your mother, well, Why is he doing this? there's no logical explanation except that I knew I wanted to draw on myself and poke holes in myself. When I would see sailors in full bodysuits, in the early days, it was just like: that's what I want. It was just some kind of magnetic attraction that I knew that that's what I wanted to do, I never had any doubts. I don't know what this kind of thing is called, but I just knew I was going to be a heavily tattooed sailor. (John J.)

For the above informants, tattoos are a link to something deeper, an instinctive drive within the self. Again, if all primitive societies do it, then it *must* be natural.

At the same time that middle-class North Americans are wearing tribal tattoos, the indigenous people of Hawaii, Australia, and New Zealand are experiencing their own tattoo revival. Sometimes the tattoos that they wear are in the tradition of their culture and sometimes they are Western images. Quite often, their tribal tattoos have been created in the United States by Western tattooists. For example, I met a hula dancer from Hawaii with a tattoo of the three faces of the volcano goddess Pele. While her tattoo is not a native design, it draws from native mythology.

Neotribal tattooist Leo Zulueta explains the phenomenon this way: "This whole modern primitives thing is really blown up. It's the piercing and everything. I think the kind of people that are drawn to that are looking for some kind of deeper thing, something deeper than the high-tech society that we live in." Primitivist tattoos

and philosophies are diametrically opposed to civilization and technology. Just as the native exhibits in nineteenth-century world's fairs were used to showcase the highest achievements of Western civilization, primitive tattoos today are used to distance the wearer from those same achievements—which are now seen as failures.

Not everyone accepts wholeheartedly the primitivist discourse, however. Since the late seventies, when piercing and other body modifications began to appear in the tattoo community via members of the S/M community, there has been heated debate over this issue. Leaders of the National Tattoo Association have attempted to exclude visible piercings from NTA conventions in order to present a "family-friendly" atmosphere. The other major tattoo organization, the Alliance of Professional Tattooists, also discourages a connection between tattooing and piercing. As one writer on RAB puts it, APT feels that "piercing is piercing, tattooing is tattooing and ne'er the twain shall meet." Obviously, this viewpoint is anathema to many of the younger and gay and lesbian members of the tattoo community who are themselves pierced. One heavily pierced tattooist told me, "You know, it's the mid-1990s, let's act like it. I am a member of the National Tattoo Association, I'm proud to be a member. Because of that I respect their views. . . . But I don't like it, I don't agree with it."

The history of Fakir Musafar's connection with the tattoo community is also illustrative of the uneasy alliance between tattooing and piercing, or between the traditional tattoo community and the modern primitive movement. In *Leatherfolk* (1991), Musafar describes his "coming out" as a modern primitive at the 1978 National Tattoo Association convention. Of his performance there —in which he hooked daggers in his chest, had bricks broken on his back, and dragged a belly dancer around by the holes in his chest— Musafar writes: "They actually were not ready for this. This was not my community. I did not fit in. Whatever it was they were looking for, no matter how off the normal track it was, it was fine as long as it didn't involve physical commitment or the physical body except in a very superficial way. But when you got to a point of what I was recommending, where they had to get involved with the body 'Ooooh no. That's going too far!' So this was not my community" (Bean 1991:308). This quote demonstrates that in 1977, when modern primitivism was a deeply ingrained part of the S/M commu-

nity, the tattoo community was far from embracing the primitivist discourse or the physical displays that often accompany it. At that time, the tattoo community, and especially the tattoo conventions, were still almost completely dominated by bikers and more traditional working-class folks who had yet to embrace these forms of behavior.

But today, and even within the middle-class tattoo community, the modern primitive discourse is not universally embraced. Many old-time tattooists, those who practice traditional tattooing, and many younger tattooists as well, see it as nonsense. One middle-class, college-educated tattooist said, "So much of my dissatisfaction with contemporary tattooing developed out of the weird half-baked 'New Tribalism' nonsense. I always attributed this re-invention to class neurosis" (Mike T., tattooist). Another tattooist, also middle class, agreed, "I was always put off by the strange people who would wander into my studio and use the language of spirituality and self discovery—searching for legitimacy in misinformed and uninformed notions of pre-technological peoples (imperialism of belief?). It always smacked of wholesale nonsense to me—appropriating values and belief systems as natural resources. Pretty bogus" (Paul H., tattooist, letter dated March 26, 1994).

Andrew Ross, in his discussion of the appropriation of forties' Hollywood glamour in gay camp, writes that camp is the "recreation of surplus value from forgotten forms of labor . . . by liberating the objects and discourses of the past from disdain and neglect" (1989:151). In a sense, this is what the primitivist use of tattoos has accomplished: non-Western tattoos and belief systems were "liberated" from primitive peoples and can now be properly positioned as aspects of fine art. But these (primitive) forms of labor, unlike those used by camp, are not forgotten, and as I have mentioned, are undergoing their own revival. As Judith Williamson has pointed out (1986), like other fashions that are borrowed from lower-class or Third World peoples (i.e., dressing in rags, being suntanned, etc.), such looks are only fashionable when the individuals who wear them are not themselves poor or dark-skinned. This type of appropriation by middle-class purveyors of tattooing, while it may appear liberatory, "shows how characteristics of social difference are appropriated within our culture to provide the trappings of individual difference" (Williamson 1986:116).

Even those who wear primitive-based tattoos express some uneasiness about it. Jim, a young man with Native American tribal imagery tattooed on his chest and back, described his tattoos as follows: "And on the inside, the Dakota Sioux, it's kind of their tribal wheel, their belief system, you know each symbol represents something. I wanted it stylized, because I didn't want it to look like an Indian thing because we've ripped off so much stuff from the Indians anyway but I like that concept, the nature kind of thing, so I had him work that into it" (Jim L.). While Jim was clearly aware of the cultural appropriation involved in his tattoos, he felt that the imagery and meaning of the Sioux tribal wheel was important enough to have it tattooed on him. But, at least in his discussion with me, Jim seemed somewhat embarrassed about having appropriated a Native American symbol. He says that he now plans to have the tribal wheel turned into a tribal egg.

Ed Hardy, publisher of *TattooTime,* is both critical of modern primitivism and how he influenced it through the publication of "The New Tribalism": "It's intriguing to see it [primitivist rhetoric] used by people as essentially the new kitsch. They're not very original designs, but they pick up on this thing how it's meaningful for them, how it's a journey or a rite of passage and all that stuff, and it's kind of incredible that that's going on. You know it makes them feel better and they like it and that's okay. I get so sick of hearing all that stuff, and of course I know that I started a lot of it because I started focusing on that in the first *TattooTime* just kind of to make people aware of it, but it's just so corny now" (interview with the author).

Through the discourse of modern primitives, the working-class history of tattooing in the United States has essentially been denied and a new history has been created. The new history is based on the histories of non-Western, nonindustrialized people who practice tattooing. But the practice of tattooing among non-Western peoples is only one part of the picture. More importantly, such societies represent a spiritual and social ideal. Social relations between people in so-called primitive societies are marked by equality, and members live in harmony with both nature and with their own internal desires. Native Americans, Dyaks, Samoans, and others represent the kind of idealized past from which the contemporary tattoo community has apparently evolved. Dan Rosenblatt de-

scribes this new history as an "evolutionary mapping of human diversity onto a temporal scale" (1997:303) in the way that the practices and qualities thought to exist among non-Western peoples predate, in an evolutionary sense, our own discovery of those practices.

It is my position that the creation of this new past sanctions a cultural tradition that was once seen as low class and, through the essentialist language of primitivism, naturalizes it. The rationale is that because "all primitive societies" practiced tattooing and piercing, it is only natural that we should, too. (Furthermore, many promoters of primitivism imply that tattooing has not been accepted in the United States due to its unfortunate connection with bikers who do not understand the "real" purpose of tattooing.) In the introduction to *Modern Primitives,* Vale and Juno allow that this notion of the primitive is "dubiously idealized and only partially understood" and state, "What is implied by the revival of 'modern primitive' activities is the desire for, and the dream of, a *more ideal society*" (emphasis in original; 1989:4). Here, then, is the attempt not only to mimic an idealized past but to *outdo* it (Yengoyan 1992). By wearing non-Western tattoos and adopting a primitivist lifestyle, white middle-class Americans feel that they are symbolically undoing the conquest of the primitive world. Yet they are also, I believe, engaged in its re-colonization.

Not everyone today finds the kinds of meanings in their tattoos that I have been describing in this chapter. Many people I interviewed had no readily prepared narrative, and offered only one-line answers to my questions. Even so, it seems clear from the narratives I have included that for an increasing number of men and women today, tattoos that embody notions of spirituality, empowerment, or primitivism are an important means for constructing meaning and identity. They also provide a way to resist a society seen as repressive. Both the social significance and the personal meaning of these tattoos are intertwined in the narratives, creating a picture of the new American tattoo that transcends imagery and bodies and is, to the members of the new tattoo community, far more important.

Faye Ginsburg, in her discussion of the role of personal narrative in the modern abortion debate, writes that "the problem of constituting the self in relation to changing historical experience is solved, frequently, through the creation of new social formations"

(1989:221). With this in mind, we can see how contemporary tattooed people constitute themselves through their participation in the new tattoo community. Their personal motivations for becoming tattooed, and for choosing a tattoo, are linked to a critical view of a changing society, with the new tattoo community providing an alternative to that society. Ginsburg continues, "As they redefine themselves through their efforts to reshape society, they are accomplishing a paradigmatically American task" (221). Thus the North American tattoo community is narcissistically focused on the self and is also engaged in a larger movement to reconfigure the structure of U.S. society by using its notion of primitive society as the model.

# *Conclusion*

## The Future of a Movement

The New Age, Robert Bly-type, drum-beating shit is transparently hokey to all but the most alienated of white, white men. I don't pander to that hooey so it doesn't really affect me too much. What really gets me though, is that with the influx of capital, the "best and brightest" of the bourgeois art mentality are being attracted to the field. I mean these fucking kids who presume themselves artists spout service industry maxims straight out of the K-Mart management manual as if they were some kind of substitute for a personal philosophy. And it just makes it harder for those of us who don't want to do the kind of bowing and scraping the yuppie clientele expect. They not only want you to shave their pimply asses, pretend that Calvin and Hobbes personify that "wild one" attitude, listen to their pathetic, prudish body-image hang-ups, but at the end you're supposed to hand them some kind of certificate that certifies them as cool enough to sit in at after hours be-bop jam sessions.

—Todd H., tattooist

Life in the United States, especially for the young, has been greatly transformed in the last thirty years. We have seen the rise of personal computers and the accompanying creation of cyberspace, a steadily worsening economy, increasing depersonalization in all aspects of social life, a wealth of new social movements addressing concerns as divergent as abortion, animal rights, the environment, and sexuality, and an increasingly diversified—and divided—society. Although the younger generation has less disposable income than previous generations, there are now more ways to spend it as entertainment and leisure industries compete for expanding markets. In addition, we have seen in recent years moves by both the political right and left to repudiate the technocratic, materialistic, and depersonalized values of the 1980s and 1990s in favor of a return to "family values" and "community."

The contemporary tattoo community offers us a glimpse into how a growing number of modern North Americans are responding to some of these changes. The tattoo community, at least in its latest incarnation, offers its members a means of transcending the most negative aspects of the modern world in favor of one thought to be more primitive (i.e., natural), more communal, and more spiritual. This message has been embraced by both customers and artists and can especially be seen among the youngest members of the community.

## From Baby Boomers to Generation X

The middle-class tattoo community was originally forged in the 1970s by a small group of "baby boomer" tattoo artists and their mostly middle-class clients. Today, however, it is younger tattooists like Eddie Deutsch, Freddy Corbin, Dan Higgs, and Filip Leu who are leading the field in terms of design innovations and charismatic personal style. These artists and their fans occupy that generation known popularly as Generation X. The members of Generation X, or those who were born between approximately 1961 and 1981, have become the media darlings of the tattoo community. The artists in this generation, known by older tattooists as "young turks," are prominently featured in tattoo magazines and are highly visible at

tattoo conventions. Their clients, too—many with bold designs on their arms, heads, and legs, complemented by multiple body piercings—are prominent at conventions, clubs, and other places where tattooed people congregate. While many of the professional baby boomers choose to hide their fine art tattoos, many of the younger generation, without the white-collar jobs of middle-class boomers, proudly display their tattoos on highly visible parts of their bodies. Interestingly, tattooists who were once considered young turks just a few years ago are now becoming more conservative as they view newer, younger tattooists as unwelcome competition. One older tattooist said, "Yeah, I think there's a lot of new, young tattooists coming up who are doing really great work, but I don't keep up with the magazines so I don't know a lot of them. It's interesting because you see people like Eddie D. who's been tattooing about nine years or something and he really resents new people getting into it, who he feels are crowding things. That's just the way it is. There's a tremendous amount of competition, especially among the young people, because they don't have that long view. I think it's hard to maintain the same level of enthusiasm after many years" (Benny H., tattooist).

The differential use of tattoos between Xers and baby boomers has much to do with the differing expectations, family backgrounds, and financial positions of each group. Neil Howe and Bill Strauss in their book, *13th Gen* (1993), discuss the stresses that those belonging to Generation X have had to deal with: disintegrated families, working mothers, failed schools, no-growth economy, minimum-wage jobs, and little-to-no chance of buying a house or achieving the level of financial security that their parents had. In addition, they write

Every day, over 2,500 American children witness the divorce or separation of their parents. Every day, 90 kids are taken from their parents' custody and committed to foster homes. Every day, thirteen Americans age 15 to 24 commit suicide, and another sixteen are murdered. Every day, the typical 14 year-old watches 3 hours of TV and does 1 hour of homework. Every day, over 2,200 kids drop out of school. Every day, 3,610 teenagers are assaulted, 630 are robbed, and 80 are raped. Every day, over 100,000 high-school students

bring guns to school. Every day, 500 adolescents begin using illegal drugs and 1,000 begin drinking alcohol. Every day, 1,000 unwed teenage girls become mothers. (Howe and Strauss 1993:33)

The cumulative effect of all of these factors, according to Howe and Strauss, is a generation that is cynical, independent, and resentful of baby boomers for taking all the wealth and leaving only environmental and economic destruction for them.

These generational factors operate within the tattoo community as well. While many boomer tattooists and fans favor the New Age and self-help discourses, many of the young turks, on the other hand, are rebels. Some are interested in getting only the coolest new tattoos available, and others favor the modern primitive lifestyle. Baby boomer tattooists play by the rules via apprenticeships, working in professional street shops, and for some today, by paying homage to traditional tattoo styles. Xers are often self-trained, and many begin by working out of their apartments rather than in a professional shop. Many even have the audacity to open their own youth-oriented studios without ever having worked with an experienced tattooist.

In terms of economics, Xers occupy a different position as well. On the one hand, they wear the newest (and most expensive) tattoos by the most cutting-edge artists. On the other hand, despite coming from solid middle-class backgrounds, many are (relatively) poor, holding low-paying jobs with little future. Thus Xers' socioeconomic position overrides many of the class distinctions that I have discussed in this book: they wear the designs that the middle-class artists made possible, yet reject much of the ideology that was developed along with those styles, favoring instead a more rebellious attitude.

Where middle-class baby boomers entered tattooing through hippies and the idealistic social movements of the early seventies, Xers entered through punk rock and the megaconsumerism that has marked the eighties (and that was, and still is, aimed at this generation). Not only are the Xers' aesthetics substantially different but their attitudes about tattooing are different as well, with a more cynical, less idealistic notion of tattooing as the norm for the younger generation. It is an attitude that rejects modern society and its values to a much greater extent than that of the previous genera-

tion. Tattooing, for many of the younger generation, can be seen as a means to both challenge the commodification of their generation, as well as to participate in that commodification, via the consumption of trendy, expensive tattoos—the ultimate consumer item.

Today many modern kids, both middle class and working class, use their tattoos in a way that recalls the more marginal working-class uses of the tattoo: as a form of resistance. But rather than using their tattoos as a form of class rebellion, many Xers are objecting to the conditions of late twentieth-century North America—thus the focus on the primitive in the language of so many. As Daniel Rosenblatt writes, "I suggested earlier that the use of the 'primitive' as a source of opposition to the status quo had roots in an underlying ambivalence about progress based in a Christian ambivalence about worldly labor in general. Part of what is involved in valorizing the primitive is to rewrite the narrative of progress as a story of the exclusion of other human possibilities. While few among modern primitives wish to reject entirely the fruits of what we see as 'our progress,' they see these fruits as having been gained at the expense of losing other aspects of what it takes to be fully realized human beings" (1997:322). Indeed, Xers who seek a more authentic life experience than what is provided by the megaconsumerism of the mall, or the often alienating reality of computers, could do worse, I suppose, than to use tattoos to resist these experiences. While I remain cynical about the idea of a resistance movement based on the appropriation of a set of images and ideas from other cultures (whose members do not benefit from their participation), I have to admit that tattoos, given their particularly subversive history in Western civilization, are not a bad choice.

## The Tattoo of the Future

The American tattoo has changed enormously in the last thirty years. What started out as a highly standardized image commemorating patriotism, loved ones, or memorable events (an image that had not changed appreciably since the nineteenth century) quickly became linked to new social formations in the years following the end of World War II. Bikers and Chicano gangs began to shape the tattoo to their own lifestyles and aesthetics, changing the style,

imagery, and set of meanings associated with the tattoo. Later, middle-class men and women also began to re-work the traditional images of the tattoo in order to fit their own changing lifestyles. Just as there is no single working-class tattoo (classic American tattoos, biker tattoos, and Chicano tattoos are easily distinguished from one another and occupy very different social positions), there is also no single middle-class tattoo. Since the eighties, tattoo styles have multiplied, and customers today can choose from tribal, neo-tribal, circuitry, Celtic, Japanese, neo-traditional, photo-realistic, Chicano-style, and a host of other styles and techniques. Images range from rain forest scenes, science fiction/fantasy scenes, portraits, copies of "fine art," children's drawings, Northwest Indian designs, and Sanskrit lettering, as well as the more traditional animals, flowers, and hearts. Along with the new images, tattoo clients can also choose from a selection of ideologies with which to make sense of their new tattoos. Tattoos can now represent spirituality, a connection to the earth, an instinctive drive, or a connection to the primitive. What makes these most recent transformations especially remarkable is that they have occurred within the span of about fifteen years.

What direction will tattooing take in the future? Will tattooing continue its inroads into the middle-class community? And will the youngest generations lead the way? It is difficult to say whether, as many feel, the renaissance is simply a trend that will burn itself out. Some tattooists, in fact, hope that it does. I spoke with a number of old-timers and a few younger, more educated tattooists who are critical of many of the changes in the tattoo community. Most welcome the technological and artistic advancements (although not all do), but many are equally critical of what they see as a drop in traditional values in the community. The following comments are from tattooists—working class and middle class, young and old, East Coast and West Coast—who are alarmed at the direction that contemporary tattooing is taking:

It [contemporary tattooing] seems confused and misdirected in its intent most of the time: kids playing with experimental behavior without really considering what they're doing. A lot of it seems really "young" and undeveloped to me . . . sloppy, to put it bluntly. As someone who has tattooed in New York City for more than a decade,

I have seen the gradual progression of "mainstreaming" exercise its influence on the art form. I find people being pretty cavalier about permanently changing the appearance of their bodies, bowing to a social shift without giving it much thought. I found myself turning 60 percent of the potential customers away because they just didn't have a clue about what they were doing. . . . I guess that's why I'm enjoying talking to the older New York City tattooers. They describe an art form composed of a unique and pragmatic set of values that somehow has gotten away from them. (Larry M., tattooist)

Tattooing's become fashion now, it's become trendy. But because of all the attention it's getting, you know MTV, the media, it's like anything else where the kids see something on TV, whether it's a tattoo or a pair of shoes or something, they treat it as the same thing. It's a fashion statement. . . . I always thought it should be more than just a fashion statement. But the media, they take tattooing and take it down to its lowest common denominator so people can understand it. (Hal M., tattooist)

For Hal and Larry, tattooing has become fashion because everyone has one and very little thought is put into getting them today. This perspective is totally at odds with the statements given by most of my young, heavily tattooed informants. They claim that their tattoos are extremely meaningful, spiritually powerful, and represent a lifelong commitment. To me, this disparity in viewpoints points to more than just a generational difference. What seems to be occurring is a form of class backlash: the very same middle-class tattooists who were at the forefront of the renaissance now look nostalgically back to the old days of blue-collar values. Another tattooist made these comments to me on the modern scene: "Everybody's got tattoos these days. Used to be a big thing if you had a bunch of tattoos. Not anymore, now everybody's got a bunch of tattoos. . . . I know I'd hate to be wearing some of the shit these people are wearing in another fifteen years. I wouldn't feel very good about it! But you know, that's probably what people were saying about me fifteen years ago. I hope the trend burns itself out, I hope so" (Sam P., tattooist). As more people wear tattoos, tattooing starts to become an entirely mundane, mainstream practice. Many tattooists feel that tattooing will lose its uniqueness as tattoos become a normal part of everyday life. Again, this is attributed to the presence of the younger

generation: Gen Xers are thought to have a more cavalier attitude toward tattooing and do not seem to respect the values and traditions of the old-timers.

Another fear is that as tattoos become mainstream, they also become whitewashed. With so many people becoming tattooed today, the stakes will have to rise in order to keep some of the shock value that is traditionally associated with tattooing. As tattoos become ubiquitous, those wearing tattoos will have to wear ever-more-visible and ever-more-subversive tattoos — like facial and head tattoos — in order to stand out from the crowd. How else can you retain any individuality when everyone wears tattoos? Lyle Tuttle was once asked by a reporter to predict the future of tattooing. He said, "it's shot its wad." He explains,

> I don't see a dull future for [tattooing], 'cause there's a certain amount of people who's gonna get tattooed. But it's gonna be over-saturated. The baby being born today, there's a fifty-fifty chance he's gonna be suckling a tattooed bosom. He's gonna get to kindergarten and his kindergarten teacher is gonna be hiking up her underwear 'cause everyone who's got tattoos loves to show 'em. So when that kid grows up, it's going to be a pretty goddamn mundane practice. So anytime anything gets over-saturated people lose interest. The old, Can you top this? It's gonna be pretty difficult to top some of these characters who are out here. Captain Don,[1] he's been on the road for years, doing his fire-eating, tattooed man shows. So he looks up one time into the audience and the audience has more tattoos than he has! So he's gotta bolster his up now. . . . Some of these guys nowadays have their necks done, the tops of their heads, I mean there's more goofballs running around with that stuff on their heads. I don't even have anything on my hands!

What is interesting about these comments is that much of what these tattooists lament in the new tattooing—a loss in "traditional" values, very little thought being put into receiving a tattoo, sloppy and poorly conceived tattoos—echoes what was once said by middle-class tattooists about traditional working-class tattooing. We have seen how elite tattooists, magazine editors, and tattoo organizations have constructed modern tattooing as a response to working-class tattooing. Traditional, working-class tattooing, on the other hand, has been characterized as lacking in sophistication

and significance and is worn by people who put very little time or thought into their tattoos. Yet it seems that today, a number of (older and younger) tattooists are reacting negatively to this construction of traditional U.S. tattooing. They are asserting that classic American tattooing *did* have something valuable to offer, something that is being lost in all of the trends, conventions, and magazines. The traditional American tattoo—with its easy-to-read imagery that reflected the old-fashioned values of God, mother, and country—is being displaced in favor of the contemporary tattoo, with its often unrecognizable imagery and exotic content. The contemporary tattoo is high fashion, but at the same time, it alienates those whose tattoos are no longer favored.

At a tattoo convention in San Diego in 1993, I met a tattooist named Leo who admired an old-fashioned tattoo on my arm. It is a bluebird holding a banner with my (now ex-) husband's name in it. He said to me,

> There's a certain emotional feeling that reflects the moment that you put it on, and it's still there, and if tattoos do that, then they've served the wearer. If they're just there for total decoration then it's like a paint job on a car, it doesn't tell you much. That tattoo tells me more about you and about your values than any of your other tattoos. It's a genuine tattoo. It tells a story. I like stories and tattoos, no matter how well done, and if they don't tell a story that involves you emotionally, then they're just there for decoration, then they're not a valid tattoo. There has to be some emotional appeal or they're not, to my way of thinking, a real tattoo. It tells people what you are and what you believe in, so there's no mistakes.

Ironically, the name tattoo that Leo admired is my poorest-quality tattoo, yet it is the one tattoo that spoke the most to him. It was given to me by an old-time tattooist—called "Butcher Bob" by the other tattooists in his town—whose machines and techniques were stuck in the fifties. But for Leo, this tattoo tells an old-fashioned story of love. So what if the love didn't last? My tattoo, like my original motivation in getting it, may be naïve, but it is a concrete sign of the feelings that I once had. Tattoos like this one, according to Leo, tell a story all by themselves. Modern tattoos, on the other hand, do not. The *wearer* must construct a narrative to explain them, because the tattoos are no longer able to do this. Leo goes on,

It's easier for me to be around that kind of tattooing than the high-tech chrome with the light bouncing off of it, because emotionally, that doesn't give me the same satisfaction. And once tattooing, I think, gets away from the emotional foundation and gets into some kind of high art, technical glitter, people are going to lose interest in it because there's no longer the emotional connection. And once you break the emotional connection, then people have no use for it. It just becomes an inanimate object, like a machine, a chair, a desk or something like that. It doesn't have any value other than it's a well-executed tattoo done by a highly educated tattoo artist. (Leo T., tattooist)

For Leo, it is the old-fashioned, traditional tattoos favored by his customers that have the emotional foundation that he values. In many ways, this position is a radical challenge to the dominant perspective on tattooing that I have outlined in this book—which maintains that only a fine art, custom tattoo can have that kind of emotional resonance. I see in the statements made by Leo and the other tattooists represented in this chapter not just a throwback to a golden past. I also see a glimpse into a possible future for contemporary tattooing, one in which the history and values of traditional North American tattooing are respected.

As far as what it is today, I can't label it, I can't say tattooing is this or tattooing is that, I don't know. All I know is what I do, and what I do is basically do the things that I like. If people want to share my vision of what I think tattooing is all about, then I think that's fine. You know it's like not everybody wants to eat fish on Fridays. So that's how I see it. (Hal M., tattooist)

# Notes

## Preface

1 I can even understand those who would *not* speak with me, like the New York tattooist who said that he would talk to me only if I got tattooed by him—at $200 an hour! As another tattooist explained it, "Let's face it, graduate theses don't have much to offer, percentage-wise."

## Introduction Bodies and Social Orders

1 In the text, I often use the terms "North American" and (less so) "American" to describe what is usually U.S.-specific culture, people, and styles. While I try to be as specific as possible in my writing, this is often unavoidable, simply because the English language does not have an adjective to refer to the United States. I apologize to my Canadian readers for this usage, as it tends to implicate Canada and Canadians in statements that may or may not refer to them.

2 This book was largely researched and written from 1990 to 1995 and thus does not include many of the changes that have occurred within the tattoo culture since that time.

3 Readers will notice that this book is almost entirely based on the ethnography of the middle-class tattoo community. This is not accidental. While I acknowledge that the book would gain from a greater emphasis on working-class perspectives, my intention in researching this project was to carry out an in-depth look at the middle class's participation in the tattoo culture. Perhaps future researchers will take on what I have not—an ethnography of working-class tattooing in the United States—as I believe that only a full ethnography will do justice to this fascinating subject.

4 "Flash" refers to highly standardized tattoo designs, found on poster-sized sheets on most street shop walls. Flash designs are either drawn by the tattooist who runs the shop or they are purchased from other tattooists. Some flash sheets found in contemporary tattoo shops date back to the 1940s, but most are from the 1970s or 1980s.

5 Mary Douglas (1966, 1982) was perhaps the first anthropologist to centralize the cultural analysis of the body in her work and thus her influence on contemporary studies of the body is significant. Douglas was concerned with the universal human anxiety about disorder, and wrote that societies respond to disorder through the classification of things both natural and social. Through the creation of categories (such as pure and impure) and their accompanying rules, people are able to contain disorder and restore order to society. For Douglas, the body is the most natural symbol for and medium of classification, and thus rules associated with controlling the body and its processes emerge as a powerful means of social control. The body, then, acts as a model for the social body such that threats to the limits of the physical body are also threats to the social body and must be rigidly controlled. There is an ongoing exchange of meanings between the two kinds of bodily experience—physical and social—so that each reinforces the other. Douglas realized that the body can also be a site of resistance, as people can and do mark their own bodies in ways that threaten the existing social order, and this becomes an important focus in much of today's scholarship on the body.

Foucault (1979, 1980a, 1980b) was also concerned with the physical body and the ways in which it is regulated. But for Foucault, modern Western bodies are not subject to the same kinds of social control that Douglas describes in tribal societies. Instead they are disciplined through various controlling mechanisms located through-out the social body, such as medicine, psychiatry, education, law, or social policy. But power is not just wielded by particular institutions— rather, it is a part of all social relations. Furthermore, the body is not simply the target of power; it is the source of power as well because, as Foucault demonstrated, with the multitude of regulatory agencies available throughout society, bodies begin to discipline themselves and each other.

Foucault's contribution to an understanding of the body in culture has been tremendous, as can be seen by much of the recent scholar-ship on the body (O'Neill 1985; Polhemus 1978; B. Turner 1984; Arm-strong 1985; Featherstone et al. 1991). Many recent studies have taken as their target the gendered body (Martin 1987; Russo 1987; Gallop 1988; Jagger and Bordo 1989; Bordo 1990; Butler 1990; Mascia-Lees and Sharpe 1992) and have moved beyond Foucault in a variety of

ways. These studies take on topics such as the role that fashion plays in the construction of the female body (Silverman 1986; Gaines 1990; Wilson 1987) or how women's bodies are constituted through the discourses of science (Martin 1987; Jagger and Bordo 1989; Bordo 1990). For example, Emily Martin, in her work on medical constructions of the female body (1987), looks at how social control over the body has moved from the legal realm of corporal punishment, as per Foucault, to the medical realm of science. Other writers (Grosz 1990; Mascia-Lees and Sharpe 1992), again following Foucault, demonstrate that the body is a canvas on which patterns of significance are inscribed and counterinscribed. Mascia-Lees and Sharpe, for example, literalize this notion in their discussion of how the tattoo is a literal example of how culture writes on the body. Many recent works emphasize as well the ongoing struggle for control over the (female) body, as women challenge, through their bodies, dominant notions of beauty, femininity, or respectability. Butler (1990) and Russo (1987) in particular focus on female bodies that challenge conventional notions, bodies that through self-marking are seen as "subversive" or "out of bounds." But these writers move beyond Foucault, who seems to deny the possibility that bodies can successfully operate as sites of resistance. For Foucault, as bodies resist control, power responds with an entirely new mode of control, and the struggle continues (Foucault 1980b). This question of resistance and control is never fully resolved in my own work, as I see working-class and middle-class members of the tattoo community continuously challenging each other for control over the community and its defining sign.

6 A practice, thought by many to be analogous to tattooing and found in much of sub-Saharan Africa, which involves cutting the skin to produce raised scars for aesthetic and social purposes.

7 See Sanders 1989 for a summary of this research.

## 1. Finding Community
### Shops, Conventions, Magazines, and Cyberspace

1 Most custom tattooists charge between $100 and $200 an hour. Street shops traditionally charge for the individual tattoo, and many have price sheets that correspond to colored tags on the flash. Tattoos in a street shop can cost from $25 to $400 for a single piece.

2 Facial tattoos are traditionally the mark of a convict. Even without that explicit connection, facial tattoos are extremely stigmatizing in the nontattooed world, and most tattooists do not want to contribute to marking an individual for life as an outcast.

3 The process goes something like this: Once the client chooses a design, the tattooist must make a stencil for it. Typically, the tattooist will trace the image onto rice paper with a special pencil and transfer the image to the body with soap, or often deodorant stick. Earlier in the century, when most tattoo designs were picked off of the tattooist's wall, a tattooist would have permanent stencils, drawn on acetate, which would be used to transfer the drawing to the body. Once the design is on the body, the tattooist first uses a liner machine to outline the design (usually in black), and then switches to a shader to color the design. Liner or shader, all tattoo machines consist of anywhere from one to twelve needles soldered to a needle bar; the motor causes the needle bar to vibrate up and down within a tube, which is connected to the motor. The tattooist dips the tip of the machine into a small cup into which he or she has poured a small amount of ink. As the needles emerge from the tube, the machine works like a sewing machine, injecting small doses of pigment into the skin. In any professional street shop, the needles and needle tubes are either brand new for each client, or have been sterilized prior to each use, and the inks are fresh for each client.

4 All of these aspects of tattooing are laid out in Sanders 1987.

5 Although the first tattoo convention in the modern sense (a commercial event with tattooists, vendors, fans, and contests) was organized by Dave Yurkew in Texas in 1976, before that there were other, smaller conventions. There was one in Hamburg, Germany, in 1956; Les Skuse in Britain used to host the Annual Bristol Tattoo Club Party; and Milt Zeis in America used to hold get-togethers for tattooists in the 1940s. None of these, however, were conventions as I have defined them above.

6 On the other hand, some tattooists were very friendly with other tattooists, corresponding with one another, sharing flash and design tips, and visiting one another. But as Kenny points out, much of these were long-distance friendships.

7 The National Tattoo Association is the largest association of tattooists and enthusiasts in the world. Membership dues are $40 per year and include an I.D. card, a certificate for tattooists, and a subscription to the monthly newsletter. Their first convention was in 1979 in Denver, and they have hosted a convention every year since that time.

8 One middle-class tattooist said this about the importance of bodily appearance at tattoo conventions: "You know, these people who go on stage, they're terribly out of shape and they have no recognition of the fact that tattoos are an embellishment of the physical body and the idea of tattoos as some kind of enhancement. That's okay, you know it's a free country, but it's just kind of creepy and sad to me."

9 Bakhtin writes further, "in the atmosphere of Mardi Gras, reveling, dancing, music were all closely combined with slaughter, dismemberment, bowels, excrement, and other images of the material bodily lower stratum" (1984:223–24). The combination of sexuality and excrement, and death and renewal, is a primary feature of what Bakhtin calls the grotesque concept of the body. The grotesque body—which is open, secreting, protruding, and unfinished—is everywhere present at the convention as well. The tattooed body, too, is unfinished, its borders open and extended, and through the acquisition of more tattoos, it is literally "a body in the act of becoming" (311).

10 According to Turner, a dialectic occurs between structure and antistructure in that antistructure, as is found in carnival, defines structure and ultimately exists to support it. Carnival, in this reading, reinforces the conservative values of society. Rather than actually changing anything, the subversive behaviors represented in carnival dissipate, thus the status quo remains unchallenged once the carnival is over. In this understanding, the tattoo convention acts as a release valve for the working classes: the pressures that have built up over the year are released at a certain time and place, with no threat to mainstream, middle-class society. Of course, Bakhtin also recognized that once the state appropriates the carnival forms of folk culture, as happened in seventeenth-century Europe, they turn into trivial spectacles and lose their utopian and political character, becoming just another tool of bourgeois social control.

11 Tellingly, there was, as of the end of 1995 when I wrote much of this manuscript, no World Wide Web site devoted to tattooing. When I posted a question about this on RAB, someone wrote back with the response "This is a *chat* group!" In other words, the key element of RAB is *not* the visual images found in the tattoos (or piercings) but the discourse that surrounds it. By 1997, as this book went to press, a website had been established, known as the Rabbit Hole. The newsgroup, however, remains primary.

12 I found an interesting example of this on the "Angry Biker Homepage" website. In their definition of the "True American Biker," the author writes: "It may be easier to say who is not a biker—like RUBS and yuppie scum." Here "ass-kissing, yuppie scumbags that have assumed the position of spokesmen for the True American Biker" are specifically excluded from membership in the community of true bikers.

## 2. *Cultural Roots* The History of Tattooing in the West

1 Tattooed Native Americans were also noted by Europeans, as early as the sixteenth century, and included Alaskan Aleuts, Pacific Eskimos, Wichita, Haida, Iriquois, Osage, Kwaikiutl, Cherokee, and most California Indians like the Miwok, Modoc, Wintun, Washo, Mono, and the Pomo. The observation of tattooing among Native Americans contributed to their "savage" appearance and later contributed to the narratives told by tattooed carnival acts, but Native American tattoos probably did not influence westerners to become tattooed as did Polynesian tattooing.

2 A carny is a person who travels with a carnival, or sometimes a circus.

3 Patricia Allen (1991) notes that both O'Connell and Rutherford may well have been tattooed in the South Seas, although probably not on the islands that they claim to have been tattooed on, and their stories are most certainly fabricated.

4 Unlike many of the tattooed ladies at the time, Betty resisted the "native capture" narratives that were used to draw patrons to her act and hated being called the Tattooed Venus (Chuck Eldridge, personal communication).

5 Genital tattoos have always been a topic around which jokes and stories circulated. Penis tattoos in particular, due to the difficulty in tattooing, the nature of the designs requested, and the effects on the person being tattooed, were (and are) a favorite topic in tattoo shops. Legendary designs included eyeballs or flies on the glans, and barber poles, lollipops, and "YOUR NAME" on the shaft. One joke tells of a man who got a hundred dollar bill tattooed on his penis: "He got it so that his wife could stretch their money and blow a hundred dollars just like that!" Another refers to the naval tradition of getting a rooster (cock) tattooed below the knee: If you put a chicken on one leg and a pig on the other, and if the ship sunk, you wouldn't go down with the ship. Additionally, the man can say to people, "my cock goes down to there," pointing to his lower leg. A related joke was to have a cherry tattooed on the body. A man could say to a woman, "here's my cherry, where's yours?" Following are other classic genital tattoo stories:

> I had a guy who wanted me to tattoo a dot on his cock. He asked the price and I told him it would cost $10 and $20 if he came and, sure enough, he came. In a year's time he must have had me put 100 dots on his cock. (Jack Armstrong, cited in Morse 1977:74)

> This guy was getting tattooed by one of my co-workers in my shop. He wanted "Kosher" in Hebrew tattooed on his dick. So he goes to a

store where they sell kosher wine and he asks the guy who runs the store (who is Jewish) to write out "Kosher" in Hebrew, from a wine label, onto a piece of paper to take with him to the tattooist. So he does this. Then he's over here getting tattooed and I get this call for this guy. I say he can't talk right now, he's being tattooed. But the guy's real insistent and really wants to talk to him. So I say, OK, and I go get the guy. By this time, the tattoo's almost done. Turns out the guy had written the wrong Hebrew word down for him. What he actually wrote was "Boiled." So this guy's got "Boiled" tattooed on his dick! (Scott H., tattooist)

A guy in the service is getting his dick inspected for health, venereal diseases, etc. It's called the "short arm inspection." The sergeant comes along and sees his dick has a tattoo on it. "What's that?" "It's my girlfriend's name." "Oh, her name is Dot?" "No, when I have a hard-on it says Dorothy!" (Al C.)

Although I have no way of knowing, it seems to me that genital tattoos—and the jokes surrounding them—are not nearly as popular today as they were in the prerenaissance period, perhaps due to the seriousness with which tattoos are treated by many in the middle class.

6  Needles get sharper over time, rather than duller, due to their constant friction inside the needle tube. They often curl over into a fish hook shape from too much use as well. The fact that needles were rarely changed is one of the reasons why traditional American tattooing hurt so much more than modern tattooing.

7  "Mom" tattoos are in many ways akin to the patriotic tattoos in that both express deep love for the mother—both the biological mother as well as the motherland. Nationalist discourse, as Katherine Verdery points out in a paper on gender-nation in Eastern Europe (n.d.), is often gendered, in that *men* defend *feminized* nations. Nations only become masculinized when they triumph. Thus a sailor's choice of a "Mom" tattoo is both an expression of personal affiliation as well as a more nationalist sentiment.

8  Earlier tattooists, however, lamented the end of patriotic tattooing after World War I (Govenar 1984).

9  Tattooing was recently legalized in New York City after a thirty-three year ban.

10  Many of these studies were based on Lombroso's 1895 book, *L'Homme Criminel*, a psychiatric look at the connection between tattoos and criminal behavior.

## 3. *Appropriation and Transformation*
### The Origins of the Renaissance

1 Traditional Japanese tattooing is still not acceptable among the middle class in Japan, but many Japanese youth are now wearing Western tattoos, received by American tattooists, as part of a larger movement in favor of all things American.

2 Sailor Jerry, on the other hand, felt that if it were not for Tuttle's relentless publicity campaigns, health authorities would never have targeted tattooing in the first place.

3 The tattooists that Hardy trained or hired, too, have all gone on to be leaders in the field: Bill Salmon, Chuck Eldridge, the late Greg Irons, the late Jamie Summers, Bob Roberts, Leo Zulueta, Freddy Corbin, Dan Higgs, Eddy Deutsche, and others.

4 In fact, through tattooing, many middle-class tattoo customers are now exploring their "Celtic roots." This awakening interest in all things Celtic (including music, dance, language, religion) strikes me as a way in which white people, who are typically excluded from ethnic revivals, are able to express ethnicity.

5 Many artists and enthusiasts today do favor classic American cartoon designs and especially those that are influenced by the work of underground cartoonists like Big Daddy Roth and the Pizz, or artists like Robert Williams. But the revival of neotraditional styles is found primarily among young tattooists who are hard-core enthusiasts. I would still argue that non-Western tattoo styles remain most popular, especially with new tattoo enthusiasts.

## 4. *Discourse and Differentiation*
### Media Representation and Tattoo Organizations

1 Of course, the conflation of populations and tattoo styles occurs in the opposite direction as well and not just in the mainstream press. Within the tattoo community, middle-class tattoo enthusiasts often lump all working-class tattoos and their wearers together (and see them as equally threatening). At the same time and in a similar fashion, working-class tattoo enthusiasts often lump together women, gays, and yuppies. In both cases, there is a melding of diverse populations into a single category, and this process allows subgroups of tattoo artists and wearers to displace some of their class hostilities onto easily identifiable opponents.

2 There are a number of other biker tattoo magazines that I will not dis-

cuss, because their editorial focus is extremely narrow, such as *Tattoo Flash, Tattoos for Men, Tattoos for Women,* and *Skin Art.* All of these magazines are dedicated to showcasing photos of tattoos, with little or no editorial content, and are primarily aimed at people who are looking for tattoo design inspiration. Since 1995, when this book was written, there are now online tattoo magazines like *Skin Two Online,* which I will also not address here.

3 It was suggested by a reader of this manuscript that many of the letters to the editor that I have cited, both in the highbrow magazines like *Tattoo Advocate,* as well as in the biker magazines like *Tattoo Revue,* were perhaps written by the magazine editors themselves to promote their own agendas. While I cannot verify whether or not this is the case, it is intriguing to think that these letters are a deliberate attempt to shape, rather than simply reflect, the community.

4 Shaw first worked as an editor with the biker magazine *Tattoo Revue.* I was told by one magazine editor that the people at *Outlaw Biker* wanted to start a tattoo magazine, but they needed someone to access the tattoo community because "they didn't know squat about tattooing," so they hired Shaw to be their access. Evidently after he left *Tattoo Revue,* he moved over to *ITA* to act as that magazine's contact in the tattoo community. I was told that "he got so much resistance from all the tattooists that they had to fire him. The tattooists refused to do business with him. You can't do a tattoo magazine without access to the artists, so they fired him and Jonathan went his merry way" (interview with the author).

5 Since both *Tattoo* and *Tattoo Revue* were published before most of the newer, highbrow tattoo magazines came onto the market, middle-class tattoo wearers did not have much choice in terms of magazines that covered tattooing.

6 According to Lani Teshima (1995), Spider Webb's organization, the Tattoo Club of America, would be the oldest and largest tattoo organization in the United States (founded in 1970, membership of 45,000). While I do not doubt its age, I do doubt the membership figures, as Webb is known to exaggerate details like this.

7 Membership in this organization is capped at 1,000, with a long waiting list of tattooists and enthusiasts hoping to eventually get in.

8 Although virtually all professional tattooists today are aware of the risks of transmitting diseases like hepatitis B and HIV and now sterilize tattoo equipment and wear latex gloves, for some, this is still not enough. One San Diego dermatologist is now calling for regulations including written exams for tattooists, written consent forms, and limiting the practice of tattooing to "mentally competent" adults (Peterson 1995).

9 Competition between tattooists can often become vicious. At a tattoo convention in San Diego in 1995, someone had posted fliers in the bathrooms with the message: "[Name] infected over 60 people with the AIDS virus by mixing his own blood in our customers ink. [Name] had OUR studio closed in Joliet, Illinois. [Name] now owns his own studio in Chicago, Illinois. [Name] now wants to get into piercing. [Name] is very spiteful. [Name] wants to KILL EVERYONE. Please don't be careless and have this man tattoo you. BEWARE OF [Name]— DON'T GET AIDS." This message was signed "A public service announcement from the American Tattoo Association." There is, to my knowledge, no such thing as the American Tattoo Association, so I do not know who sponsored the message. Immediately after finding the posters, a woman came into the bathroom and began removing them all, saying that it was not true. I have never found out where it came from or what it was created for, other than to ruin a man's reputation.

10 Here I am only referring to the practice of tattooing by male prisoners.

11 Convict tattooists are not unaware of the stigma associated with prison tattoos, and many will not tattoo a young prisoner who has not been tattooed, especially if it's clear that he is not going to become a lifer.

12 In 1993, the Old Idaho Penitentiary, in conjunction with the Idaho Commission on the Arts, put on a show titled "Marked Men: Prison Tattoos as Art and Expression." Also, some tattoo magazines (as well as mainstream magazines like *Natural History*, November 1993) are featuring articles about prison tattooing, both in the United States and elsewhere.

13 Original typos and grammatical errors included.

## 5. *The Creation of Meaning* I  The New Text

1 The "New Class" or "Knowledge Class" refers to those members of the middle class who are particularly well favored in terms of education, income, status, and personal freedom, "a professional middle class centering around information rather than the commerce or the production of the older, entrepreneurial middle class" (Mechling and Mechling 1991:98). While I use this term to refer to these movements, I do not mean to imply that the new class (or middle class) was exclusively involved in them. However, I think it is clear that the middle-class professionals who wrote the books to which I refer in this chapter, and who gave the seminars, became the primary spokespeople for the various movements and thus played a major role in defining what, exactly, these movements were about.

2 "13" is shorthand for marijuana, while "1%" refers to the famous state-

ment by the American Motorcycle Association that only 1 percent of all bikers are outlaws. 1%, when seen on a tattoo or on another form of biker art, is a badge of honor.

3 I use Aram Yengoyan's definition of prior text as "the conscious, discursive, and unconscious ontological axioms that members of a society possess through tacit agreement" (1992:7).

## 6. *The Creation of Meaning* II  The Tattoo Narratives

1 Gay men, on the other hand, have explained their tattoos to me in those terms.

2 Of course this is not always the case. Historically, as in the present, the tattoos women wore were often signs of ownership, not of independence. Many early circus and carnival attractions were tattooed by their husbands and many, such as performers Artfullette, Artoria (both of whom were tattooed in the 1920s), and Irene Libarry (tattooed in 1902), would not have had careers if it weren't for their tattooist-husbands. This practice still continues today, with wives and "old ladies" of tattooists wearing their husbands' work on their bodies and often their husbands' names as well. I still carry my ex-husband's name on my arm. (Although it is probably more common for men to wear their wives'/girlfriends' names than vice versa).

3 I did not include modern primitivism as a social movement in chapter 6 because of its direct link to tattooing. It was not, as was the case for the New Age or the self-help movements, a New Class movement whose ideologies were borrowed and imported into tattooing. Rather, modern primitivism is *about* body modifications, and I felt that its discussion fit better into this chapter.

## *Conclusion*  The Future of a Movement

1 Captain Don is a tattooed sword swallower who has been traveling with various circus and carnival sideshows for thirty years.

# Bibliography

Ablon, Joan. 1982. "Field Method in Working with Middle Class Americans." In *Anthropology for the Eighties*, ed. Johnetta Cole, 38–43. London: Free Press.

Adler, Margot. 1979. *Drawing Down the Moon*. Boston: Beacon Press.

Agris, Joseph. 1977. "Tattoos in Women." *Plastic and Reconstructive Surgery* 60: 22–37.

Allen, Tricia. 1991. "European Explorers and Marquesan Tattooing: The Wildest Island Style." *TattooTime* 5: 86–101.

Anderson, Benedict. 1983. *Imagined Communities*. London: Verso.

Armstrong, David. 1985. *The Political Anatomy of the Body*. Cambridge: Cambridge University Press.

Arnold, Frank. 1994. "Harleys, Tatts and Affect: Trends in the Negotiation of Belonging." Paper presented at Popular Culture Association Annual Conference, Chicago.

Audibert, Chris. 1986. "Gone Are the Days." *Tattoo Historian* no. 10: 12.

Aurre, Judy. 1982. "Meet Betty Broadbent." *Tattoo Historian* no. 1: 21–23.

———. 1983. "Meet Bert Grimm." *Tattoo Historian* no. 2: 12–14.

Bakhtin, Mikhail. 1984. *Rabelais and His World*. Bloomington: Indiana University Press.

Baldwin, Guy. 1991. "A Second Coming Out." In *Leatherfolk*, ed. Mark Thompson, 169–78. Boston: Alyson Publications.

Basile, Bob. 1985. "Japan's Tattoo Revolution." *TattooTime* 3: 74–76.

Bass, Ellen, and Laura Davis. 1988. *The Courage to Heal: A Guide for Women Survivors of Child Sexual Abuse*. New York: Perennia Library.

Beal, George Brinton. 1989. "The Tattooed Lady." *Tattoo Archive* (fall): 44.

Bean, Joseph. 1991. "Magical Masochist: A Conversation with Fakir Musafar." In *Leatherfolk*, ed. Mark Thompson, 303–19. Boston: Alyson Publications.

Beard, Steve. 1992. "The Tattooed Lady: A Mythology." In *Tattooed Women*, ed. Chris Wroblewski, 1–6. New York: Carol Publishing Group.

Beattie, Melody. 1987. *Codependent No More*. San Francisco: Harper and Row.

Bellah, Robert, Richard Madsen, William Sullivan, Ann Swidler, and Steven Tipton. 1985. *Habits of the Heart*. Berkeley: University of California Press.

Blanchard, Marc. 1991. "Post-Bourgeois Tattoo: Reflections on Skin Writing in Late Capitalist Societies." *Visual Anthropology Review* 7, no. 2: 11–21.

Bly, Robert. 1990. *Iron John: A Book about Men*. Reading, Mass.: Addison-Wesley Publishing Company.

Bogdan, Robert. 1988. *Freak Show*. Chicago: University of Chicago Press.

Bojorquez, Jennifer. 1992. "Body Images." *The Sacramento Bee*, July 10.

Bordo, Susan. 1990. "Reading the Slender Body." In *Body Politics: Women and the Discourses of Science*, ed. Mary Jacobus, Evelyn Fox Keller, and Sally Shuttleworth, 83–111. New York: Routledge.

Bourdieu, Pierre. 1977. *Outline of a Theory of Practice*. Cambridge: Cambridge University Press.

———. 1984. *Distinction: A Social Critique of the Judgement of Taste*. Cambridge, Mass.: Harvard University Press.

Brain, Robert. 1979. *The Decorated Body*. New York: Harper and Row.

Briggs, J. 1958. "Tattooing." *Medical Times* no. 87: 1030–39.

Bronnikov, Arkady G. 1993. "Telltale Tattoos in Russian Prisons." *Natural History* 11: 50–59.

Burchett, George, and Peter Leighton. 1958. *Memoirs of a Tattooist*. London: Oldbourne Book Company.

Burma, John. 1965. "Self-Tattooing Among Delinquents: A Research Note." In *Dress, Adornment and the Social Order*, ed. M. E. Roach and J. B. Eicher, 271–79. New York: Wiley.

Burns, David. 1980. *Feeling Good: The New Mood Therapy*. New York: Morrow.

Butler, Judith. 1990. *Gender Trouble: Feminism and the Subversion of Identity*. New York: Routledge.

Campbell, Brenda. 1992. "Mirrors and Windows: The Movement of Meaning in Tattoo." Paper presented at American Anthropological Association Annual Meeting, San Francisco.

Campbell, Joseph. 1949. *The Hero with a Thousand Faces*. New York: Pantheon Books.

———. 1959. *The Masks of God: Primitive Mythology*. New York: Viking Press.

———. 1962. *The Masks of God: Oriental Mythology*. New York: Viking Press.

———. 1964. *The Masks of God: Occidental Mythology*. New York: Viking Press.

———. 1968. *The Masks of God: Creative Mythology*. New York: Viking Press.

———. 1972. *Myths to Live By*. New York: Penguin Books.

Castañeda, Carlos. 1968. *The Teachings of Don Juan: A Yaqui Way of Knowledge*. New York: Ballantine Books.

———. 1971. *A Separate Reality: Further Conversations with Don Juan*. New York: Pocket Books.

———. 1972. *Journey to Ixtlan: The Lessons of Don Juan*. New York: Simon and Schuster.

———. 1976. *Tales of Power*. New York: Pocket Books.

Chapkis, Wendy. 1986. *Beauty Secrets: Women and the Politics of Appearance*. Boston: South End Press.

Christ, Mary, and Judith Plaskow, eds. 1979. *Weaving the Visions: New Patterns in Feminist Spirituality*. San Francisco: Harper Collins.

Colson, Kenneth. 1994. "Tattooing as American Folklore." Paper presented at Popular Culture Association Annual Conference, Chicago.

Coons, Hannibal. 1992. "Skin Game Michelangelos." *Tattoo Archive* (spring): 24–29.

Daly, Mary. 1973. *Beyond God the Father*. Boston: Beacon.

Deleuze, Gilles, and Felix Guattari. 1983. *Anti-Oedipus: Capitalism and Schizophrenia*. Minneapolis: University of Minnesota Press.

DeMello, Margo. 1991. "Anchors, Hearts and Eagles: From the Literal to the Symbolic in American Tattooing." In *Literacies: Writing Systems and Literate Practices*. Davis Working Papers in Linguistics 4, ed. David Schmidt and Janet Smith, 93–110. Davis: University of California.

———. 1993. "The Convict Body: Tattooing among American Male Prisoners." *Anthropology Today* 9, no. 6: 10–13.

———. 1995a. "The Carnivalesque Body: Women and Tattoos." In *Pierced Hearts and True Love: A Century of Drawings for Tattoos*, ed. Don Ed Hardy, 73–79. Honolulu: Hardy Marks Publications.

———. 1995b. "'Not Just For Bikers Anymore': Popular Representations of American Tattooing." *Journal of Popular Culture* 29, no. 3: 37–52.

di Leonardo, Micaela. 1984. *The Varieties of Ethnic Experience*. Ithaca: Cornell University Press.

Dominguez, Virginia. 1986. *White by Definition: Social Classification in Creole Louisiana*. New Brunswick: Rutgers University Press.

———. 1989. *People as Subject, People as Object: Selfhood and Peoplehood in Contemporary Israel*. Madison: University of Wisconsin Press.

Douglas, Mary. 1966. *Purity and Danger: An Analysis of Concepts of Pollution and Taboo*. London: Routledge and Kegan Paul.

———. 1982. *Natural Symbols: Explorations in Cosmology*. New York: Pantheon.

Dyer, Wayne. 1976. *Your Erroneous Zones*. New York: Harper-Perennial.

Ebenstein, Hanns. 1953. *Pierced Hearts and True Love: The History of Tattooing*. London: Derek Verschoyle.

Ebin, Victoria. 1979. *The Body Decorated*. London: Thames and Hudson.

Ehrenreich, Barbara. 1989. *Fear of Falling: The Inner Life of the Middle Class*. New York: Harper Perennial.

Eldridge, Chuck. 1983. "TABC." *Tattoo Historian* no. 2: 9–10.

———. 1985a. "Tattoo History from A to Z." *Tattoo Historian* no. 8: 4–37.

———. 1985b. "Tattoo History from A to Z." *Tattoo Historian* no. 7: 4–39.

———. 1986. "Tattoo History from A to Z." *Tattoo Historian* no. 10: 4–36.

———. 1987. "Tattoo History from A to Z." *Tattoo Historian* no. 11: 4–39.

———. 1989a. "Navy Traditions." *Tattoo Archive* (winter): 51–53.

———. 1989b. "Tattoos as Identification." *Tattoo Archive* (summer): 37–40.

———. 1990. "The Marlboro Man." *Tattoo Archive* (spring): 7–9.

———. 1990a. "Maori Tattoo." *Tattoo Archive* (fall): 75–77.

———. 1991. "Tattoo Machines." *Tattoo Archive* (winter): 20–23.

———. 1992. "Tattoo History from A to Z." *Tattoo Archive* (fall): 1–4.

———. 1993. "American Circus 1793–1993." *Tattoo Archive* (winter): 17–19.

Elias, Norbert. 1978. *The Civilizing Process*. New York: Urizen Books.

Enloe, Cynthia. 1989. *Bananas, Beaches and Bases: Making Feminist Sense of International Politics*. Berkeley: University of California Press.

Estes, C. P. 1992. *Women Who Run with the Wolves: Myths and Stories of the Wild Woman Archetype*. New York: Ballantine Books.

Fahim, Hussein, ed. 1982. *Indigenous Anthropology in Non-Western Countries*. Durham, N.C.: Carolina Academic Press.

Featherstone, Mike, Mike Hepworth, and Bryan Turner, eds. 1991. *The Body: Social Process and Cultural Theory*. London: Sage Publications.

Fellowes, C. H. 1971. *The Tattoo Book*. Princeton: Pyne.

Ferguson, Marilyn. 1980. *The Aquarian Conspiracy: Personal and Social Transformation in the 1980s*. New York: Putnam Books.

Fiske, John. 1989. *Understanding Popular Culture*. New York: Routledge.

Foucault, Michel. 1979. *Discipline and Punishment: The Birth of the Prison*. New York: Vintage Books.

———. 1980a. *The History of Sexuality: Volume I, An Introduction*. New York: Pantheon Books.

———. 1980b. *Power/Knowledge: Selected Interviews and Other Writings. 1972–1977*. New York: Pantheon Books.

Fox, James. 1976. "Self-Imposed Stigmata: A Study of Tattooing among Female Inmates." Ph.D. diss. Albany: State University of New York.

Frankenberg, Ruth. 1993. *White Women, Race Matters: The Social Construction of Whiteness*. Minneapolis: University of Minnesota Press.

Fraser, Laura. 1992. "Tattoo You: The Psychology of Body Manipulations." *SF Weekly*, December 9.

Freund, Peter. 1982. *The Civilized Body: Social Domination, Control and Health*. Philadelphia: Temple University Press.

Gaines, Jane. 1990. "Fabricating the Female Body." In *Fabrications: Costume and the Female Body*, ed. Jane Gaines and Charlotte Herzog, 1–27. New York: Routledge.

Gallop, Jane. 1988. *Thinking through the Body*. New York: Columbia University Press.

Gambold, Liesl. 1992. "Personal Symbols and Public Displays of Affliction: Tattoo Culture in Urban America." Paper presented at American Anthropological Association Annual Meeting, San Francisco.

Gardner, Gerald. 1954. *Witchcraft Today*. New York: Magickal Childe.

Gathercole, Peter. 1988. "Contexts of Maori Moko." In *Marks of Civilization*, ed. Arnold Rubin, 171–78. Los Angeles: Museum of Cultural History, University of California.

Gell, Alfred. 1993. *Wrapping in Images: Tattooing in Polynesia*. Oxford: Oxford University Press.

Ginsburg, Faye. 1989. *Contested Lives: The Abortion Debate in an American Community*. Berkeley: University of California Press.

Goldstein, Norman. 1979. "Psychological Implications of Tattoos." *Journal of Dermatologic Surgery and Oncology* 5: 883–88.

Govenar, Alan. 1977. "The Acquisition of Tattooing Competence." *Folklore Annual of the University Folklore Association* nos. 7–8: 43–53.

———. 1981. "Introduction." In *Stoney Knows How: Life as a Tattoo Artist*, ed. Leonard St. Clair and Alan Govenar, xi–xxxii. Lexington: University Press of Kentucky.

———. 1983. "Christian Tattoos." *TattooTime* 2: 4–11.

———. 1984. "Issues in the Documentation of Tattooing in the Western World." Ph.D. diss. Dallas: University of Texas.

———. 1988. "The Variable Context of Chicano Tattooing." In *Marks of Civilization*, ed. Arnold Rubin, 209–17. Los Angeles: Museum of Cultural History, University of California.

Graves, Robert. 1966. *The White Goddess*. New York: Farrar, Straus and Giroux.

Grosz, Elizabeth. 1990. "Inscriptions and Body Maps: Representations and the Corporeal." In *Feminine, Masculine and Representation*, ed. Terry Threadgold and Anne Cranny-Francis. Boston: Allen and Unwin.

Hall, Douglas Kent. 1988. *In Prison*. New York: Henry Holt and Company.

Hambly, W. D. 1974. *The History of Tattooing and Its Significance*. Detroit: Gale Research.

Handler, Richard. 1988. *Nationalism and the Politics of Culture in Quebec*. Madison: University of Wisconsin Press.

Haraway, Donna. 1984. "Teddy Bear Patriarchy: Taxidermy in the Garden of Eden, New York City, 1908–1936." *Social Text* no. 11: 20–64.

Hardy, D. E. 1982a. "The New Tribalism." *TattooTime* 1: 3–9.

———. 1982b. "The Name Game." *TattooTime* 1: 50–54.

———. 1982c. "Sailor Jerry, The Upsetter." *TattooTime* 1: 26–32.

———. 1985. "Rock of Ages." *TattooTime* 3: 28–32.

———. 1994. "Introduction." In *Sailor Jerry Collins: American Tattoo Master*, ed. D. E. Hardy, 11–26. Honolulu: Hardy Marks Publications.

Harris, Thomas. 1967. *I'm OK, You're OK*. New York: Avon Books.

Hartigan, John, Jr. 1997. "Name Calling: Objectifying 'Poor Whites' and 'White Trash' in Detroit." In *White Trash: Race and Class in America*, ed. Matt Wray and Annalee Newitz, 41–56. New York: Routledge.

Hebdige, Dick. 1979. *Subculture: The Meaning of Style*. London: Methuen.

———. 1988. *Hiding in the Light*. London: Routledge.

Hobsbawm, Eric. 1983. "Introduction." In *The Invention of Tradition*, ed. Eric Hobsbawm and Terence Ranger, 1–14. Cambridge: Cambridge University Press.

Hopcke, Robert. 1991. "S/M and the Psychology of Gay Male Initiation: An Archetypal Perspective." In *Leatherfolk*, ed. Mark Thompson, 65–76. Boston: Alyson Publications.

Howe, Neil, and Bill Strauss. 1993. *13th Gen*. New York: Vintage Books.

Jagger, Alison, and Susan Bordo, eds. 1989. *Gender/Body/Knowledge*. New Brunswick: Rutgers University Press.

Kaeppler, Adrienne. 1988. "Hawaiian Tattoo: A Conjunction of Genealogy and Aesthetics." In *Marks of Civilization*, ed. Arnold Rubin, 157–70. Los Angeles: Museum of Cultural History, University of California.

Kalland, Arne. 1993. "Whale Politics and Green Legitimacy: A Critique of the Anti-Whaling Campaign." *Anthropology Today* 9, no. 6: 3–7.

Keen, Sam. 1991. *Fire in the Belly: On Being a Man*. New York: Bantam Books.

Kipnis, Aaron. 1991. *Knights without Armor: A Practical Guide for Men in Quest of a Masculine Soul*. New York: Jeremy Tarcher/Perigee.

Kipnis, Laura. 1992. "(Male) Desire and (Female) Disgust: Reading *Hustler*." In *Cultural Studies*, ed. Lawrence Grossberg, Cary Nelson, and Paul Treichler, 373–91. New York: Routledge.

Klimko, Frank. 1993. "A Surgeon Erases Gangs' Tattoos." *The San Diego Union-Tribune*, February 15.

Kodl, Kim. 1990. "Tattoos: Campus Skin Sketches." *The California Aggie*, November 7.

Lasch, Christopher. 1979. *The Culture of Narcissism*. New York: Warner Books.

Laurence, Leslie. 1994. *The Imperfect Sacrifice*. Unpublished manuscript.

Lawless, Elaine. 1988. *Handmaidens of the Lord: Pentecostal Women Preach-*

*ers and Traditional Religion.* Philadelphia: University of Pennsylvania Press.

Lewis, David. 1992. "Prison Tattooing." *Tattoo International* (January): 12.

Libman, Gary. 1990. "Illustrated Man Is No Skinflint." *Los Angeles Times,* April 20.

Limón, José. 1991. "Representation, Ethnicity and the Precursory Ethnography: Notes of a Native Anthropologist." In *Recapturing Anthropology,* ed. Richard G. Fox, 115–36. Santa Fe: School of American Research Press.

Louie, Elaine. 1991. "The Best Selling Tattoos." *Wall Street Journal,* March 5.

Malone, Michael. 1991. "Michael Malone." *TattooTime* 5: 52–73.

Marchand, Shoshana. 1992. "Hooked: Mind and Body Games among the Modern Primitives." *The Bay Guardian,* May 27.

Martin, Emily. 1987. *The Woman in the Body: A Cultural Analysis of Reproduction.* Boston: Beacon Press.

Mascia-Lees, Frances, and Patricia Sharpe, eds. 1992. *Tattoo, Torture, Mutilation and Adornment: The Denaturalization of the Body in Culture and Text.* New York: State University of New York Press.

Matthews, John, ed. 1991. *Choirs of the God: Revisioning Masculinity.* London: Mandala.

McAuliffe, Mike. 1990. "Body by Hardy." *The Argus,* February 19.

McCabe, Michael. 1995. "Coney Island Tattoo: The Growth of Inclusive Culture in the Age of the Machine." In *Pierced Hearts and True Love: A Century of Drawings for Tattoos,* ed. Don Ed Hardy, 49–55. Honolulu: Hardy Marks Publications.

McCallum, Donald. 1988. "Historical and Cultural Dimensions of the Tattoo in Japan." In *Marks of Civilization,* ed. Arnold Rubin, 109–34. Los Angeles: Museum of Cultural History, University of California.

McCubrey, Joanne. 1990. "Walking Art." *Mountain Democrat,* February 9.

McRobbie, Angela. 1978. "Working-Class Girls and the Culture of Femininity." In *Women Take Issue,* ed. Women's Study Group. London: Huchinson.

Mechling, Elizabeth Walker, and Jay Mechling. 1991. "Kind and Cruel America: The Rhetoric of Animal Rights." In *Rhetorical Dimensions in Media: A Critical Casebook,* ed. Martin J. Medhurst and Thomas W. Benson, 110–42. Dubuque, Iowa: Kendall/Hunt Publishing Company.

———. 1994. "The Jung and the Restless: The Mythopoetic Men's Movement." *The Southern Communication Journal* (winter): 97–111.

Meredith, Robin. 1997. "Tattoo Art Gains Color and Appeal, Despite Risk." *New York Times,* March 15.

Miercke, Elizabeth. 1992. "American Ethnography and Body Tattoos." Paper presented at American Anthropological Association Annual Meeting, San Francisco.

Moffatt, Michael. 1992. "Ethnographic Writing about American Culture." *Annual Review of Anthropology* 21, ed. Bernard Siegel, Alan Beals, and Stephen Tyler: 205–29.

Moore, Robert, and Douglas Gillette. 1990. *King, Warrior, Magician, Lover: Rediscovering the Archetypes of the Mature Masculine.* San Francisco: Harper San Francisco.

———. 1991. *The King Within.* New York: Morrow.

———. 1992. *The Warrior Within.* New York: Morrow.

Morse, Albert. 1977. *The Tattooists.* San Francisco: Albert Morse.

Morton, Walt. 1993. "Body Motif-ication: Tattoo and Cultural Identity." Paper presented at California American Studies Association Conference, Reno.

Murphy, Robert. 1990. *The Body Silent.* New York: Norton.

Murray, Margaret. 1921. *Witch-Cult in Central Europe.* Oxford: Oxford University Press.

Nader, Laura. 1974. "Up the Anthropologist: Perspectives Gained from Studying Up." In *Reinventing Anthropology,* ed. D. Hymes, 284–311. New York: Random House.

Newitz, Annalee, and Matt Wray. 1997. "Introduction." In *White Trash: Race and Class in America,* ed. Matt Wray and Annalee Newitz, 1–12. New York: Routledge.

Newman, Gustave. 1982. "The Implications of Tattooing in Prisoners." *Journal of Clinical Psychiatry* no. 43: 231–34.

Nilsen, Richard. 1991. "Fine Art in the Flesh." *The Arizona Republic,* April 14.

Ohnuki-Tierney, Emiko. 1984. "Native Anthropologists." *American Ethnologist* no. 11: 584–86.

O'Neill, John. 1985. *Five Bodies: The Human Shape of Modern Society.* Ithaca: Cornell University Press.

Orvino, Rachel. 1992. "Pins and Needles: Tattoo Art Struts Its Stuff." *Sacramento News and Review,* June 18.

Parry, Albert. 1971. *Tattoo: Secrets of a Strange Art Practiced by the Natives of the United States.* New York: Colier.

Peck, M. Scott. 1978. *The Road Less Traveled.* New York: Simon and Schuster.

Perin, Constance. 1977. *Everything in Its Place: Social Order and Land Use in America.* Princeton: Princeton University Press.

———. 1991. *Belonging in America.* Madison: University of Wisconsin Press.

Peterson, Kimberly. 1995. "Doctor Wants to Inject More Safety into the Regulations on Tattooing." *San Diego Union-Tribune,* June 29.

Polhemus, Ted, ed. 1978. *The Body Reader: Social Aspects of the Human Body.* New York: Pantheon.

Radway, Janice. 1991. "Interpretive Communities and Variable Literacies: The Functions of Romance Reading." In *Rethinking Popular Culture*, ed. Chandra Mukerji and Michael Schudson, 465–86. Berkeley: University of California Press.

———. 1984. *Reading the Romance*. Chapel Hill: University of North Carolina Press.

Raven, Cliff. 1982. "Thoughts on Pre-Technological Tattooing." *TattooTime* 1: 10.

Richie, Donald, and Ian Buruma. 1980. *Japanese Tattoo*. New York: Weatherhill.

Robison, Peter. 1993. "Tattooed Tough Guys Seek to Zap Their Outlaw Images." *Sacramento Bee*, July 9.

Root, Deborah. 1996. *Cannibal Culture: Art, Appropriation, and the Commodification of Difference*. Boulder: Westview Press.

Rose, Dan. 1987. *Black American Street Life*. Philadelphia: University of Pennsylvania Press.

Rosenblatt, Daniel. 1997. "The Antisocial Skin: Structure, Resistance, and 'Modern Primitive' Adornment in the United States." *Cultural Anthropology* 12, no. 3: 287–334.

Ross, Andrew. 1989. *No Respect: Intellectuals and Popular Culture*. New York: Routledge.

Rubin, Arnold. 1988a. "Tattoo Trends in Gujarat." In *Marks of Civilization*, ed. Arnold Rubin, 141–54. Los Angeles: Museum of Cultural History, University of California.

———. 1988b. "Tattoo Renaissance." In *Marks of Civilization*, ed. Arnold Rubin, 233–64. Los Angeles: Museum of Cultural History, University of California.

Russo, Mary. 1987. "Female Grotesques: Carnival and Theory." In *Feminist Studies: Critical Studies*, ed. Teresa De Lauretis, 213–29. Bloomington: Indiana University Press.

Sanders, Clinton. 1987. "Psychos and Outlaws: Scientific Images of Tattooed Persons." *TattooTime* 4: 64–68.

———. 1989. *Customizing the Body: The Art and Culture of Tattooing*. Philadelphia: Temple University Press.

Scheper-Hughes, Nancy. 1992. *Death without Weeping: The Violence of Everyday Life in Brazil*. Berkeley: University of California Press.

Scutt, R. W. B., and C. Gotch. 1974. *Art, Sex and Symbol: The Mystery of Tattooing*. New York: A. S. Barnes.

Sheehy, Gail. 1976. *Passages*. New York: Bantam Books.

Silverman, Kaja. 1986. "Notes on a Fashionable Discourse." In *Studies in Entertainment: Critical Approaches to Mass Culture*, ed. Tania Modleski, 139–54. Bloomington: Indiana University Press.

Smith, Juana. 1989. "Women and Tattoos." Paper presented at American Anthropological Association Annual Meeting, Chicago.

Solari, J. J. 1992. "Fantasies on Flesh." *Easyriders* (October).

Sontag, Susan. 1978. *Illness as Metaphor*. New York: Farrar, Straus and Giroux.

——. 1989. *AIDS and Its Metaphors*. New York: Farrar, Straus and Giroux.

Spitzack, Carole. 1988. "The Confession Mirror: Plastic Images for Surgery." *Canadian Journal of Political and Social Theory* 12, nos. 1–2: 38–50.

Stacey, Judith. 1990. *Brave New Families: Stories of Domestic Upheaval in Late Twentieth Century America*. New York: Basic Books.

Stafford, Greg. 1991. "The Monsters." In *Choirs of the Gods: Revisioning Masculinity*, ed. John Matthews. London: Mandala.

Stallybrass, Peter, and Allon White. 1986. *The Politics and Poetics of Transgression*. Ithaca: Cornell University Press.

Starhawk. 1979. *The Spiral Dance: A Rebirth of the Ancient Religion of the Great Goddess*. San Francisco: Harper and Row.

St. Clair, Leonard, and Alan Govenar. 1981. *Stoney Knows How: Life as a Tattoo Artist*. Lexington: University of Kentucky Press.

Steward, Samuel. 1990. *Bad Boys and Tough Tattoos: A Social History of the Tattoo with Gangs, Sailors and Street-Corner Punks, 1950–1965*. New York: Harrington Park Press.

Sturtevant, William. 1971. "A Short History of the Strange Custom of Tattooing." In *The Tattoo Book*, ed. C. H. Fellowes, 1–10. Princeton, N.J.: The Pyne Press.

Sulu'ape, Petelo. 1991. "History of Samoan Tattooing." *TattooTime* 5: 102–9.

Taylor, A. J. W. 1970. "Tattooing among Male and Female Offenders of Different Ages in Different Types of Institutions." *Genetic Psychology Monographs* 81: 81–119.

Teish, Luisah. 1985. *Jambalaya*. San Francisco: Harper and Row.

Teshima-Miller, Lani. 1995. rec.arts.bodyart Frequently Asked Questions (FAQ). Usenet rec.arts.bodyart, available via anonymous FTP: rtfm.mit.edu:/pub/news-answers/bodyart.

Thevoz, Michel. 1984. *The Painted Body*. New York: Rizzoli International Publications.

Thompson, Mark, ed. 1991. *Leatherfolk*. Boston: Alyson Publications.

Truscott, Carol. 1991. "S/M: Some Questions and a Few Answers." In *Leatherfolk*, ed. Mark Thompson, 15–36. Boston: Alyson Publications.

Turner, Bryan. 1984. *The Body and Society: Explorations in Social Theory*. New York: Basil Blackwell.

Turner, Terence. 1995. "Social Body and Embodied Subject: Bodiliness,

Subjectivity and Sociality among the Kayapo." *Current Anthropology* 10, no. 2: 143–70.

Turner, Victor. 1969. *The Ritual Process*. Ithaca: Cornell University Press.

Tuttle, Judy. 1987. "Omi You Were Great!" *Tattoo Historian* no. 11: 17–21.

Tuttle, Lyle. 1985. "Professor Charles Wagner." *Tattoo Historian* no. 8: 7–11.

———. 1986. *Historic and Patriotic Tattooing*. San Francisco: Tattoo Art Museum.

———. 1987. "Professional Tattooing." *Tattoo Historian* no. 11: 17–26.

Vale, V., and Andrea Juno. 1989. *Modern Primitives*. San Francisco: Re/Search Publications.

Wallace, Anthony. 1956. "Revitalization Movements." *American Anthropologist* 58: 264–81.

Ward, Jim. 1979. "Piercing: The Primitive Touch." *PFIQ* 6: 9–12.

Webb, Doc. 1978. *The Honest Skin Game*. San Diego: Doc Webb.

———. 1985. "Sailors 'N' Tattoos." *TattooTime* 3: 3–13.

Werne, Lisa. 1991. "Joining the Realm of the Marked." *The Orion*, September 25.

Weston, Kath. 1991. *Families We Choose: Lesbians, Gays, Kinship*. New York: Columbia University Press.

Williamson, Judith. 1986. "Woman Is an Island." In *Studies in Entertainment: Critical Approaches to Mass Culture*, ed. Tania Modleski, 99–118. Bloomington: Indiana University Press.

Wilson, Elizabeth. 1987. *Adorned in Dreams: Fashion and Modernity*. Berkeley: University of California Press.

Wilson, Peter. 1991. "Runaway Child." In *Choirs of the Gods: Revisioning Masculinity*, ed. John Matthews. London: Mandala.

Wojcik, Daniel. 1995. *Punk and Neo-Tribal Body Art*. Jackson: University Press of Mississippi.

Yengoyan, Aram. 1992. *Culture and Ideology in Contemporary Southeast Asian Societies: The Development of Traditions*. Honolulu: Environment and Policy Institute, East-West Center.

———. 1994. "Culture, Ideology and World's Fairs: Colonizer and Colonized in Comparative Perspectives." In *Fair Representations: World's Fairs and the Modern World*, ed. Robert Rydell and Nancy Gwinn. Amsterdam: VU University Press.

Zeis, Milton. 1947. *Tattooing the World Over*, vol. 1. New York: Milton Zeis.

———. 1952. *Zeus School of Tattooing Home Study Course*. New York: Milton Zeis.

# Index

Panky, Hanky, 112
Perry, Kris, 128
*PFIQ*, 175, 177
Piercing, 37, 174–175, 180
Primitivism, 146, 174–183, 189. *See also* Tribalism
Prison: position within tattoo community, 132–134; as tattoo style, 69–70, 80, 91
Punk, 86, 89, 91

RAB *See* Rec.arts.bodyart
Raven, Cliff, 74, 79, 82, 86
Realistic Tattoo, 80, 85
Rec.arts.bodyart, 37–40, 160, 165, 169–170, 180, 199 n.11
Riddler, Horace. *See* Great Omi, The
Riley, Tom, 50
Roberts, Bob, 85, 202 n.3
Rogers, Paul, 52, 73, 103
Root, Deborah, 14
Rosenblatt, Daniel, 161, 189
Ross, Andrew, 181
Rubin, Arnold, 50, 79, 91
Rudy, Jack, 80, 85
Rutherford, John, 56

Sailor: as class marker, 5–6; as tattoo customer, 63–66
Salmon, Bill, 202 n.3
Sanders, Clinton, 102, 126, 138, 197 n.7, 198 n.4
Scheper-Hughes, Nancy, 140
Schiffmacher, Henk. *See* Panky, Hanky
Scratcher: as class marker, 5–6; definition of, 102
Self-help, 143–144
Shaw, Jonathan, 108–111, 130–131, 203 n.4
Shaw, Robert, 52, 103, 131
Sideshow, 47–49, 53–59
*Skin and Ink*, 121
S/M, 86, 143, 146, 174–175, 180–181

Sparrow, Phil, 79. *See also* Steward, Samuel
Starhawk, 147, 151
Steward, Samuel, 61–62. *See also* Sparrow, Phil
Strauss, Bill, 187–188
Summers, Jamie, 144, 164, 202 n.3

*Tattoo*, 101, 113–118, 132
*Tattoo Advocate*, 101, 104–108
Tattoo City, 85
Tattoo Club of America, 203 n.6
Tattoo community: borders within, 134–135; class and status within, 5–9; definitions of, 3–5; discourses of, 22–25; entry into, vii–viii; history of, 21–22; as imagined community, 40–43; location of, 17–18; researcher's relationship to, vii–x; rituals of, 20–21
Tattoo conventions: as aspects of community, 20–22; contests within, 28–31; description of, 26–29; differing perspectives on, 25–26; as example of the carnivalesque, 29–32
Tattooed natives. *See* Sideshows
*Tattoo Enthusiast Quarterly*, 23, 129
Tattoo Expo, 80, 104
Tattooing: Americanization of, 49–52; biker, 67–68; as borrowed tradition, 11–12; Chicano, 84–86; colonial roots of, 45–49; and deviance, 67; as discursive tradition, 12–13, 151–158; Japanese, 72–74; as mark of difference, 13–14; Micronesian, 87–88; military, 49–51, 63–66; origin of term, 45; Polynesian, 45–49; in prison, 69–70; process of, 198 n.3; regulations surrounding, 66, 78–79, 201 n.9, 202 n.2, 203 n.8; as tool for transformation, 143–151,

2665

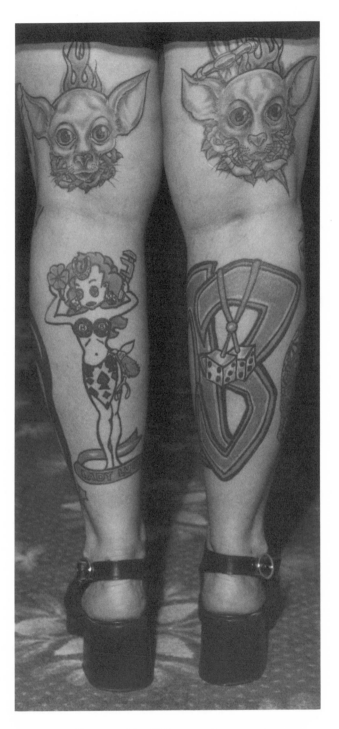

Lynn Cosnell tattooed by different artists.

*Photo by Vida Pavesich*

Margo DeMello is an independent scholar.

Author tattooed by Joe Vegas.

*Photo by Vida Pavesich.*

*Library of Congress Cataloging-in-Publication Data*

DeMello, Margo.

Bodies of inscription : a cultural history of the modern tattoo commu-
nity / Margo DeMello.

p.   cm.

Includes bibliographical references and index.

ISBN 0-8223-2432-6 (cloth : alk. paper). — ISBN 0-8223-2467-9 (paper :
alk. paper)

1. Tattooing—United States.   2. Tattooing—United States—Social as-
pects.   I. Title.

GT2346.U6D45   2000

391.6'5—dc21          99-29368